Occupation : Boundary

Occupation : Boundary
Art, Architecture, and Culture at the Water

Cathy Simon

with Carrie Eastman

Essays by
Laurie Olin
John King
Justine Shapiro-Kline

Drawings by
Bárbara Miglietti

Edited by Ashley Simone

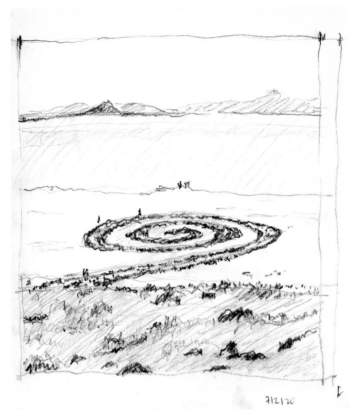

712/20

In Memoriam: John Robert Simon

November 18, 1951, New York City–April 10, 2020, Salt Lake City

We will scatter our own
ashes, scatter them in a spiral

between lake and sky,
cadmium yellow sky.
—"Midnights: La Jetée," Michael Palmer, 2020

For the boundary between sea
and land is the most fleeting and
transitory feature of the earth.
—Rachel Carson, "The Shape of Ancient
Seas," in *The Sea Around Us*, 1951

Liminal,
Not Minimal

Laurie Olin

Water is the blood of the earth. It gives
life to all creatures. Humans and animals
need it and are instinctively drawn to it,
seeking lakes and streams, rivers and shores.
Migrating animals and people have followed it,
and the life it has supported, up over mountains
and down again to the sea. Our earliest settle-
ments were adjacent to water. Children are inevi-
tably attracted to water; you can't keep them out of
puddles or the sea. Adults invariably walk up to the edge
and put a toe in it, or place their hands in a basin.

Travel by raft, canoe, or boat set commerce in motion
beyond the scope of foot travel, whether by two feet or four.
Throughout the world, cites developed on the banks and shores
of lakes, rivers, and oceans from Baghdad and Beirut to Carthage
and Naples, from Mumbai to Shanghai, London, Boston and Rio.
Over time, indigenous people and explorers created landings and set-
tlements that have led to the largest and most dynamic communities on
the planet. These inevitably have been *liminal* realms; transitional places,
combinations of people and goods, events and structures; habitats of inter-
action between ideas, things, and territories; sites for exchange and ship-
ping, making and taking, as found in Hong Kong and Capetown, Vancouver
and Rio, San Francisco, and Amsterdam.

For millennia people have been attracted to cities on the water's edge,
arriving at coastlines from landlocked regions. The boundary conditions they
sought later were transformed into cities, growing dramatically in compar-
ison to inland conditions characterized by an absence of oceans and great
rivers. Like millions of others, I too migrated from the interior, the depths of
a continent, to such liminal places, first from Wisconsin to Vancouver and
Seattle, and then from the heart of Alaska to New York, London, Rome, and
eventually Philadelphia. All were great cities, on major rivers and seas, with a
long history of transshipment and the exchange of goods, people, and ideas.
Throughout my life, I have never spent long periods far from the ocean or
a vital river. Even Fairbanks, Alaska was located on the Chena River, which
leads to the Tanana River, which leads to the Yukon, which leads to the Bering
Sea, which connects to the Arctic and Pacific Oceans, which connect to the
Indian, Atlantic, Baltic, and Mediterranean. While in the Army at Fort Ord on
Monterey Bay, I haunted the beach at Carmel, Cannery Row in Monterey,
and San Francisco with its wharves, fishermen, and marinas. Later, I lived in
Seattle and hung out along the waterfront of Elliot Bay, Skid Road, and Pike
Place Market with its view of Puget Sound and the world beyond. Moving
to New York, I reveled—as did Melville, Whitman, and others—in its island
archipelago of energy and ambition, architecture and commerce, art and

cosmopolitan intercourse of migrants, immigrants, careerists, native sons, and rural refugees. Subsequent periods spent abroad in London, Rome, and Paris reinforced my appreciation of such historic mixing bowls and influential centers of commerce, governance, and creativity. Some from conservative corners within the heart-of-the-heart of the interior may even include New Orleans and Los Angeles among notable places of foreign, even exotic, character and effervescence. But due in large part to the presence of flood hazard, neither has developed a meaningful urban riverfront. In the course of all my shifting about, I have worked on architecture, urban design, and landscape design projects on the aqueous margins of New York, London, Los Angeles, Seattle, and San Francisco. Like millions of others, I have spent vacations with my family at the seashore for what seems like forever. We have been to Cornwall, Scotland, Venice, Maine, Nantucket, Martha's Vineyard, Cape Cod, Cape May, Fire Island, Long Island, St John Island, Lopez Island, and the coasts of Washington and Oregon.

This litany may seem overly personal, a symptom of our solipsist age, not relevant to Cathy Simon's book. It's not. Aside from what may be an atypical amount of movement and number of examples, my example is the reality for millions upon millions of people. The vast majority of the world's population lives within one-hundred feet of sea level or a short distance from navigable bodies of water. Not only is the population of the world continuing to grow at a troubling rate, but it also is moving to locations of a liminal state in proximity to littoral situations, namely urban waterfronts. Cities are also dynamic, not static, which is what one says about nature and landscapes. People not only exist in nature but are a part of it. If you, like me, believe this and will agree that cites are forms of landscapes—albeit rich, dynamic, and complex ones that consist of more than mere buildings and utilities, but also of spaces, parks, streets, sky, birds, animals, climate, weather, topography— then an urban edge adjacent to a body of water may logically be considered analogous to liminal territories in wild nature. One can see that this is true.

During my lifetime, I have seen dramatic changes to the waterfronts of great cities around the world. Nearly all of the deep-water ports, which formerly had finger piers and wharves bristling with ships, cargo, activity, and people are no longer useful for shipping activities. This was precipitated by a change in cargo shipping from smaller prewar ships to giant freighters stacked high with containers that needed acres and acres of flat land adjacent to the piers, and not by dock strikes on the East and West coasts following World War II as some once believed. New York's cargo shipping moved to New Jersey; San Francisco's moved to Oakland; London's moved to Tilbury; Vancouver's to the Fraser River; Boston and Seattle's shifted away from their historic waterfronts to nearby landfills that had been tidal marshes. The result has been that after a period of decline, the older historic waterfronts have been repurposed for an influx of development, redevelopment, and rediscovery of the littoral and its attraction—becoming sites for parks, opera houses, and esplanades, aquariums, office towers, mixed-use and residential communities, museums, aquariums, sports, entertainment, and art facilities.

Water has been an inspiration and topic for a wide variety of art ranging from George Frideric Handel's "Water Music" and Claude Debussy's "La Mer" to numerous Chinese and Japanese monumental scrolls and screens as diverse as those of the twelfth-century Southern Song and the brilliant

seventeenth-century Kyoto decorative work of Tawaraya Sōtatsu and Honemi Kōetsu, or the nineteenth-century prints by Katsushika Hokusai and Utagawa Hiroshige in Japan. In addition to these examples originating from Asia, several western painters have engaged water in an urban context and amidst the various milieu of cities and waterfronts. Giovanni Antonio Canal, known as Canaletto, and Francesco Guardi documented the factual developments of commerce, the wealth of church and state, and the instrumentality of contemporary life and leisure in conjunction with the aqueous world of Venice. Over a century later, J.M.W. Turner and James Abbott McNeil Whistler also addressed the subject in strikingly different ways. Whistler began by scrutinizing and documenting the commercial docklands of London's East End in an extensive series of etchings and engravings depicting the docks, boats, masts, wharves, bridges, and public houses, along with their denizens and went on to produce paintings rendered using gouache and watercolor in his famous nineteenth-century "nocturne" paintings, many of which are now in the collections of the British Museum or the Freer Gallery in Washington, D.C. In these drawings and paintings, one first sees engagement in the social and commercial world of Dickens, which later shifts to a consideration bordering on obsession with the visual, formal, sensual, and poetic possibilities in the changeable light and atmosphere of this realm. Turner, beginning as an illustrator, initially produced a record of harbors and quays in Britain and abroad, but moved as well to a distillation of light and color in both harbor subjects and situations at sea, especially involving extreme atmospheric and weather effects. At the end of the century, John Singer Sargent also demonstrated fascination with the challenge of representing water, whether in an alpine stream, mountain lake, villa gardens, or urban fountains. He, too, was deeply affected by the visual splendor and possibilities in Venice and produced many watercolor renditions of different locations and moods, architecture, boats, people, and activities in the urban fabric that interacted with the canals and lagoons.

Many designers—architects and landscape architects—have been drawn to the possibilities of engagement with water since classical antiquity. The first century in Rome saw an explosion of seaside villas, especially around the Bay of Naples, but also in the lake district of the north. Tiberius and others challenged their architects to produce work that would astonish and delight with waterside porticos, extensive fishponds, and grottos filled with art. The Renaissance and Baroque eras produced the handsome bridges and beautiful waterside churches of Venice, such as Santa Maria della Salute by Baldassare Longhena, San Giorgio Majore and Il Redentore by Andrea Palladio, as well as spectacular urban water landings such as those of Alessandro Specchi and Francesco De Sanctis in Rome, or the grand ensemble built for the Royal Naval College by John Vanbrugh and Nicholas Hawksmoor in London. Beginning in the nineteenth century through the middle of the twentieth century, however, industry drove people from most of the waterfronts in Europe and America. There were a few exceptions, particularly in the occasional engagement of talented designers working for wealthy industrialists on private retreats such as Vizcaya, the spectacular villa Charles Deering built in Coral Gables on Biscayne Bay, or at Gwinn by Charles Adam Platt and Warren Manning on Lake Erie in Cleveland, both of which are superb works of landscape, architecture, and decorative art. In the latter part of the twentieth century, however, architects and ambitious clients have once again responded to the stimulus of water and its proximity

in urban settings, with examples ranging from Aldo Rossi's whimsical and dreamy Teatro del Mondo to recent works such as Snøhetta's Opera House in Oslo, and Jean Nouvel's Guthrie Theater in Minneapolis. The abandonment of aging industrial port infrastructure, which has taken place in many western cities, has come to provide a wealth of opportunities for the art of landscape architecture to be deployed at the edges between cities and the water. Artists and designers active during the latter half of the twentieth and the early decades of the twenty-first century have produced a number of engaging works in the Netherlands, Scandinavia, Britain, Spain, Canada, Mexico, and the United States—from Agnes Denes' wheat field at Battery Park City to Olafur Eliasson's waterfall project in the East River of New York City. Numerous recent waterfront parks have been realized by a list of landscape architects and architects that includes Adrianne Greuze, George Hargreaves and Mary Margaret Jones, Kathryn Gustafson, Michael Van Valkenburgh, Peter Walker, Marion Weiss and Michael Manfredi, Konjian Yu, myself, and many others.

What can I possibly conclude from this? It is in large part about the edge. Specifically, of being drawn to it, to a condition and place characterized by infinite change and ambiguous possibility. Truly, a liminal state. Here are beauty and flow, danger and support, succor. The ocean is fecund. It is also dangerous. Cities are dynamic hives of people and activity that are generative, inspiring, creative, productive, and rewarding as places to live, work, play, and interact. They can also be difficult, emotionless, heartless, cruel, and dangerous. It is this yeasty context, this coming together of so many factors and forces, and so much history, of past, present, and future, that make waterfronts—great urban waterfronts—exciting and compelling. They may well be an inexhaustible subject. Still, there is every reason to consider them, to linger and look closely at them as a topic, to contemplate several in detail, to meditate upon impact beyond literal, physical manifestations to that of a deeper cultural level. One must also acknowledge the significance of climate change, sea-level rise, and the global increase in the perturbations of weather—cyclonic storms, drought, floods—that will impact the diverse realms of important urban waterfronts. Effects will be seen from New York to Bangladesh, from Venice to Vancouver and Miami. It is, thus, urgent that we contemplate great and small urban waterfronts to discover means by which to embrace them and foster their potential for resilience.

And so one considers Cathy Simon's thoughtful endeavor, a multifaceted consideration of many interrelated topics and issues engendered by great urban waterfronts. Cathy Simon is an uncommon architect and planner who has not pursued a conventional practice based upon style, celebrity, fashion, or the making of individual structures that surprise, shock, and call attention to themselves and the designer. Instead, her portfolio reveals an abiding interest in socially pertinent problems with a subtlety, regardless of scale or context, that addresses questions of situation and art, motivation and need. For her, context is not merely that which is physically adjacent but also is established in a more ecological sense by social and environmental topics. Whether designing a library on a campus hillside or an urban civic ensemble, Simon has demonstrated concern for relationships that are not merely matters of bricks and stone, form and structure, or the other tangible apparatuses of architecture that she handles with aplomb. She reveals concern for the sensual involvement of those who will confront her work,

including children, the elderly, the disenfranchised. Intellectual engagement is located in the work by way of her regard for time, memory, and the particular regional, economic, historical, and political situation in which she is working. Such engagement is exemplified in her remarkably successful transformation of the historic Ferry Building on the San Francisco waterfront, which avoided becoming a "festival market" as has been the case for projects mounted in similar contexts by corporate development firms. Instead, the Ferry Building is a social hub that has transcended the programs of shopping and tourism to become woven into the daily life of citizens and the cycles of life in the city. Simon is an architect in a larger, deeper sense, one suggested by Vitruvius and Alberti, which implies understanding and 'building' at multiple scales, with materials and with intent for wellbeing and social purpose. Through her collaborations with other professionals—engineers, landscape architects, planners, mechanical and lighting designers, lawyers—and the community at large, she thrives as a critical link, interpreting, guiding, and shaping the efforts of many. This is another kind of liminal space that Simon deftly occupies. We can commend her for the unusual talent she possesses to operate in this space, from where she has realized creative and innovative schools in San Francisco, the planning of a new university campus in a needy suburb, and the adaptive transformation of the historic San Francisco Presidio. Throughout her life and work, Cathy Simon has demonstrated both curiosity and generosity, along with engagement in situations that matter. It is no surprise that she has turned her energy and concern to urban waterfronts. They represent an urgent situation for humanity to address and need our attention more so today than ever before.

Introduction

Whenever I find myself growing grim about the mouth.... then, I account it high time to get to sea as soon as I can. This is my substitute for pistol and ball. There is nothing surprising in this. If they but knew it, almost all men in their degree, sometime or other, cherish the very same feelings toward the ocean with me.... Circumambulate the city of a dreamy Sabbath afternoon.... What do you see? Posted like silent sentinels all around the town, stand thousands upon thousands of mortal men fixed in ocean reveries.... But look! Here come more crowds, pacing straight for the water, and seemingly bound for a dive. Strange! Nothing will content them but the extremest limit of the land; loitering under the shady lee of yonder warehouses will not suffice. No. They must get just as nigh the water as they possibly can without falling. And there they stand—miles of them—leagues. Inlanders all, they come from lanes and alleys, streets avenues—north, east, south, and west. Yet here they all unite.... Why did the old Persians hold the sea holy? Why did the Greeks give it a separate deity, and own brother of Jove? Surely all this is not without meaning. And still deeper the meaning of that story of Narcissus, who because he could not grasp the tormenting, mild image he saw in the fountain, plunged into it and was drowned. But that same image, we ourselves see in all rivers and oceans. It is the image of the ungraspable phantom of life, and this is the key to it all.[1]
— Herman Melville, *Moby Dick*, Chapter 1, "Loomings"

Melville, in his passage above, describes the "extremest limit of the land," and how crowds are drawn to this point at the edge of the revered sea, regarded as holy by the Persians and Greeks. I, too, have been drawn to this place on earth all my life, coming of age in New York City, with its vacillating relationship with the waterfront, and in my design career, mostly in San Francisco. The urban waterfront specifically has attracted me because it is at this point that the daily life of the city, with all of its vibrant and complicated networks, comes close to spilling over the edge. In the city, this threshold between all that comprises urban life meets all that is holy about the sea. And we are left with a space so charged it can be deemed only poetic. But it is more than that, for the urban waterfront also has borne pragmatic responsibility. Where the static architecture of the city meets the dynamism of water; where the horizon is revealed in expanse; where that which is known meets that which is mysterious: we burden this threshold with our most onerous tasks.

Throughout history, proximity to the world's oceans, bays, and rivers has determined the settlement of towns. Spiro Kostof, in his definition of a city, says that cities are "places favored by a source of income. . ." such as "a

geomorphic resource like a natural harbor. . ."[2] It is no wonder, then, that many of the world's most fascinating cities derive their identities and sense of place from the water. Waterways were sources of political and economic power in that they provided vital connections beyond the town and region before the world was globally more seamlessly connected as we know it to be today. Access to urban waterfronts facilitated commerce by making import and export possible, and similarly, this access had the same effect on immigration and travel. The relationship between the town and water also fostered industry, allowing for fishing and whaling, waste disposal, and the powering and cooling of industrial machines.

During recent decades, shifts in economic, industrial, and military forces have affected how our waterfronts function. Whereas at one time, waterways were used to transport coal and petroleum, the rise of alternative and renewable energy sources, as well as the trade of resources on an international scale, have made local and regional shipment and local and regional ports obsolete. Ocean travel is a mode of the past. Grand changes in trade practices have led to the abandonment and deterioration of once busy commercial piers. These changes have left our waterfront sites in a state of decline. What's more is that presently, global trade demands consolidated, deep-water ports to accommodate larger-than-ever-before ships, and requires vast infrastructure networks of accessible rail and highway systems to serve them. Meeting these demands for infrastructure further jeopardizes historic urban ports.

In addition, the nature of the role the waterfront has played in American military operations has also changed. Since the period of relative peace following World War II and the end of the Cold War, specifically between 1988 and 2005, the United States has decommissioned many of its waterfront military bases. This decommissioning program, known as Base Realignment and Closure (BRAC), has resulted in the closure of significant bases in Northern California and the East Coast, including Treasure Island Naval Station, The Presidio of San Francisco, Hunter's Point Naval Shipyard, Fort Cronkhite and Fort Baker, and the Alameda Naval Air Station, as well as New York's Brooklyn Navy Yard, and the Coast Guard station in Governor's Island, leaving vast tracts of land along the urban waterfront neglected, contaminated, and vacant.

Simultaneous with the decline of our urban industrial and military waterfront is the crisis condition of our climate. It is no secret that our world's polar ice caps and mountain glaciers are melting, oceans are rising, storm events such as hurricanes, flash floods, and tornadoes, as well as "natural" disasters, such as droughts and forest fires, have become more devastating and more frequent. "Climate change is increasingly visible, increasingly irreversible and increasingly significant to people all over the world," wrote Henk Ovink, Dutch Special Envoy for International Water Affairs. He continues, "Like a diabolical magnifying glass, a warming climate enlarges the force and frequency of storms, lengthens the periods of droughts and swells human misery as millions lose their possessions, jobs, friends, and families."[3] And the threat to our beloved coastal cities is arguably the greatest. The aged industries present in these vulnerable waterfront cities pose a particular environmental hazard if hit by the superstorms of the present, not to mention the threat to disenfranchised populations, neighborhoods,

and businesses frequently marginalized to our topographically lowest, most vulnerable real estate.

But the issue of climate change is not merely a local, regional, or national one. The actions of our international leaders have vast repercussions on our lives. What comes to mind, of course, is the Trump administration's untimely withdrawal from the 2016 Paris Agreement. It is difficult to predict how drastic actions such as these will effect our waterways. What direct and indirect implications will policy have on rising sea levels and the precipitation of extreme storm events? Will our cities flood in a manner unprecedented? Will we be required to think of our shorelines in new ways, applying substantial adaptations in an attempt to create resiliency? It is in this atmosphere, where increased globalization has rendered our ports and industrial waterfronts obsolete and where climate change has created a sequence of disasters for our cities, that interest in rehabilitating the urban waterfront has emerged in the consciousness of Americans, Europeans, and others.

It is at this moment that we recall the poetics of water, its religious nature, and its ability to nurture, heal, and revive us. We recall the long tradition of representing both the calm and the storm of the sea in drawing and painting. And we recall Melville's crowds being drawn to the edge of the land, and the Persians, and the Greeks, and the Old and New Testaments. Suddenly, we need to be on the water. We recognize that the water is both utilitarian, for industry, commerce, and military functions, and spiritual, for healing and rejuvenation. Its power is forceful and threatening, particularly in this climate crisis, yet we yearn for it. The desire to create or find public open space for culture, leisure, and active recreation on the water's edge has emerged as a powerful force with the momentum to sway social opinion and political positions.

Planners of cities, grappling with increasing populations, have recognized the potential for repurposing post-industrial waterfront sites as a catalyst for reviving urban neighborhoods. Whereas the model in most industrial cities had been to separate city life from the working harbor, new approaches serve to reconnect isolated, frequently abandoned, polluted ports to their cities in a manner that ensures public safety, protects existing infrastructure, and fosters green principles.

All of this is to create context for *Occupation:Boundary*. It is against this backdrop that I set out to reflect on the evolution of the urban waterfront and demonstrate how great place making can occur at this boundary. Design has the capacity to untangle complexities, to solve problems, to deliver positive concrete responses, and to engender connection through exploration, research, integration, and inspiration. Grounded in research, analysis, and thought, in discovery and invention, and in science and art, design envisions the future and determines the routes to get there. Design is both a process and an outcome. It is dynamic, incorporating both function and delight. I put forth the examples in *Occupation:Boundary* that show how creative intervention at the waterfront has the power to renew our cities.

In the introduction to her compelling book *Toward an Urban Ecology*, landscape architect and urban designer Kate Orff asks, "What is the agency of the urban designer?" and then, "How do we not just make landscapes,

buildings, and public spaces, but make change?"[4] I have dedicated my practice to enacting change, and I am devoted to the idea that my colleagues and I hold the power to make progress at various scales. As an architect and urban designer, my work has been explicitly about people and places, about regeneration and transformation, about designing to nurture community and create common ground. In writing this book, I set out to accomplish a series of related objectives, the first of which I hope to have achieved partially in this introduction: To convey to my reader the otherworldliness of the waterfront. I seek to describe a place that is like no other, a threshold that is neither land nor water. I will examine the role this liminal space has played in the history of cities, for in many cases, it is the waterfront that has determined the very existence of the city itself. In *Occupation:Boundary*, I explore the role the architect has played and continues to play in determining how the waterfront is developed and redeveloped. I will describe my own experience and how I have considered, observed, and manipulated the way this threshold functions as a beacon for culture and a simultaneous gateway to both the city and the sea.

The book is divided into three parts: Archive, Strategy, and Exhibit. Archive is concerned with the Past, the Work, the Culture, and Art of the waterfront. Strategy responds respectively to each of these four states with corresponding guidelines in Interpret, Invite, Rethink, and Transform. Strategy also examines how my colleagues in architecture and landscape architecture have responded to the city and its edge condition. Finally, Exhibit shows how I have incorporated the lessons in Archive and the guidelines in Strategy in my own interventions.

Occupation:Boundary, therefore, is a hybrid: part anecdotal history, part personal history, part didactic text describing strategies for waterfront design, and part portfolio, exhibiting my career's worth of waterfront projects alongside projects by other designers that operate to nurture and transform urban communities. It is a necessary amalgamation of emotion and instinct, of acquired knowledge, observation, and experience. The words of this book have come easily; the more arduous process has been to edit them. I hope to provide a cohesive narrative that can be used both by designers and others drawn to the evocative realm that is the water's edge and to elucidate the tools that designers have at their disposal—space, materiality and color, transparency and opacity, movement and stasis, aspect and prospect—to shape our environments, create ennobling and memorable places for people at the boundary between the city and the sea.

Notes

1. Herman Melville, *Moby Dick or the Whale* (New York: Bobbs Merrill, 1964), 26.
2. Spiro Kostof, *The City Shaped: Urban Patterns and Meanings through History* (London: Thames and Hudson, 1991), 38.
3. Henk Ovink and Boeijenga Jelte, *Too Big: Rebuild by Design: A Transformative Approach to Climate Change* (Rotterdam: Nai010 Publishers, 2018), 34.
4. Kate Orff, *Toward an Urban Ecology* (New York: The Monacelli Press, 2016), 7.

Past

The best types of public space
allow for the inclusion of multiple
meanings and all levels of society. . . .
In the articulation of urban water-
fronts, these issues are crucial. The
visibility of these sites means the water-
front becomes the stage upon which the
most important pieces are set. In doing so,
the waterfront is an expression of what we
are as a culture. The urban waterfront pro-
vides possibilities to create pieces of a city. . .
that enrich life, offer decency and hope as well as
functionality, and can give some notion of the urban
ways of living celebrated by Baudelaire and Benjamin,
Oscar Wilde and Otto Wagner. . . .
— Richard Marshall, *Waterfronts in Post-Industrial
Cities*, 2001

Since this book is a hybrid, part personal history and part narra-
tive, about my career as an architect working on the waterfront,
I will begin by telling some of my earliest memories of the water, of
going to beaches with my parents, and of summer camp in coastal
Maine, and later write about waterfront cities and how they have been
built and used.

The idea is that there exists both a personal past and a universal past. My
personal past has to do with things that are close to my heart, so I will write
about my parents and my time as a parent, as well as my coming of age as a
designer, in order to give context for other parts of this book. There is a link
between what drives a person, her interests and passions, and what she is
able to accomplish in her life. Where does that which makes a person who
she is stop and that which drives a person's work begin? Are they one and
the same?

My story started in Los Angeles, where my father, a young doctor, was
stationed until he went oversea, and my mother and I moved in with my
maternal grandparents and aunts in upstate New York. It continued when,
after the war, we moved to Bank Street in Greenwich Village. This journey
from one coast to the next is a theme in my life and my career. And both
coasts, specifically New York City and San Francisco, are so much a part of
me and my work that they take the lead as referenced places in my writing.

In New York I remember riding in our car with my parents on the West Side
Highway, when it was still elevated, and looking out at the ocean liners. I
saw them from Battery Park and the Staten Island Ferry, too. I saw Holland
American Ships and French and Italian ships, and it was an exciting event
when the Queen Elizabeth, with her two smokestacks, and the Queen Mary,
with her three, would arrive or depart for they were escorted by tugboats

and fireboats. Where were the passengers traveling? Where had they been? Why are these important memories for me?

I remember traveling to visit my paternal grandparents on the open deck of the Staten Island Ferry and watching passenger and cargo-ship traffic during a time long before the construction of the Verrazzano Narrows Bridge. And once, when it was still possible, we traveled in a small ferry to Liberty Island to ascend the arm and torch of the Statue of Liberty. From there, we would have had a vast perspective, looking out at the Hudson and East Rivers, to the Upper Bay, and toward Sandy Hook in the distance, and turning around to look back at the Battery and lower Manhattan. Was I left breathless by the landscape, taking in how the waterways converged at this point and how the light reflected on the water? Or was it the cityscape that impressed me, with the Battery in the foreground of all those buildings? Or was it the draw of the waterfront infrastructure, the bridges, piers, ports, and docks that I was never allowed to visit?

My parents loved the ocean and the beach, and we would make our way there from Greenwich Village even during the winter months. We always had a car and would drive to enjoy Robert Moses' Jacob Riis park when few others did. We would go during the crowded summer months as well, even though polio still raged, presenting a tangible threat that was a part of urban life at the time.

There were also summers spent on Cape Cod with my parents, first in Wellfleet where we stayed in the now famous Cape Cod modernist houses designed by Marcel Breuer, Serge Chermayeff, and Paul Weidlinger and later in Provincetown, in an apartment next door to the home and studio of Helen Frankenthaler and Robert Motherwell. It was during these extended stays that I learned how the ocean works, and I learned both to love and

Riis Park Beach, summer 1948, Cathy, Paul Epstein, and Bitten Simon

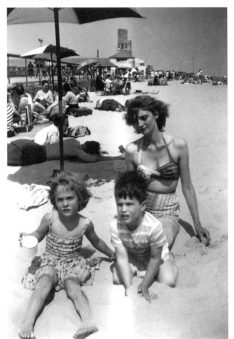

Riis Park Beach, fall 1950, Cathy, Kate Hays, and Elsa Ready

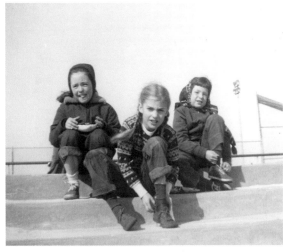

respect its waves. I spent time on the Penobscot Bay, in Maine, at a summer camp where we sailed for days on the Alamar, a 45-foot, broad beamed schooner, and visited Hurricane Island, which beginning in the 1880s, was a vibrant industrial settlement, a company town, where granite, including that which was used on New York City sidewalks and the Brooklyn Bridge, was quarried. By 1914, however, the demand for Hurricane Island granite had decreased and the town was abandoned. But there was plenty there for me. There was this story: that there had been Swedes, Finns, Irish, Scots, English, and Italians brought to a tiny piece of land in the ocean to work, to take rock from the ground so that it could be transported to make my city. There had been a railroad, houses with tables and chairs, and beds, and there had been churches with great music, all right here on the water.[1] And present on the island when I was there were ruins and fragments of carved stone, physical evidence of this life on the waterfront that was so different from mine — physical traces that helped me know this past.

The Alamar took us places like Frenchboro on the Gulf of Maine's Long Island where even during the summer, the mail was delivered only twice a week, by boat. We visited Mount Dessert Light and its lighthouse keeper whose story revealed the struggle of life here on the water, the harsh reality of winter storms, and both the draw and pain of isolation.

I kept going to the water and when I was sixteen, upon spending a summer as an American Field Service exchange student in Indonesia, crossed the Pacific Ocean on Hikawa Maru, a Japanese ship with a significant history that included carrying Jewish Holocaust refugees to the United States and Canada in the early 1940s. I, along with several hundred other young people

The Alamar, built 1947

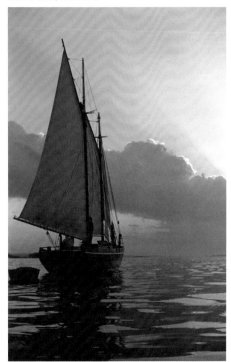

Granite foundation at
Hurricane Island

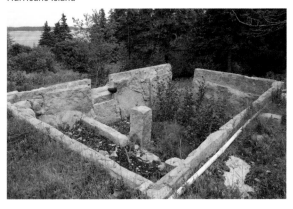

Archive : Past

who had been in Asia, including a group of Japanese Fulbright students, spent two weeks traveling from Yokohama to Seattle. During these two weeks, we passed the International Dateline and lived two September firsts. It is a fact I will never forget for on the second of these September firsts, with a gigantic full moon overhead, on the first clear night we had had on the trip, a Japanese student coming to study in the United States jumped overboard into the expansive gray sea. He was lost forever.

There was an endlessness and a nothingness present with only the horizon and sky as context; we did not even see another ship during the entire trip. But this endlessness did not terrify me at all, rather, I found it compelling and mysterious.

My parents gave me access to this ocean culture, but I cannot decipher whether they, in their love of the water, insisted that I have this exposure or if I was born with the desire for it. Whose idea was it to go to Cape Cod, and Maine, and to take the trips on the Alamar and the Hikawa Maru? I was a girl born in the 1940s, but it was assumed that I would do something, that is, to have a career—something of my own. And it was expected by both of my parents that this pursuit would be in the service of the public good. My mother had been trained as a nurse, and my father had been a surgeon who, along with his partners, had operated pro bono on atomic-bomb victims known as the Hiroshima Maidens and passed to Japanese colleagues, pioneering reconstructive surgical techniques. My father's mother had been the first female tenement building inspector in New York until she married and had a family. My mother was good at many things and was a talented artist, although she, being a wife and mother in the 1940s and 50s, did not pursue them. But I would be encouraged by these three figures—my mother, father, and grandmother—to accomplish something.

I hope it is clear why I do not live inland: from New York to Cape Cod and Maine; to places I have traveled; to San Francisco, where I moved in the 1970s. San Francisco is home to me as much as New York is, and I would argue that there is something about its newness, its relatively recent natural history, and its relatively recent pattern of being settled which has offered me opportunities as a woman that I may not have had in New York. And San Francisco, with the intensity of the Pacific Ocean to the west, with its beautiful bridge, and its great Bay, has grounded my fifty years of placemaking. This journey, from the beach with my parents in the 1940s to the occasion of collecting these thoughts in this book has always been about the water.

But there is something else about my past that is integral to my work, and it is not secondary but rather a synchronized part of this journey. When my parents and I would travel to the beaches on Long Island and Cape Cod, we were coming from a special kind of urban experience; one of post-War Greenwich Village where art was central to our lives. My childhood near the water was also a childhood immersed in a culture of painting, music, writing, theater, and ballet. My parents made their lives about pursuing art; they collected it and traveled to Italy during summers to experience Renaissance works. They surrounded themselves with people who were like minded and exposed me to as much as they could. My father operated on our upstairs neighbor, Nat Schoenberg. Nat had been badly burned in an accident and in exchange for this care, Schoenberg and his wife, Min, gifted my parents a

portrait of me at age three done by the Russian born artist, Moses Sawyer, who had studied under Robert Henri and George Bellows. It seems like a far-away time and place where such a barter would occur but that was Greenwich Village in the 1940s.

At Wellesley, I officially was studying art history, but the curriculum in that department was supplemented by a rigorous studio component that allowed me the opportunity to make three-dimensional work that I felt was relevant to the time. When I went to write my thesis on contemporary sculpture,[2] immersing myself in the writings and works of Gabo, Pevsner, Julio Gonzalez, and David Smith, among others, I did so from a carrel in the art library. It is only in hindsight that I realize the significance of this spot, for from it, I looked out past Paul Rudolph's Jewett Art Center to Lake Waban. There, in that spot, with Rudolph's art center and the lake, were all the tools I needed.

Around this time, another artistic force entered my life as I began a partnership and later married the poet Michael Palmer. Michael was at Harvard while I was at Wellesley, and he was as serious about his art as I was about mine. After I completed my Master of Architecture degree at the Harvard Graduate School of Design, we each pursued our own art and had a daughter, Sarah Palmer, who would pursue hers. My cousin, Sarah, with whom I grew up, married the painter and pastel artist, Irving Petlin, and for nearly forty years, he and Michael collaborated on many projects. During those decades, Michael and I spent time with them at the water on Martha's Vineyard. Art was all around us at work and at home.

Home? These two homes. New York City and San Francisco. What are their histories? What are the similarities and differences between the two? How were they made and remade? Their coastlines and harbors, like so many waterfront cities were shaped and formed into what we humans needed them to be.

Many parallels exist in the histories of my two cities, specifically in regard to the liminal space between land and sea. What is common to both is a narrative that involves the rise and fall of each city's industrial waterfront followed by a reclamation. Crucial to the initial successes of both places were favorable natural features, in particular, deep, protected harbors. What follows here is first a description of the natural histories of New York and San Francisco and then an exploration of how these histories precipitated development, that is, trade, global connections, and expansion, and what the nature of this development was. After an extended period of growth, advancements in shipping technology rendered the historic industrial ports of New York and San Francisco obsolete. The waterfronts of both cities were abandoned and there existed physical and psychological barriers to their being occupied. Much of my work has involved reclaiming San Francisco's waterfront, the process and products of which will be shown later in the book. In the reclamation effort, I was accompanied by other architects, urban designers, and placemakers in San Francisco, and had east coast counterparts in New York doing similar work on that waterfront.

Differences, of course, exist in the histories of New York and San Francisco but how do they pertain to this story? What circumstances were central to

New York's formation that were absent in San Francisco? What about each settlement story was distinctive? Who emigrated to each city? What has been the cultural relationship to the water in each place and why? How was New York City made? Eric W. Sanderson in his natural history, *Mannahatta*, writes, "Ten thousand years ago, Manhattan was a hill beside a great fjord, the Hudson River canyon. Before that, Manhattan was a doormat to ice—at least twice in the last two hundred thousand years glaciers have bloodied Manhattan's nose and scraped off her skin. Manhattan has also been part of the seabed, and lain for hundreds of millennia in the crust of the earth, deformed by extreme heat and pressure. . . Some of the rocks on the island today are over a billion years old."[3] Outcroppings of this rock that support the pilings of the Manhattan's skyscrapers, remain visible only in Central Park, although at one time were visible throughout the island,[4] a fact that speaks to the concealed natural history of the place.

A complement to the hills of geological Manhattan is its waters. In *Morning Snow-Hudson River*, we see both, as George Bellows exhibits the Palisades beyond the Hudson from the great heights of Manhattan's Upper West Side. New York City is a series of islands in an estuary, where the freshwater of the Hudson River meets the saltwater of the New York Harbor. What's more is that Manhattan had been characterized by an abundance of freshwater ponds, streams, and springs, which all fostered the successful colonization of the island and contributed to the organization of the lower portion of the borough's street system.[5]

Years and years after this formation, after the last glacier melted leaving behind a 150-mile body of water that was Lake Hudson, it broke through the Verrazzano Narrows to become the Hudson River. The discovery, exploration, and settlement of the Hudson River embodied 19th-century values, and it was these values that were expressed in the Hudson River School paintings of this region's landscape,[6] which depict the sublime landscape that surrounded the Hudson throughout the Catskills and the Adirondacks, but also in the American West and South America. Frederic Church, the second-generation Hudson River School painter, a student of Thomas Cole's, and a devout Protestant, painted a Romantic, dramatic nature with rigorous technique. He is known for his paintings of Niagara Falls and of the

George Bellows, *A Morning Snow – Hudson River*, 1910

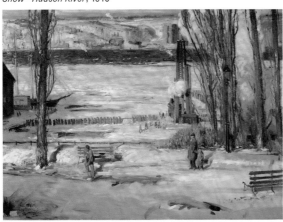

Frederick Church, *Sunset in the Hudson Valley*, 1870–75

Andes, but he also worked from his home, Olana, that sits on a ridge, high above the Hudson and allowed him to study this river in the context of its steep edges, as it made its way north to Lake Tear of the Clouds, and south, toward the Upper and Lower Bays of New York Harbor, and then out to the Atlantic Ocean.

The forces that made the hills and waters of this region also made one of the world's greatest natural harbors. New York Harbor is deep, especially at the Verrazzano Narrows, but is also protected. The violent storms of the Atlantic must pass the natural landform barriers that are Brooklyn, Staten Island, and parts of Long Island to get at this harbor. In addition, the forces were generous, creating even more waterway connections for this region as the Upper Bay links via the Hudson River to Albany and the East River to the Long Island Sound and beyond to New England.[7]

Then there is my other city, San Francisco. California's one-time state librarian, the historian Kevin Starr, says that this city's Bay, a stone's throw from so many of my projects, was formed when "mountains on the shore-line collapsed and the sea rushed in," and is considered "one of the world's finest."[8]

Nature's complexity can be seen in San Francisco at the northeastern edge of the Bay where the Sacramento and San Joaquin rivers converge to create the Delta, a landscape characterized by estuaries, tidelands, and marshes that is neither solid ground nor sea but made all the more complicated when engineered for agriculture, and then re-engineered with levees and canals, time and time again.[9]

Of course, there is the reality of San Francisco's geological history to con-sider, as well. California's landscape, compared to New York's, is a young one, formed by the active volcanoes and earthquakes in the Pacific Rim's Ring of Fire that are a byproduct of tectonic movement. The sequence of landforms moving east-to-west begins with the Sierra Nevada at the border of the state, which are followed by the Central Valley, the Coastal Ranges, and the Pacific Ocean. The geological forces that shaped the western edge of this country left fault lines running from the region north of San Francisco to Mexico.[10]

The presence of this geological history and its potential activity looms large in California. I experienced the 1989, 7.1 Loma Prieta earthquake while stopped at a traffic light with my daughter and her friend in the car. I thought we had been rear-ended, but then the shaking continued. In San Francisco, seismic design is a major driver for all built work; base condi-tions, that is sandy soils, bay mud, subterranean creeks, and marshlands all pose particular challenges. Each project is undertaken with a team of engineers to consider and evaluate seismicity. I have been required, as part of my profession, to understand the forces that create earthquakes, and my specific work on adaptive reuse projects has required additional, innovative design strategies.

Architects in New York City are not forced to address seismic issues in the way that those in San Francisco do. The consideration I have described is not likely assumed by the typical New Yorker who may face hurricanes and

blizzards but lives without the threat of the particular natural force that is an earthquake. Philip L. Fradkin, in his book, *The Great Earthquake and Firestorms of 1906*, makes an interesting comparison of San Francisco's earthquake and subsequent fires to the September 11 attack at the World Trade Center. "The mightier force that rose unexpectedly from the earth's interior was no less fearsome than the airplanes that descended apocalyptically from the sky. Both San Francisco and New York City were ill prepared. Both had been forewarned . . . The respective populations were traumatized . . . And, like gleaming phoenixes from the ashes, the structures of both cities rose—more glorious and vulnerable than before."[11]

The geological history of San Francisco is revealed in the city's steep hills even though its street system turns its back on this topography in a manner reminiscent of the way New York's street grid, as mapped in the Commissioner's Plan of 1811, ignored existing conditions, imposing itself on woods, farms, wetlands, hills, rock outcroppings, estates, and existing buildings for almost eight miles from Houston Street to 155th Street, and east to west, into eleven avenue blocks extending river to river. In 1839, San Francisco's initial grid with north-south and east-west streets was established around a plaza, which would become Portsmouth Square, and eight years later, a second grid extended over Telegraph, Russian, and Nob hills. Landowners both objected to the plan to terrace roadways, in order to lessen their slopes and make gentler their curves, and insisted that the simultaneous and competing San Francisco street grids meet at a 45-degree angle with the diagonal boulevard, Market Street, mediating the two. Wayne Thiebaud's paintings recorded how San Francisco's streets failed to follow the natural contours in any logical way, running up and down against the topography in, for example, *Sunset Streets* where the roadways are rendered flat, almost in elevation, depicting how they fight the contours rather than wrap around them.

Wayne Thiebaud, *Sunset Streets*, 1985

The two natural histories of New York City and San Francisco resulted in water-rich bodies of land surrounded by (or partially surrounded by) bodies of water with deep harbors and, therefore, much promise of productivity. Both cities were inhabited by Native Americans and settled by Europeans. While it does not seem that the native inhabitants of New York City had the desire to overwhelm the natural systems in that place, can the same be said for those who came next? Did they possess the desire to overpower existing systems? The Dutch, of course, involved New York in its empire, sailing to it as a post, just as they sailed to Asia for spices, Africa for slaves, and South America for sugar. And they were followed by the British, who used New York's seaport to supply its Caribbean colonies with agriculture, and as a strategic military base against the French.[12]

San Francisco similarly was inhabited by Native Americans and in a tale that speaks to the mystical powers of land and climate, the Europeans, who first sailed past the Golden Gate, did so for years, time and time again, without identifying its rich harbor, protected by the shape of the land and dense fog.[13] By the 1770s, however, the Spanish had set up the Presidio and the Mission Dolores, and in the middle of the 19th century, the United States took over San Francisco just in time for California's Gold Rush. San Francisco became the center of this phenomenon, its non-Native American population increasing, from fewer than 10,000 in 1848 to 255,000, three years later. Of this specific time, Starr says, "Within three years,. . . a new metropolis, San Francisco, had sprung into existence like Atlantis rising from the sea."[14]

San Francisco's harbor and system of connector rivers were important to this expansion as ships carried people, food, and supplies to California's Gold Rush.[15] Warehouses, housing for workers, manufacturing plants, and industry expanded the port. Then, just following this period, "The port became the distributing center of goods for consumption in the rapidly developing western territory, and when the transcontinental railroads were

Political cartoon, 1882

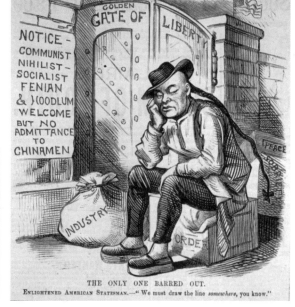

Yerba Buena Cove,
daguerreotype photograph
by Sterling C. McIntyre, 1851

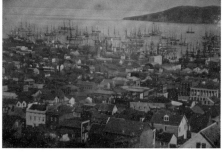

completed, its functions were increased to include the concentration of cargoes for shipment to the Orient and other parts of the world."[16] Later, in the 20th century, San Francisco's waterfront was characterized by finger piers, railroad terminals and warehouses. In addition, it was a logistics center for the United States during its World War II fight in the Pacific.[17]

Associated with the expansion of San Francisco was the influx of people, many of whom were immigrants to the United States. By the early 1900s, San Francisco had a higher proportion of foreign-born residents relative to its total population than any other city in the United States, including New York."[18] During the time of the Gold Rush, Hispanics, including Peruvians, Chileans, and Mexicans, along with Chinese, were among those who immigrated to mine gold, and these groups experienced vicious racism at the hands of Americans.[19]

In addition, African Americans had begun to immigrate to California in large number during the Gold Rush, and during World War II, southern African Americans were among those thousands of people who migrated to San Francisco looking for employment in the Bay Area's shipyards and defense industries. This wave of immigration caused a housing shortage and African American migrants, who endured discriminatory housing practices that denied them access to most of the city's neighborhoods, suffered the most. The government responded by building housing for naval workers that was available to all, but when white servicemen returned for their jobs after World War II, the Hunters Point neighborhood suffered.[20]

There exist discriminatory practices associated with New York's Brooklyn Navy Yard, as well, where during World War II, African Americans (along with women) were hired in greater number, and in an expanded capacity. In these years, the Fort Greene neighborhood, which housed many workers, first would undergo significant change to accommodate them including the conversion of many of the area's historic row houses into boarding houses as well as the establishment of extensive government-initiated housing development, known as the Fort Greene Houses. After the war ended, the neighborhood would undergo significant change again: "The loss of manufacturing jobs that was one of the most decisive factors in the decline of Fort Greene was a direct result of city policy, namely that of Robert Moses and his use of Title I funds. This loss of jobs, accompanied by the construction of massive public housing projects in the area, led to increasing ghettoization and the "white flight" from Fort Greene."[21] And that is without mentioning mortgage practices of the time and the highway systems that were put into place, further facilitating this flight and dividing and isolating neighborhoods.

New York could not have a Gold Rush, but it did, however, experience growth that was simultaneously the catalyst for and result of the city's dynamic expansion. New York had been a seaport city, but the exporting of the country's new industrial products in addition to its agricultural goods made its waterfront the busiest in the world. What existed there was a culture of workers who lived near the waterfront and a system of infrastructure, including the piers, docks, wharves, warehouses, and waterfront streets that facilitated the transfer of goods back and forth between land and sea.[22]

The port of New York City, in addition to serving as a center for the transfer of goods, was the gateway for Irish, German, Jewish and Italian immigrants entering the east coast of the United States. While the Irish dominated the waterfront, other ethnic groups found maritime work as well.[23] My husband Michael's grandfather, Michael Perri, an immigrant from southern Italy who had been abandoned on the streets at 9 years old, carried water to the men building the Williamsburg Bridge, while pursuing his education at Cooper Union at night. In general, "Immigration fueled the rise of New York City to become America's entrepot to the world, the leading industrial city in the country, a global center of finance, and the largest city in the United States."[24]

While other east coast cities had great harbors, only New York had the Erie Canal, a work of infrastructure so great, it could connect, early on, the Midwest to the ocean and the world beyond. The Commissioners' Plan of 1811 that extended the grid through Manhattan, the city's mass immigration, and the opening of the Erie Canal resulted in the extensively developed metropolitan area that was pictured in the 1847 map of New York City. 90 years after the Erie Canal, the opening of the Panama Canal would raise hopes that San Francisco could dominate trade across the Pacific, outcompeting

Manhattan, New York,
1942

Port of San Francisco
with Telegraph Hill and
Alcatraz Island in the
background, c. 1925

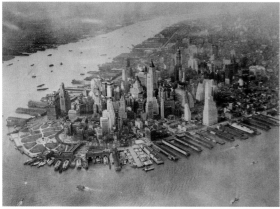

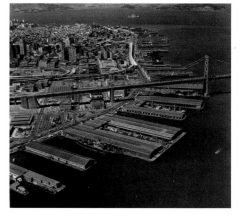

Erie Canal at Little Falls,
1880–97, photograph by
William Henry Jackson

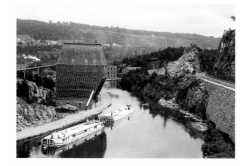

other West coast ports, although World War I interfered with these hopes and lowered those expectations.[25]

Protecting economically valuable harbors in New York and San Francisco was important from the beginning. Early on, New York Harbor, and therefore international trade, was protected with a system of unified forts, that included Fort Jay and Castle William on Governor's Island. And in San Francisco, the Presidio served first as colonial Spain's military outpost, then, in the mid 19th-century, was taken over by the United States Army and developed into the most important Army post on the Pacific Ocean. It held strong against threats from Native Americans from the east and was key in the projection of the American military in the Pacific and into Asia. What also is common in both of these coastal cities is that these military facilities would become decommissioned, leaving large tracts of often highly polluted land on the waterfront.

What brought about the fall of these two waterfronts? One key component was the institutionalized use of the standardized shipping container. Marc Levinson, in his book *The Box: How the Shipping Container Made the World Smaller and the World Economy Bigger* (2006) explains in detail the industry of breakbulk shipping, that is the shipping of items handled individually, before the 1950s:

> *Freight transportation was an urban industry, employing millions of people who drove, dragged, or pushed cargo through city streets to or from the piers. On the waterfront itself, swarms of workers clambered up gangplanks with loads on their backs or toiled deep in the holds of ships, stowing boxes and barrels in every available corner... using them [ships] to move goods was still a hugely complicated project in the 1950s. At the shipper's factory or warehouse, the freight would be loaded piece by piece on a truck or railcar. The truck or train would deliver hundreds or thousands of such items to the waterfront. Each had to be unloaded separately, recorded on a tally sheet, and carried to storage in a transit shed, a warehouse stretching alongside the dock. When a ship was ready to load, each item was removed from the transit shed, counted once more, and hauled or dragged to shipside.[26]*

Postcard of Castle William, Governor's Island, New York City, 1910

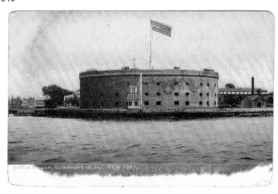

Fort Point, located at the mouth of the Golden Gate, San Francisco, built during the Civil War

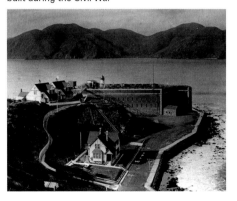

A similar process involving extensive labor existed on the receiving end of each shipment. The innovation of the standardized container made shipping faster, cheaper and more reliable, and rendered obsolete the large warehouses and huge depots previously associated with maritime work. The "Brooklyn and Manhattan waterfronts, which had been characterized by vivid maritime traffic, with many longshoremen loading and unloading countless vessels,"[27] were abandoned. This downfall of the lively old port went hand-in-hand in the establishment of the container port in New Jersey where there was laydown area for the new shipping methods and transportation, and for vast new networks of trucks and trains. Similarly, the maritime activities of the San Francisco Port moved across the Bay to Oakland. The character of New York, San Francisco, and other port cities was forever changed as the workings of the harbor were no longer connected to the city.

New York City's piers were no longer in use, but they, like waterfronts in San Francisco and like many or most cities throughout the United States, were off-limits for it was a commonly held opinion that the waterfront was unfit for the public. In addition to abandoned warehouses and piers, other unused or abandoned facilities lined both waterfronts; there were shipyards such as the Brooklyn Navy Yard and Hunters Point Naval Shipyard; there were rail yards, such as the Hudson Rail Yards and Mission Bay's Southern Pacific Yards; and, there were power plants such as Con Edison's on New York's East Side and San Francisco's Potrero Power Plant.

Reinforcing the idea that these waterfronts possessed no value as public space were the highways, that is the West Side Highway, the FDR, and the Brooklyn Queens Expressway in New York and the Embarcadero Freeway, Bayshore Freeway, and US101 in San Francisco, that acted as physical barriers between the waterfront and the city. It is impossible to think of these highways without considering Lewis Mumford's prophetic *The Highway and the City* from 1953. In this treatise, Mumford describes the failure of the elevated rail system in New York and other cities. These systems were loud,

Hunters Point Naval
Shipyard, San Francisco,
built in 1870 as a
shipyard, purchased by
the U.S. Navy in 1940,
decommissioned in 1996

Elevated West Side
Highway, Manhattan,
New York, built 1929–51,
abandoned in 1973,
demolished in 1989,
photograph by Berenice
Abbot, 1937

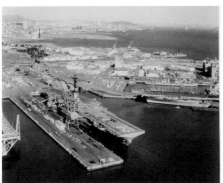

lowered the value of adjacent properties, and created dangerous obstacles for at-grade movement. He goes on to describe the irony that existed when, just as the old, elevated railways were being torn down in the name of progress, a new series of elevated conduits, although these for cars and trucks, was being built.[28]

Mumford says that like "the railroad, again, the motorway has repeatedly taken possession of the most valuable recreation space the city possesses, not merely thieving land once dedicated to park uses, but by cutting off easy access to the waterfront parks. . ." Included in his list of "social crimes" is the "partial defacement of the San Francisco waterfront. . ."[29] Mumford knew all of this early on. He was talking about urban planning and common sense, about quality of life, and about values.

How is the water's edge viewed, and from what perspective? Is it seen from close up or from a distance, approaching the shore or departing from it? Certainly, the water's edge represented outward access toward a global culture for sophisticated water infrastructure connected even the most provincial midcontinental locale to the coast and then to Europe, Asia, South America, and Africa. The waterfront was international, by nature, a threshold where people, their customs, languages, and illnesses were exchanged, and goods from all over the world were traded. Mumford offers a local perspective of the waterfront in the preceding passage, where he expresses the importance of the waterfront as an asset for the city's inhabitants. The edge of the land, as viewed from the water, had historically defined the approach to this country. Steamships had been the primary means of transportation for immigration, and New York at Ellis Island was the central gateway for incoming immigrants to the United States' East Coast. The Ferry Building was central to arriving in San Francisco. The caption to a candid photo taken from a ship in motion, with waves and birds flying in the foreground reads: "In 1906, the Ferry Building was the most prominent feature of the city, an expression of the role the port played at that time."[30]

I think back to my own approach during trips on the Staten Island Ferry, across the Verrazzano Narrows. I think of Whitman's beloved poem, "Crossing Brooklyn Ferry," originally published in 1855.

Embarcadero Freeway, San Francisco, built 1950–59, damaged in 1989 during the Loma Prieta Earthquake, demolished in 1991, photograph by Wernher Krutein

Ferries and Ferry Building, San Francisco, 1915

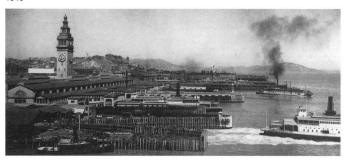

Others will enter the gates of the ferry and cross from shore to shore,
Others will watch the run of the flood-tide,
Others will see the shipping of Manhattan north and west, and the heights of
 Brooklyn to the south and east,
Others will see the islands large and small;
Fifty years hence, others will see them as they cross, the sun half an hour high,
A hundred years hence, or ever so many hundred years hence,
 others will see them,
Will enjoy the sunset, the pouring-in of the flood-tide, the falling-back to
 the sea of the ebb-tide.

Whitman recounts what passengers may have experienced as they crossed the tidal estuary that is the East River. But others, fifty and "so many hundred" of years later would not experience the "flood-tide" or the islands or the sun "half an hour high" on their commute. Whitman could not have anticipated how drastically the trip he recorded would change. Travel would shift almost entirely away from the water. A hundred years hence, in fact, it was Mumford who knew this approach to the waterfront had changed for good. Approaching the city, by the middle of the 20th century, would be characterized by the car and its bridges, tunnels, and elevated highways rather than by Whitman's "the falling-back to the sea of the ebb-tide."

Whitman's "shipping of Manhattan north and west" was gone and the car dominated culture made the waterfront difficult to access. The space between city and water, which was once, in the 19th century, so valuable as it was the point between manufacturing and transportation, became residual. But designers and planners, beginning in the 1960s, recognized the importance and potential of these large tracts of waterfront land.

New York City, whose edge was once wrapped in finger piers, has been difficult to develop. New York is known for its vocal constituents who, for many years, opposed large-scale waterfront redevelopment projects. As a result, much of the waterfront has been revitalized into parkland as in Hudson

Hudson River Park,
Manhattan

Brooklyn Ferry, 1909

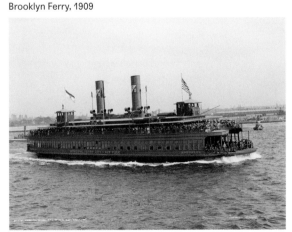

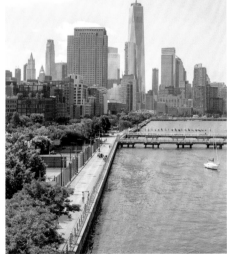

River Park, Brooklyn Bridge Park, and those along the East River, including Domino Park and Hunters Point South Park.[31]

In San Francisco, a partnership between private and public entities has transformed parts of the waterfront into mixed-use destinations that attract visitors for business and recreation. This process of revitalization was facilitated by the removal of the Embarcadero Freeway in 1991. Further, Mike Buhler and Jay Turnbull, in their introduction to Michael Corbett's book, *Port City: The History and Transformation of the Port of San Francisco, 1848–2010*, write that reconnecting the city through this demolition and with "the rehabilitation of the Ferry Building is one of San Francisco's greatest successes in a generation."[32]

Given my past, it is no coincidence or surprise that the two most important cities to me personally and for my work have been coastal. How crucial is proximity to water in the making of great cities? Many of world's most important cities are located on the water, and many port cities, such as Istanbul, Amsterdam, and London are capitals reflecting the political importance of these places. As was the case with New York and San Francisco, travel by ship through waterways tied the "global to the local," and created trading networks that were linked to social and financial networks. These networks became the infrastructure of cultural capital, where technology, professional practice, customs, architecture, and general knowledge extended beyond regional boundaries from port to port.[33]

It is obvious but productive to consider why cities exist on the water. At the most basic level, lakes and rivers provided drinking water but also access to edible marine plants and animals and to sanitation. Water enabled manufacturing as it is necessary for fabricating, productions, washing, diluting, and cooling. Trade happened in waterfront cities because water transportation, especially before the Industrial Revolution, was so much more efficient than land transportation. Existing on the water gave cities a military advantage as its soldiers could travel by water to attack, but simultaneously, these

Ferry Building, 2003, photograph by Richard Barnes

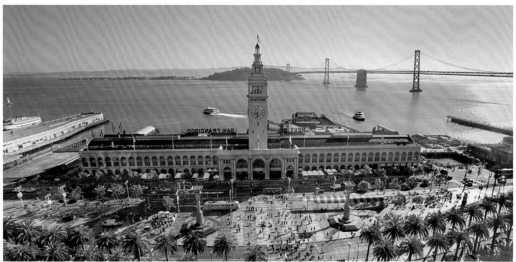

cities themselves were also vulnerable to sieges and blockades. In addition, waterfront cities can be characterized as having a constant military presence to protect and control the economically important trade that occurred there.

It is no surprise that a city was settled on the island that is Manhattan and another on the tip of the San Francisco peninsula. These cities exist precisely because they are on the water. Both are estuarine cities, but New York's system is large and complicated. They both have deep, protected harbors and shorelines that have been edited extensively. In these ways, the past of one corresponds to the past of the other.

What's more is that in modern times, both New York and San Francisco followed a somewhat predictable course of urban and industrial maritime cities: trade facilitated the development of the port and city; the advancement in industrial shipping methods led to the expansion of the waterfront and the subsequent need for larger ships and facilities; this expansion resulted in the movement of port activities away from the historic port; and finally, the abandonment of the historic port. And in this way, the pasts of these correspond to the pasts of many others.

There is a point I have to make now and to which I certainly will return. I have written about my childhood on the beaches of New York, Cape Cod, and Maine and my teenage years on ships in the Pacific and the Atlantic oceans. I have written about my studies at Wellesley and a little thus far of my career working on San Francisco's Bay. During this life, art has been present. But what does that mean? It was present in the way my parents lived their lives and set up a world for me that fostered imagination and creativity. It was not so much something for me to absorb as it has been a lens through which I view all that exists in nature, including the water, and all that has been constructed by humans over time, including cities, their buildings, and their edges.

To partake in this dialogue, I carry with me always the diverse works of Octavio Paz: poetry, essays of art criticism, essays on literature, history, politics, and morality. The breadth and the depth are toward the point: he was a 'man of letters' who was sure that in order to make poetry, that is, in order to make his art, he was required to know and write on the greater world around him.[34] Paz considered the threat to literature and the arts by a "faceless, soulless, and directionless economic process;" by the "impersonal, impartial, inflexible" market that is "not fond of literature," and implied in that statement, not fond of art either.[35] "Who reads books of poems?" he asks. Who is enlightened by that which is outside of his or her traditional purview? First the ruling class, then the bourgeoisie have appreciated this 'other voice' that falls someplace "between revolution and religion," "the voice of passions and of visions;" that which is "otherworldly and this-worldly."[36] And of those who make poetry? They recognize this 'other voice' in themselves.

The call for me has been to wake the 'other voice' that has been "fast asleep in the heart of hearts of mankind."[37] Think of the 'other voice' when examining the past, when gauging the line between the natural and built worlds. Architecture should be practiced, and lives should be lived, with ears and

eyes opened, and souls awakened. Go forward conscious of the human imagination and the sublime embodied in art.

The sublime: that which inspires awe and wonder and possesses greatness; that which has inspired artists and writers in particular relation to landscape. The landscape for me is one at the water, and I first hear whispers from the 'other voice' about a Swiss mountain and a lake. I can tune out critics who think J.M.W. Turner relies on his undeniable mastery of technique for his *Blue Rigi*. (p. 70) Do not mistake his talent and greatness for trickery. The painting has me recall the wonderment as night changes to day, yet again, time after time; the freshness of morning and its blue air; and the anticipation that occurs before immersion into the still water.

And this is what I take with me from coast to coast, city to city, building to building. I take this art, this lens, this voice, and I turn it toward that which exists just at the edge of the human world.

Notes

1. Eleanor Motley Richardson, *Hurricane Island – The Town That Disappeared* (Rockland, Maine: The Island Institute, 1997). Excerpt reprinted by Hurricane Island, Center for Science and Leadership. Accessed 2018. http://www.hurricaneisland.net/history.

2. The thesis, titled *Space as Form: A Study of Twentieth-Century Plastic Values* was written under Professor John McAndrew.

3. Eric W. Sanderson, *Mannahatta: A Natural History of New York City* (New York: Abrams, 2009), 70.

4. Sanderson, *Mannahatta*, 70–71.

5. Sanderson, *Mannahatta* , 84 and 98.

6. For basic information on the Hudson River School and Church, see Kevin J. Avery, "The Hudson River School, The Metropolitan Museum of Art," The Met's Heilbrunn Timeline of Art History, accessed February 24, 2020, https://www.metmuseum.org/toah/hd/hurs/hd_hurs.htm.

7. Kurt C. Schlichting, *Waterfront Manhattan: From Henry Hudson to the High Line* (Baltimore: John Hopkins University Press, 2018), 2–3.

8. Kevin Starr, *California: A History* (New York: Modern Library, 2005), 7.

9. Jane Wolff, *Delta Primer: A Field Guide to the California Delta* (California: William Stout Publishers, 2003), 37–40.

10. Starr provides a good introduction to the natural history of California and this text relies on his description of the state and regional landscape and geological history, and then later, for his description of the Gold Rush Starr, *California*, 5–16.

11. Philip L. Fradkin, *The Great Earthquake and Firestorms of 1906: How San Francisco Nearly Destroyed Itself* (Berkeley: University of California Press, 2005), 3–4.

12. Edwin G. Burrows, *Gotham: A History of New York City to 1898* (New York: Oxford University Press, 1999), xvii-xviii.

13. Gary Kamiya, "How Sir Francis Drake Sailed into West Marin," SFGate, August 10, 2013, https://www.sfgate.com/bayarea/article/How-Sir-Francis-Drake-sailed-into-West-Marin-4721760.php.

14. Starr, *California*, 80.

15. Michael R. Corbett, *Port City: The History and Transformation of the Port of San Francisco, 1848–2010* (San Francisco Architectural Heritage, 2010), 56.

16. Corbett, *Port City*, 58.

17. Anne Cook, Richard Marshall, and Alden Raine, "Port and City Relations: San Francisco and Boston," in *Waterfronts in Post-Industrial Cities* (New York: Spon Press, 2001), 119.

18. Starr, *California*, 307.

19. Starr, *California*, 85–87.

20. Albert S. Broussard, *Black San Francisco: The Struggle for Racial Equality in the West, 1900–1954* (Lawrence, Kan: University Press of Kansas, 1993), 2–3.

21. Winifred Curran, "City Policy and Urban Renewal: A Case Study of Fort Greene, Brooklyn," *Middle States Geographer*, 1998, 31: 73–82. Accessed in 2018. http://msaag.aag.org/wp-content/uploads/2013/05/8_Curran.pdf

22. Schlichting, *Waterfront Manhattan*, 1–10.

23. Schlichting, *Waterfront Manhattan*, 90–95.

24. Schlichting, *Waterfront Manhattan*, 89.

25. Corbett, *Port City*, 58–62.

26. Marc Levinson, *The Box: How the Shipping Container Made the World Smaller and the World Economy Bigger* (Princeton: Princeton University Press, 2006), 16–17.

27. Lars Amenda, "Shipping Chinatowns and Container Terminals," in *Port Cities: Dynamic Landscapes and Global Networks* (New York: Routledge, 2011), 51.

28. Lewis Mumford, *The Highway and the City: Essays* (New York: Harcourt, Brace & World, 1963), 240–41.

29. Mumford, *The Highway and the City*, 241.

30. Corbett, *Port City*, 62.

31. Corbett, *Port City*, 22.

32. Michael Buhler and Jay Turnbell, "Introduction," in *Port City: The History and Transformation of the Port of San Francisco, 1848–2010* (San Francisco Architectural Heritage, 2010), 23.

33. Carola Hein, "Changing Urban Patterns in Port Cities: History, Present, and Future," in *Port Cities: Dynamic Landscapes and Global Networks* (New York: Routledge, 2011), 6,9,15.

34. Nick Caistor, *Octavio Paz (Critical Lives)* (London: Reaktion Books, 2007), 9.

35. Octavio Paz, *The Other Voice: Essays on Modern Poetry*, (New York: Harcourt Brace Jovanovich, 1991), 141.

36. Caistor, *Octavio Paz, Critical Lives*, 151.

37. Paz, *The Other Voice*, 155.

Work

They talk of the dignity of work. . . .
The dignity is in leisure.
— Herman Melville, in a letter to his cousin, Catherine G. Lansing,
September 5, 1887

Lewis Mumford writes on the division of labor in his seminal work *The City in History,* putting forth the idea that the emergence of a single occupation or specialization, as opposed to each person tending to his or her own survival needs, was simultaneous with the emergence of the city. "The very notion of a settled division of labor, of fixation of many natural activities into a single life occupation, of confinement to a single craft, probably dates. . . from the founding of cities. . . In the city specialized work became for the first time an all-day, year-round occupation. . . As a result, the specialized worker. . . achieved excellence and efficiency in the part. . . but he lost his grip on life as a whole."[1]

Even before cities and the specialization of work, people fished the waters and resourced them for drinking water. Following the division of labor, when men were trained for specific jobs, there were those like the characters in Moby Dick who took to the water to whale: "No, when I go to sea, I go as a simple sailor, right before the mast, plumb down in the forecastle, aloft there to the royal mast-head. True, they rather order me about some, and make me jump from spar to spar, like a grasshopper in a May meadow. . . ."[2] And there were workers like those in Canaletto's *The Stonemason's Yard*, who carried their materials on Venice's distinct waterways and set up a yard in the Campo San Vidal for the rebuilding of the Church of San Vidal.

What about moving goods via water? Also following the division of labor, when trade emerged as an occupation, it became clear that transportation by water was more efficient than transportation by land. Even before the Industrial Revolution, the waterfront emerged as significant to imperialist exploration, to the exchange of humans, as in travel and slavery, in addition to the exchange of goods.

The ports of the United States' East Coast bustled with trade, and the painter Fitz Henry Lane documented New England's, capturing the essence of maritime work. His *Boston Harbor, Sunset* (1850–5) exhibits many notable characteristics for which he is well known: tranquil sky and water; a masterfully rendered, hazy atmosphere that accompanies the New England sea; and careful, detailed, portrait-like depictions of the scene's ships. The port here is expansive and even exaggerated in scale, expressive of its

grandeur and importance. The light, as illustrated by Lane, breaking through the haze to glimmer at every one of the water's subtle movements, is what links him to the Luminists and the Transcendentalists for this light is meant to be recognized as nothing less than divine.[3] In the distance on the right is a steamboat that presages the industrial future of the country.

To look at George Bellow's *A Morning Snow–Hudson River* and Alfred Steiglitz's *City of Ambitions*, both from 1910, is to observe the process of industry taking over the urban waterfront. In Bellow's image, industry is just beginning to creep into the landscape compared to Alfred Stieglitz's, where the motion captured in the image is a metaphor for the modernization that already is in progress. Smoke from buildings tall and short blow in the wind, as does the flag. The perspective implies the water's motion, as does the light that flickers on its surface in the foreground.

The edge of the city defined by the waterfront, in fact, would become the center, where manufacturing, the commerce of import and export, travel, the generation of power and mechanisms of cooling, and the disposal of waste all took place. Water had vast industrial uses, and it was essential in the production process, that is, in the fabrication, processing, washing, diluting, and cooling of almost all manufactured products including wood, paper, metals, chemicals, gasoline, and oils. In addition, all of the infrastructure associated with these industries existed here, in the boundary between the sea and land.

I can remember the manufacturing and industry that existed on the waterfront. I saw with my own eyes the piers and ships from the elevated roadway, out the windows of my parents' car. But artists documented this waterfront, which would submit completely to the work of industry, for those who missed it. Consider Charles Sheeler's seminal *American Landscape*, the portrait of the Ford Motor Company's factory at suburban Detroit's River

Alfred Stieglitz, *City of Ambition*, 1910

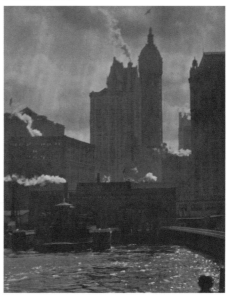

Canaletto, *Stonemason's Yard*, c. 1725

Rogue. Although it was commissioned by Ford to promote the Model A, what it does, generations later, is present a riverfront plant as a series of idealized geometric forms set against the backdrop of a clear winter sky. There is no black smoke or soot but rather white snow and white atmospheric clouds that combine with the clouds from the vertical stack; the elements of nature are not purer than those produced by industry. There is something abstract in Sheeler's pristine, and simple, three-dimensional volumes, which reappear rendered as reflections distorted by the surface of the water. Similarly, the painting is a perfect balance of darkness and light, of verticals and horizontals—the tall, singular, smokestack amidst other elements, compared to the flat river and the train, the tracks, and the mounds of snow and earth that run parallel to it. In this image, the American industrial machine is on display, its power and productivity suggested in the monumentality of the entire complex. This machine and these machines celebrate the work without the workers who are hauntingly absent from this static scene. Even in its naming, Sheeler says the American landscape has been altered and idealizes this shift.

But I also can remember the abandonment of the waterfront. Where did this work go? Advancements in technology, specifically the pervasive use of shipping containers in the middle of the 20th century, rendered historic waterfronts and the work done there obsolete. Richard Marshall, in "Contemporary Urban Space Making at the Water's Edge," explains that with advancements in the transportation of goods and with the base of this global transport shifting away from historic waterfronts, "the relationship between water and the generators of economic wealth has changed." He goes on to say that following the collapse of the industrial and manufacturing economy, what has emerged is our "information-saturated, service-oriented" economic system.[4]

What would Fitz Henry Lane, who embraced the ideas of the Luminists, immersing himself in nature to become closer to the divine, and rendering water, light, and atmosphere as part of this journey, have thought of this shift? What would previous generations of Americans who prided themselves on their industriousness, who reveled in the new American landscape per Sheeler, have thought of a society that produced nothing?

Charles Sheeler, *American Landscape*, 1930

Fitz Henry Lane, *Boston Harbor, Sunset*, 1850–1855

What happened to the working ports and harbors, which had been so carefully rendered by Lane, after their modernization and subsequent abandonment? What happened to the physical remnants of their infrastructure? In many cases, these waterfronts became residual spaces in our cities, however, as early as the 1960s, revitalizing waterfronts and adapting the abandoned buildings there became an interest of architects, urban designers, and policymakers. Marshall says that during this era, waterfront redevelopment had the promise of becoming a tool to "recreate the image" of cities, an "urban panacea" of sorts, that could spur economic growth, in general.[5] Specifically, development occurred in historic, industrial buildings that had been abandoned in the new economic system and were to bear the responsibility of rejuvenating waterfront districts and entire cities in which they were located.

This waterfront reinvention, which often took the form of the so-called festival marketplace, was often associated with consumerism. It had been centuries since a day's work in the developed world had revolved around a person obtaining water and food for him or herself. Work had long been specialized in the way Mumford described. The waterfront had been associated with earning income, from the early days of trade and imperialism, to the days of early industry, and then to the manufacturing of the post-Industrial Revolution era. It is no surprise then that even after the urban waterfront had been abandoned, its rejuvenation would be linked to and justified by the generation of wealth.

There are many reasons to reuse existing buildings that have to do with a resistance to disposability as well as with the fostering of cultural continuity. But in the context of reusing old waterfront infrastructure, did there exist a particular fascination with replication? Was there a particular comfort obtained from the past, suggesting a fear of moving toward the 21st century? Was it the reality of being a service-based, information-hungry culture, where nothing actually was made unbearable? What type of architecture would this contemporary culture breed? What would happen at the edges of New York and San Francisco?

Paul Goldberger, who was the architecture critic for the *New York Times* when Manhattan's South Street Seaport plan was realized, wrote the following a year later on July 23, 1983: "In those [other] cities it was [about] bringing a kind of activity to urban areas that had relatively little to start with.

South Street Seaport
Historic District,
Manhattan

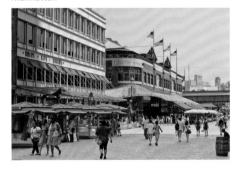

But in New York, the streets are already crawling with life and vitality—and so there was the very real question of whether this kind of neatly packaged urbanism would really make any sense here."[6] Even decades later, there is the sense that "few self-respecting New Yorkers would venture down to the South Street Seaport" leaving us to wonder whether the development of the area, in fact, retarded its growth.[7]

Although, for the first time in years, Ghirardelli Square in San Francisco is leased almost entirely, I remain skeptical whether it is a place that attracts locals or just tourists. At the time of its repurposing in the early 1960s, which involved the conversion of an entire waterfront block of historic brick buildings to a retail complex, the development team hired Lawrence Halprin for master planning and the design of all public spaces. But Ghirardelli Square reads more like one of Halprin's suburban shopping centers than it does like his retail streets.[8] Despite the fact that it exists within the boundaries of the city, the project turns its back on adjacent neighborhoods in a way that is anti-urban and anti-architectural.

Could it be that when economics is the force driving development and consumerism plays a central role in drawing people in, the result is something that falls short of architecture? What about the case of the High Line, a project that was driven by financial interests and arguably has been more successful at generating revenue than any waterfront adaptive reuse project that came before? Has it fallen short of architecture?

In the 1940s, when my family and I lived on Bank Street, between Greenwich Avenue and West 4th Streets, the West Side Elevated Railway, which would later become the High Line, crossed Bank to get to the St. John's Terminal. I knew this as an outer edge, for my world was mostly east of our apartment; we turned our backs on the industry that was present on the High Line, and of course, on the working waterfront. The steel railway viaduct

High Line and Westbeth, Manhattan, 1934

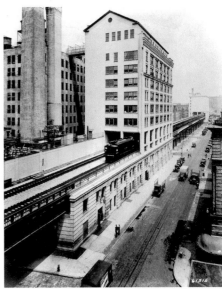

Ghirardelli Square, San Francisco

that would become the High Line was constructed and opened in 1934, nine years before I was born, as part of Robert Moses's West Side Improvement project. The hope at the time was to relieve traffic by elevating the transport of food products being moved from the waterfront to warehouses, factories, and slaughterhouses. But by the 1950s and 1960s, with the development of the interstate highway systems, industry was able to move outside of congested city centers, allowing the West Side Elevated Railway to fall into obsolescence and, by the 1980s, essentially into abandonment.[9]

The founders of the High Line claim that their specific intention was to save a relic of New York's industrial past: "We just wanted to fight Giuliani to keep it [the abandoned, elevated railway] from being demolished. . . But preservation was only the first step, and we began to realize that we could create a new public place."[10] The reality of the High Line is more complicated than this quotation reveals. The 2002 feasibility study of the project and the Friends of the High Line (FHL) campaign was explicit that the proposed conversion of the railway to a park would increase commercial activity and the value of adjacent properties; the FHL organization worked directly with city planners to rezone the area for new residential and commercial development so that oppositional property owners would be able to monetize their unused property rights, resulting in what came to be known as the "West Chelsea rezoning." The "park's creation cannot be understood without the rezoning" of West Chelsea.[11] This is to say that the boom that occurred as a result of the High Line was not a happy accident but rather, the specific intention of city government and stakeholders. In short, "large sums (inclusive of city money) were spent for the betterment of the better off..."[12]

What are the economics of the High Line? As of 2017, the High Line was estimated to have stimulated more than $2 billion in real estate development and increased the property values in the adjacent neighborhood by more than 100%.[13] The increase in property values have led to the displacement

High Line, Manhattan,
2000, photograph by
Joel Sternfeld

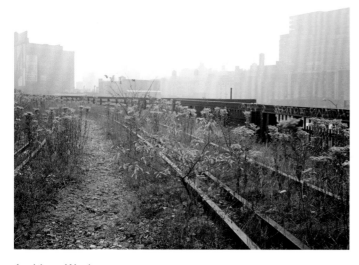

of longtime residents as well as to the displacement of remaining manufac-turing, and even art galleries. At the same time, the city spends a dispropor-tionate amount of its parks budget on the High Line, which is troubling on its own, but that funding along with the fact that the project receives enormous philanthropic donations leads to questions about the nature of public space and its relationship to real estate speculation.[14]

There is no doubt that the High Line and the policy-led gentrification that played an essential role in its establishment has been wildly successful; just a few years after its opening, the High Line became a destination more pop-ular than the Statue of Liberty.[15] The attention and praise this project has attracted from the public, and specifically from the design community, has been boundless. This fact leads to an essential consideration: Would this adaptive reuse project, which generates so much revenue have been so successful, would it be considered to be "among the most iconic urban land-scapes and public spaces of the twenty-first century"[16] had its designers not carefully and thoughtfully manipulated space and crafted experience?

What Joel Sternfeld captured in his images of the elevated railway, which were used as fierce marketing tools in the FHL campaign, was a wilderness in the city; there was a mystique associated with the abandonment of this place. The design task of James Corner of Field Operations, Diller Scofidio + Renfro, and Piet Oudelf was to preserve the mystique, or even to heighten the sense of untouchedness that existed here. But there are so many con-tradictions associated with this challenge: How do you foster wilderness in the middle of the city? Is it possible to promote occupation while simulta-neously furthering the sense of abandonment? If a park, by definition, is an area used for recreation, is it possible for this place to be based in nostalgia and meloncholy?

What they did was create a choreographed walk constructed in four phases (three phases plus a spur at 30th Street) from Gansevoort Street to 34th Street that acts as a ribbon of relief from the dense grid of the city. Climb the stairs 30 feet and immediately begin a stroll that involves looking toward both the cityscape and the Hudson River. There are recognizable features of a park, that is, seating, lighting, paving, planting, and water features, but none of these elements detracts from the feeling that one has come across a secret place, elevated above the street.

But what about these park features? The paving and the furniture here read as part of the same integrated system, for the planks merely lift to form seats. The pavement does not suggest walking in a straight line but rather a meander, if that is possible, in this narrow, linear channel. The paving is not extensive of the elevated platform, rather it is more intentional, starting, stopping, and bleeding into planted areas. At the same time, the spacing between the pavers opens at moments to allow the plants to grow among them so that it is a blending of hardscape penetrating softscape and softs-cape making a place for itself in hardscape.

No joints are closed so that water can fall between the hard surfaces to be stored for watering plants. These plants are challenged by hot, dry sum-mers, by wind, and by a shallow depth of soil. Sternfeld's images capture forever the meadows of colonizing plants that were able to germinate from

the naturally sown seeds on the abandoned elevated railway before Piet Oudolf laid his matrices of grasses, perennials, shrubs, and small trees that mimic happenstance. The planting here is a type of cultivated informality that evokes the spirit of the predecessor pioneer plants, appearing more spontaneous than it actually is.

There are also original railroad tracks that were removed, inventoried, and laid again. These relic tracks reinforce the linearity of the space and are there to say 'the past is still with us and will not be forgotten'.

There are also moments along this walk that break from the stroll and views: there is the passage between 21st and 22nd Streets where the thick plantings compress the experience; there is the theater over 10th Avenue where the street itself is the scene to view; and there is the northern end of the walk where the path opens up and turns toward the water. People move up and down the High Line, parallel to the two-way flow of the Hudson. Would the experience be the same if it were detached from the river?

The High Line hardly falls short of architecture but rather is an achievement that transcends the distinctions between design disciplines that can be so limiting. It is a project that can be claimed by architects, as well as by planners, urban designers, landscape architects, and plant designers. It engages with post-industrial infrastructure and residual urban space; it evokes the past without mimicry and cliché, thereby putting forth a product that is simultaneously contextual and forward-thinking.

The achievement that was the negotiation, or even circumventing, of city and state politics to transform the elevated railway into the High Line is not one that should be underestimated. It seems to have emerged from a

Aerial view of the High
Line, Manhattan

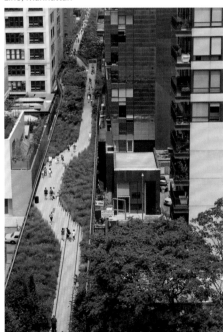

High Line, Manhattan

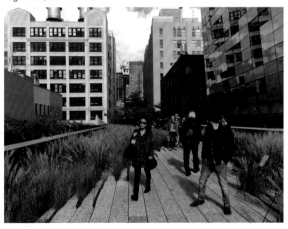

post-bureaucratic context that had to do with real estate and financial alignments as well as with the branding of the project as something vaguely sustainable and entrepreneurial; simultaneously public yet exclusive, boutiquey, and hip. The process of establishing the High Line is more in line with the 'get-it-done at any cost' attitude of Robert Moses—he was responsible for the construction of the original elevated railway structure in the 1930s—than of the 'for the people' grassroots agenda of Jane Jacobs, Moses' biggest opponent, who walked the streets of the West Village and most likely through the Meatpacking District to Chelsea, and who worked tirelessly to preserve the character of New York's neighborhoods and the organic type of social interaction that occurred on its streets.

When I am in New York, it is as though, each and every time, I am amazed that the High Line exists—that the interest groups were able to usher through such a complex project. I also am in awe of how elegant the solution put forth is and that it was seen through by the design team. And one last point of surprise every time I visit the High Line, is not simply the wild success of this project, but the irony of this success. Its enormous popularity has led to a condition of over-crowdedness, where eager tourists, along with luxury high rises built at its edges, actually detract from the characteristics of otherworldliness that made the space so distinct before its transformative reuse. A long time Chelsea community board member was quoted as saying. . . "When you go over there you see tourists from all over the world but you don't see local residents because it's really not a place for us,"[17] which, in the end, is reminiscent of the observation that "few self-respecting New Yorkers would venture down to the South Street Seaport."[18]

While it is said to be an edited reference to Paris' 1994 Promenade Plantee, the High Line has been the starting point for many subsequent projects including those such as the Lowline of New York's Lower East Side and the Underline of Miami. The naming of these projects alone indicates an effort to mimic the branding of the High Line and presumably to replicate the wealth it generates.

In an article titled "The High Line and Other Myths," Michael Van Valkenburgh is said to call out critics who focus on the "tectonics" of urban landscape architecture and specifically mentions the discourse of the High Line, which tends to revolve around topics accessible to architects such as the style of site furnishing, paving, and lighting.[19] In his work, and in particular, at the Brooklyn Bridge Park, Van Valkenburgh resists the temptation of the tectonic in favor of design objectives that involve cultivating the landscape of a new ecology and topography where there had been the infrastructure of industry, including warehouses, sheds, and piers, all built on landfill and active until containerization led to obsolescence and abandonment.

To have experienced the waterfront at Brooklyn Heights or Dumbo in the years before the Brooklyn Bridge Park, was to do so from the cool distance of the Brooklyn Heights promenade. I sat on a bench at the Promenade, in what must have been 1999 or 2000, to sketch the Manhattan skyline with the East River in its foreground. What I recorded in this sketch was that the Twin Towers, sitting all the way on the west side of Manhattan, on the man-made banks of the Hudson River were visible from this spot on the Brooklyn Heights palisade. What was not visible for me from this point, was Robert

Moses' Brooklyn Queens Expressway, for it was stacked neatly beneath the Promenade and out of my viewshed. What also was not visible for me, or at least what was not part of my primary view were the physical remnants of industry that existed in the narrow space between the East River and Brooklyn Heights, the site that would become the Brooklyn Bridge Park.

This 85-acre waterfront park is characterized by hills and valleys; by native trees and shrubs; by meadows and grass slopes; and by wetlands, marshes, and the previously inaccessible riverfront. The seven ecologies cultivated in the park are like studies in the site's natural history, and the visitor is to experience them, weaving his or her way from one to the next on footpaths and bike paths and a waterfront promenade; climbing up and down stairs, and up and down exaggerated earthen mounds. The visitor can pause on steps of reclaimed granite or sunbathe on a lawn looking out to Governor's Island.

The plantings are significant in comprising these ecologies and provide habitat for bees, butterflies, birds and other animals; they provide shade and block wind; and they also provide a distinct sensory and phenomenological experience, for plants are used to make place. There are moments of ornamentals, for example, at entrances and as punctuations throughout the landscape, but the clear emphasis is on natives. Woodland planting exists throughout the park, characterized by trees and dense shrubs. There is a sumac path and grass meadows with perennials. There are salt marshes, freshwater gardens that help collect rainwater, and there are planted swales that filter water before it flows back to the river. At some point, Michael Van Valkenburgh told me himself that a family of muskrats had moved into the park, a testament to the reclaimed ecology of the place and evidence that the intervention proved welcoming for people and creatures alike.

There is also extensive programmed space: playgrounds, and parks for swinging and water play; kayak launches, beaches, and get-downs. There are piers dedicated to rink skating and sports fields; basketball courts and volleyball courts; spaces for dogs, kids, for nature lovers, sunbathers, and athletes. There are views of the cityscape and the riverscape; of the skyline,

Brooklyn Bridge Park,
designed by Michael Van
Valkenburgh, photograph
by Alex MacLean

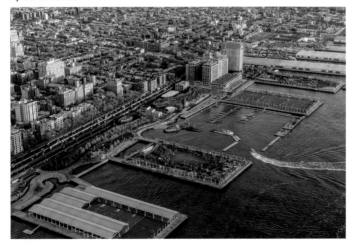

bridges, boats, and sunsets. And there are traces of the past, wooden piles piercing the surface of the water to mark where piers once existed.

The systems of ecology and program are laid on top of one another, at some moments overlapping and at others, reading with a clear and singular intention. Somehow what is present as a result of the layering, is a sense of being simultaneously immersed in an experience that has everything to do with both the natural world and the manmade world. It is a landscape cultivated to express what it means to be perched at the water's edge, between the densities of the two major cities that are Brooklyn and Manhattan. It is a landscape that mediates between waterlife and city life, filtering the existence of each for the other.

Van Valkenburgh's work seems to reflect that he always has believed in the power of landscape and knows that "while landscape was once the caboose, it is now often the engine of redevelopment."[20] Landscape certainly was the engine for development and increased values in the case of the High Line. And in the case of Brooklyn Heights and Dumbo: "two of New York's most desirable—and expensive—neighborhoods, [they] probably didn't need a shot in the arm. But Brooklyn Bridge Park gave them one anyway."[21]

Regarding the Brooklyn Bridge Park as a generator of wealth, it is relevant to consider that it operates under a mandate to be financially self-sustaining.[22] While some revenue is generated from permits and concessions, the majority of financing needed comes from a finite series of revenue-generating development projects that exist within the park's boundaries. This development includes the adaptive reuse of former industrial buildings as well as new construction for residential and retail use.

Is there something impure about the fact that the Brooklyn Bridge Park, as part of its General Project Plan that was approved in 2005, had committed to allowing private entities to develop within a public park? Or should the ingenuity of placemakers who were realistic about the need for a great public space to be self-sustained by a revenue stream be applauded?

Brooklyn Bridge Park, designed by Michael Van Valkenburgh, photograph by Etienne Frossard

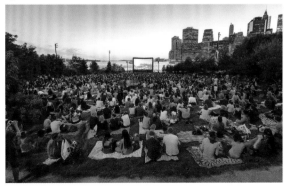

Brooklyn Bridge Park, designed by Michael Van Valkenburgh, photograph by Elizabeth Falicella

It has been said that in New York, interest groups with conflicting agendas have made it so that the most prevalent type of revitalization on the waterfront is the development of land for parks. In San Francisco, what is currently underway and may emerge as that city's wealth generating waterfront park is the expanded and further developed India Basin Shoreline Park. Gustafson Guthrie Nicol, who were selected for the commission by winning an ideas competition, will be designing the park to create a 1.5 mile-long public space along the city's southeast shoreline. The 2016 announcements in The Architect's Newspaper states: "the brownfield site that is the India Basin offers rare opportunity for the city to confront environmental and ecological issues with the implementation of a park complex. Currently, the site has little to offer in the way of amenities, but landscape development could see an influx of visitors to the area, to which business would undoubtedly follow."[23] And construction has just begun on Scape's China Basin Park which is part of the San Francisco Giant's 28 acre Mission Rock development. In this instance, the park, which is part of the first phase of work at this site, will be used as an incentive and a selling point for the rest of the project clearly making it an example of how landscape has stepped up as a driving force in real estate.[24]

A new publication by the Urban Land Institute, titled "The Case for Open Space: Why the Real Estate Industry Should Invest in Parks and Open Spaces," puts forth another model where communities and developers work together to establish publicly accessed, privately owned open spaces and asks: "How can investments in open space made by the private sector improve community health, support equitable development, and enhance real estate value?" The report suggests that this type of collaboration is more frequent and necessary considering "constrained government budgets and the often slow pace of public capital projects."

Of course, all of this requires a shift in thinking. The idea of a working waterfront might conjure up romantic images of salt of the earth lobstermen hauling traps off the coast of Maine, or the loading and unloading of one of Lane's Boston Harbor ships. I might think of the lives of the Swedes, Finns, Irish, Scots, English, and Italians who quarried rock on Hurricane Island, the piers that rhythmically lined Manhattan's edge, or the activity that took place in the Ferry Building long before I came to it.

I might even think back to Michael's grandfather carrying water during the construction of the Williamsburg Bridge. I might come back to him time and time again. And when I visit my daughter and her children, his great-granddaughter and great-great-grandsons, at their home in Fort Greene, Brooklyn, I might think of the physicality of his labor and the product of his work. We might visit the Brooklyn Bridge Park and reflect on its namesake monument, which has always been a symbol of industriousness, and consider that this site was once home to commerce, that it was once a transportation terminal, and that it was once an entry point for immigrants. We will marvel at the phenomenon that is the park's landscape, and I will marvel at the phenomenon that is the development generated by it, for as we move forward, well beyond Mumford's notion of specialized work and the division of labor, edge is no longer about livelihood.

Notes

1. Lewis Mumford, *The City in History : Its Origins, Its Transformations, and Its Prospects* (New York: Harcourt, Brace Jovanovich, Inc, 1961), 102–3.

2. "Loomings," *Moby Dick*, op. cit. pp. 27. Melville, Herman, *Moby Dick or the Whale* (New York: Bobbs Merrill, 1964), 27.

3. Elizabeth Garrity Ellis, "Cape Ann Views," in *Paintings by Fitz Hugh Lane*, ed. John Wilmerding (Washington DC: National Gallery of Art, 1988), 19–44.

4. Richard Marshall, "Contemporary Urban Space Making at the Water's Edge," in *Waterfronts in Post Industrial Cities* (New York: Spon Press, 2001), 5.

5. Marshall, 5–6.

6. Paul Goldberger, "At Seaport, Old New York With a New Look: Old New York With a New Look," *New York Times*, 1983, sec. WEEKEND.

7. Helene Stapinski, "Reclaiming South Street Seaport for New Yorkers," New York Times (Online); New York, July 27, 2017, https://search.proquest.com/docview/1923785072/abstract/B8C558885163484CPQ/1.

8. Alison Bick Hirsch, *City Choreographer : Lawrence Halprin in Urban Renewal America* (Minneapolis: University of Minnesota Press, 2014).

9. Christoph Lindner and Brian Rosa, "Introduction: From Elevated Railway to Urban Park," in *Deconstructing the High Line : Postindustrial Urbanism and the Rise of the Elevated Park* (New Brunswick, New Jersey: Rutgers University Press, 2017), 1–20.

10. Paul Goldberger, "Miracle Above Manhattan," *National Geographic; Washington*, April 2011.

11. Lindner and Rosa, "Introduction: From Elevated Railway to Urban Park," 8–9.

12. Aleksandr Bierig, "The High Line And Other Myths," *Log*, no. 18 (New York: 2010), 131–32.

13. Darren J. Patrick, "Of Success and Succesion: A Queer Urban Ecology of the High Line," in *Deconstructing the High Line*, ed. Christoph Linder and Brian Rosa, Postindustrial Urbanism and the Rise of the Elevated Park (Rutgers University Press, 2017), 143.

14. Nate Millington, "Public Space and Terrain Vague on São Paulo's Minhocão: The High Line in Translation," in *Deconstructing the High Line*, ed. Christoph Linder and Brian Rosa, Postindustrial Urbanism and the Rise of the Elevated Park (Rutgers University Press, 2017), 208.

15. Adrian Higgins, "New York's High Line: Why the Floating Promenade is so Popular," The *Washington Post; Washington, D.C.*, November 30, 2014. https://search.proquest.com/docview/1629109753/abstract/8FD9E03565A4DC4PQ/1.

16. Lindner and Rosa, "Introduction: From Elevated Railway to Urban Park," 1.

17. As quoted by Lindner and Rosa, "Introduction: From Elevated Railway to Urban Park," 10.

18. Stapinski, "Reclaiming South Street Seaport for New Yorkers."

19. Bierig, "The High Line And Other Myths," 131.

20. Bierig, "The High Line And Other Myths," 130.

21. Adam Bonislawski, "Brooklyn Bridge Park Is Turning Everything It Touches to Gold," *New York Post*, February 16, 2017, https://nypost.com/2017/02/16/brooklyn-bridge-park-is-turning-everything-it-touches-to-gold/?utm_source=url_sitebuttons&utm_medium=site%20buttons&utm_campaign=site%20buttons.

22. "Project Development," *Brooklynbridgepark.Org*, n.d., https://www.brooklynbridgepark.org/pages/project-development.

23. Jason Sayer, "Gustafson Guthrie Nichol to Design San Francisco Shoreline Parks at the India Basin Waterfront," *The Architect's Newspaper* (blog), March 16, 2016.

24. John King, "SF Giants Unveil Plan for a 5-Acre 'Constructed Ecosystem' along Bay," *San Francisco Chronicle*, September 30, 2019, https://www.sfchronicle.com/bayarea/article/SF-Giants-unveil-plan-for-a-5-acre-constructed-14477670.php.

Culture

Consider the subtleness of the
sea; how its most dreaded crea-
tures glide under water, unapparent
for the most part, and treacherously
hidden beneath the loveliest tints of
azure. Consider also the devilish bril-
liance and beauty of many of its most
remorseless tribes, as the dainty embel-
lished shape of many species of sharks.
Consider, once more, the universal cannibalism
of the sea; all whose creatures prey upon each
other, carrying on eternal war since the world
began.
 Consider all this; and then turn to the green, gentle,
and most docile earth; consider them both, the sea and
the land; and do you not find a strange analogy to some-
thing in yourself? For as this appalling ocean surrounds
the verdant land, so in the soul of man there lies one insular
Tahiti, full of peace and joy, but encompassed by all the hor-
rors of the half-known life. God keep thee! Push not off from
that isle, thou canst never return![1]
—Herman Melville, *Moby Dick*

Throughout history and across cultures, the human relationship to
water has been complex, resisting simple, binary thinking. Water, as an
entity, cannot be categorized as exclusively good or evil but instead exists
with a dual or even polysemic character, resulting in sentiments and depic-
tions that are illogical and emotional, rooted in phenomenon rather than
literal experience.

What do multiple representations of water in various and diverse media
reveal of the truths regarding the character of water? The term "media"
is broad, referring to religious stories and myths, non-fiction writing and
literature, as well as to visual art. In addition to this pursuit is the explo-
ration of interventions in the liminal space between land and sea. Here,
iconic monuments and works of infrastructure do not illustrate water in
an effort to decipher its meaning but rather engage it actively; these inter-
ventions demonstrate rather than depict the complicated human attitude
toward water.

In addition, the illogical and emotional human sentiments about water have
affected the way common or popular spaces between land and sea, such
as public beaches, waterfront amusements parks, and even pools, which
involve yet another type of immersive experience, are occupied. In these
spaces, all of the emotions of pleasure, wonderment, fear, anger, and thrill
exist and overlap where there is beauty, mystery, purity, danger, and power.
This simultaneity creates an uncomfortable vulnerability as humans seek
the known and the tangible: that with edge and form over the formless. In

these spaces, conscious and unconscious emotions are negotiated with the burden of this vulnerability, thereby allowing for malice to manifest, at times. For many religions, water bears multiple meanings as it symbolizes cleansing, purity, and salvation but also power, danger, and rage. It is an important part of ritual, for example, as in the case of baptism where it represents the purification of original sin, while at the same time, as in the story of the Flood, where it is an instrument of God's wrath but also foreshadows baptism: "For behold, I will bring a flood of waters upon the earth to destroy all flesh in which is the breath of life under heaven. Everything that is on the earth shall die."[2] (Gen. 6:17). Water as ritual is seen in Piero della Francesca's *Baptism of Christ* from circa 1450, where Christ stands in the shallow, winding River Jordan and receives watery purification from John the Baptist and the Holy Spirit, thereby representing the link between the human and the divine); while water's biblical devastation is seen in Michelangelo's *The Deluge* (1512), where humans struggle to shore seeking refuge from the rising water, and only in the background, is the ark that saves the righteous.

Poseidon, god of the sea in Greek mythology, is characterized as being volatile and vengeful, possessing the power to turn his rage toward the sea and create violent waters and similarly, harnessing that power to afflict the land with flood and drought. Poseidon also is the god of earthquakes, so it was likely his anger manifested in his striking of the ground with his trident that

Piero della Francesca,
Baptism of Christ, c. 1450

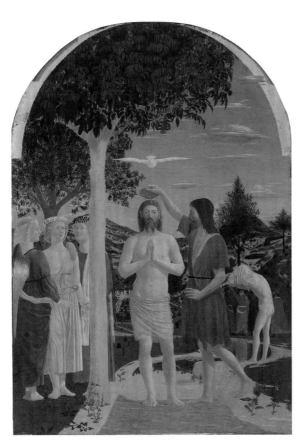

Michelangelo,
The Deluge, 1512

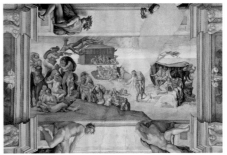

caused the earth to shake in San Francisco in 1906 and 1989. There is the River Styx, which mythically separates the world of the living from the world of the dead. The Greeks swore their oaths upon this body of water for it, as in the case of other traditions, had the power to cleanse. Think of Achilles' mother holding him by the heel and dipping the rest of his body into the Styx in order to wash away his vulnerability.

The dichotomous nature of water is present in writing including non-fiction work. Rachel Carson's prose about the sea is scientific but also personal and heartfelt. She described the mystery of her subject and the wonderment she felt upon experiencing it, and, for example, after winning the National Book Award for Non-Fiction for *The Sea Around Us* in 1952, she said:

> *The winds, the sea, and the moving tides are what they are. If there is wonder and beauty and majesty in them, science will discover these qualities. If they are not there, science cannot create them. If there is poetry in my book about the sea, it is not because I deliberately put it there, but because no one could write truthfully about the sea and leave out the poetry.[3]*

She also expressed how the ocean captivates people and draws them to it.

> *Eventually man, too, found his way back to the sea. Standing on its shores, he must have looked out upon it with wonder and curiosity, compounded with an unconscious recognition of his lineage. He could not physically re-enter the ocean as the seals and whales had done. But over the centuries, with all the skill and ingenuity and reasoning powers of his mind, he has sought to explore and investigate even its most remote parts, so that he might re-enter it mentally and imaginatively.[4]*

Carson herself was particularly moved when seeing the ocean for the first time in her twenties while at Wood's Hole, Massachusetts, and from then

Peter Paul Rubens,
Thetis dipping the infant
Achilles into the River
Styx, 1630–35

Rachel Carson and Bob
Hines, Florida Keys, 1955

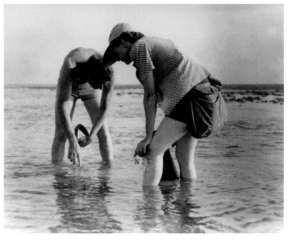

on she yearned to be around it, happiest when she was spending time on Maine's rocky coast.

However, Carson's emotional appreciation of the beauty and mystique of the sea was tempered by a logical fear of it. She was terrified to wade into the water beyond her knees and even feared to ride on boats. She had never experienced being underwater until 1949, when, as part of the research for her second book about the sea, she sailed off the coast of Miami and timidly submerged herself while clutching the boat's ladder, only to catch a glimpse of the ocean from below its surface.[5]

The dual nature of water, with its calm and power, is also present in literature and in *Moby Dick*, Melville writes:

> At such times, under an abated sun; afloat all day upon smooth, slowly heaving swells; seated in his boat, light as a birch canoe; and so sociably mixing with the soft waves themselves, that like hearth-stone cats they purr against the gunwale; these are the times of dreamy quietude, when beholding the tranquil beauty and brilliancy of the ocean's skin, one forgets the tiger heart that pants beneath it; and would not willingly remember, that this velvet paw but conceals a remorseless fang.[6]

Moby Dick emerged from a hopeful era in America; Melville visited Coney Island around the time of its writing,[7] when that place was a remote getaway from the bustling trade and port that had made New York the country's economic center and its largest city. He wrote *Moby Dick* while thousands immigrated to California to rush gold and to build San Francisco. And the emergence of this novel coincided with advancements in transportation and technology, and with the rise of democracy as an institution. The sea, the primary symbol in *Moby Dick*, is represented as multifaceted. It is "the home of both the nursing whale-mothers and the rapacious shark. It has a serenity that can nearly cure Ahab's monomania; it is also darkness and death."[8] The sea both offers its characters their livelihood and presents them with danger; it is the object of mystique and obsession.

Barry Moser, Introductory page to "Loomings," in *Moby Dick* by Herman Melville

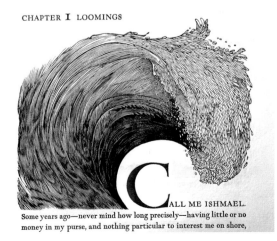

CHAPTER **I** LOOMINGS

CALL ME ISHMAEL.
Some years ago—never mind how long precisely—having little or no money in my purse, and nothing particular to interest me on shore,

Considering *Moby Dick* was written during this time of growth, when American cities, ports, and trade routes were becoming global, and when industry and advancements in technology and transportation were emerging as dominant, could the source of darkness in the novel be a sinister reflection of this expansion rather than the expression of a personal, spiritual crisis on the part of Melville? Does *Moby Dick* celebrate American progress, or is it a critique of expansionist and imperialist tendencies? Andrew Delbanco, in his 2005 biography of Melville, writes:

> At least since the 1920s, when the failure of Melville's contemporaries to recognize his genius began to be redressed, every generation has felt a need to come to terms with him in its own way... For some readers today, the Melville who counts is the corrosive critic of America, the writer who represents the United States in Moby-Dick as a bloodthirsty killing machine ...[9]

And then Delbanco concludes this section of his book with the following:

> Herman Melville was one of those writers whom Lionel Trilling described as "repositories of the dialectics of their times" in the sense that they contain "both the yes and no of their culture." In coming to terms with him, we are free to choose the prose-poet of our national destiny who imagines a world of grateful converts to the American Way, or the writer who saw the ship of state sailing toward disaster under lunatic leadership as it tries to conquer the world. In this respect he was—and is—as vast and contradictory as America itself.[10]

If Melville is both the 'yes and the no,' it is fitting then that he chose water, with its polysemic character and complex relationship to humans as his metaphor.

The 19th-century spirit of progress that went hand-in-hand with the country's expansion, and to which Melville may have alluded, was embodied by

Brooklyn Bridge,
photograph by Andrew
Henkelman

Ansel Adams, *The Golden
Gate Before the Bridge*,
San Francisco, c. 1932

feats of engineering. The process of constructing John A. Roebling's steel wire cable suspension Brooklyn Bridge was a dangerous one as its builders battled risk of falling when they worked high above the water, and risk of the bends, when they worked beneath it. At the time of its opening, the bridge spanned longer than any other and made obsolete Whitman's Brooklyn ferry across the East River. The ferry had positioned its riders close to the water and the result of this proximity was that they experienced the motion of the tidal strait: "Flood-tide below me! I watch you face to face!"[11] is the first line to Whitman's poem. Traveling across the Brooklyn Bridge via elevated railway or horse-drawn carriage removed riders from this contact with nature.

But the Brooklyn Bridge offered an entirely different experience. Cross it by vehicle or by foot, for there are "roadways and tracks at one level for the everyday traffic of life, while the walkway above was for the spirit."[12] The Bridge connected two landmasses separated by water to form an extensive metropolis. It transformed the way steel was used, and the way suspension bridges were built; this was the first time that galvanized steel wire was used in cable construction. Its gothic towers, made with granite from Hurricane Island, as well as with limestone, had to be massive enough to support the steel cable construction, tall enough to allow for boats to pass beneath the bridge's deck, and had to have footings that reached deep below the surface of the water, into the depths of the murky seabed in order to negotiate solid ground. Its steel cables may be 16 inches in diameter and may contain thousands of galvanized steel wires but sweep with ease from one tower to the next, and following the line created by this sweep and arraying out from the towers is a network of fine cable threads.[13] In David McCullough's book *The Great Bridge*, he says, "The way he had designed it, the enormous structure was a grand harmony of opposite forces—the steel of the cables in tension, the granite of the towers in compression."[14] And on the topic of the juxtaposition of the bridge's elements, Lewis Mumford wrote: "The stone plays against the steel; the heavy granite in compression, the spidery steel in tension. In this structure, the architecture of the past, massive and protective, meets the architecture of the future, light, aerial, open to sunlight, an architecture of voids rather than solids."[15]

Beyond its beauty and the innovative engineering exhibited in its design and construction, the Brooklyn Bridge symbolizes perseverance and strength, the ability to overcome adversity, the ingenuity to complete something that had never before been done, as well as the dominance of humans over the untamed forces of nature. Men and women had risked death and employed mental and physical prowess to make a structure that, to a degree, would remove them from the immediacy of the tides, the climate, and the atmosphere. "Clouds of the west! Sun there half an hour high! I see you also face to face."[16] But no more.

Decades later, in 1932, Ansel Adams, on a clear morning, just as the clouds were beginning to roll in from the north, photographed the Golden Gate with the Marin Headlands in the distance. This image would provide the last brief look at this landscape before the bridge spanning it would connect San Francisco to Marin County, defying the tides, currents, fog, and wind ever-present in the strait. The Golden Gate Bridge, like the Brooklyn Bridge, would replace ferry transport and the intimate experience with the water created

by that ride. Passengers would get a different perspective of the Pacific, the Bay, and the Marin Headlands. The Golden Gate Bridge is considered a master work of art and engineering and also, like the Brooklyn Bridge, "asserted itself as an icon of American civilization."[17]

Some monuments tell a simple tale. The Statue of Liberty embodies hope, emancipation, and opportunity from its spot in the Upper Bay. New Yorkers can see it from downtown, from Governor's Island, and from Brooklyn as it looms over Ellis Island, the iconic point of entry for many East Coast immigrants at the turn of the 20th century. Not too far up the Hudson River, is another monument that tells a different story. The Little Red Lighthouse from the classic children's book, *The Little Red Lighthouse and the Great Gray Bridge*, bears the responsibility, as do all lighthouses, of warning ships of danger that lurks in the waters. In the book, the lighthouse flashes its light and calls out "Look out… Danger… Warn-ing! Warn-ing!"[18]

In addition to depicting the calm and beauty of the sea, as we saw in *Blue Rigi* (p. 70), Turner depicted its violence. In *Slave Ship*, originally titled *Slavers Throwing Overboard the Dead and Dying—Typhoon Coming On* (1840), there is terrifying water and sky; the light, rather than incandescent or radiant, is breaking through the hazy clouds in a rage, illuminating body parts and blood and creating a chaotic and panicked scene. Is it problematic that the same soul can envision and the same hand render both extreme beauty and extreme violence? Or is this contradiction predictable, for the sublime has to do with that which evokes the strongest human emotion?

Turner's depiction of the biblical flood in *Deluge* (1805) was similarly severe. In it we see an apocalyptic biblical scene with the sea as its destructive force depicted in a manner more terrifying than the one with the same title painted by Michelangelo. The ocean is beautiful and luminous but so treacherous as it swallows all of humanity except for Noah, his family, and the animals of the world, as they will escape on the Ark whose form is barely suggested in the painting background, implying the inaccessibility of salvation. It was this painting by Turner that the San Francisco Museum of Modern Art paired with John Akomfrah's film *Vertigo Sea* (2015) in the 2018 exhibition *Sublime Seas*. In Akomfrah's three-channel video, as in Turner's painting, the viewer witnesses waves that are simultaneously inspiring and terrifying.

Joseph M. W. Turner,
*Slavers Throwing Overboard
the Dead and Dying—
Typhoon Coming*, 1840

Joseph M. W. Turner,
The Deluge, c. 1815

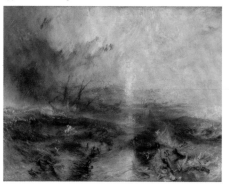

Other artists explored the contradictions of the sublime as it relates to water landscapes. Winslow Homer painted seaside leisure and rageful storms. James Abbott MacNeill Whistler painted and drew socially realistic portraits of dangerous areas of the East London docklands but later made atmospheric paintings of the Thames at night. Carl De Keyzer anticipates the beautiful and peaceful last moment before the power of the sea is released in *Moments before the Flood*. The two-panel *St. Elizabeth's Day Flood* depicts both the prelude to and aftermath of a 1421 storm that took place in the Netherlands; in one frame, the town is shown under protection by its dike system and life as usual continues but in the other, the town has been inundated by the breached dike as water, with all of its power, broke through these manmade barriers. Alice in Wonderland even suffers in Kiki Smith's 2000 lithograph *Pool of Tears 2 (after Lewis Carroll)*. In this case, both the image by the artist and the literature that inspired it express the wrath of water. Carroll writes: "'I wish I hadn't cried so much!' said Alice, as she swam about, trying to find her way out. 'I shall be punished for it, now, I suppose, by being drowned in my own tears!'"[19]

Akomfrah, in *Vertigo Sea*, seamlessly interweaves his original footage of the ocean's surface, its movement, and marine life with images captured from

Carl de Keyzer, *Moments Before the Flood*, Edinburgh, 2009

James Abbott McNeill Whistler, *Nocturne in Blue and Silver*, 1871–72

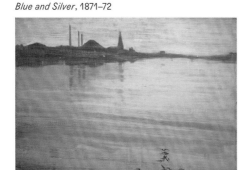

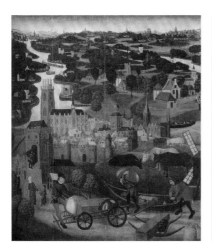

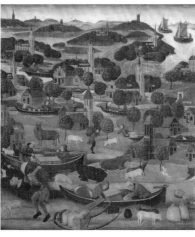

Master of the St. Elizabeth Panels, *The Saint Elizabeth's Day Flood*, c. 1490–95

the BBC's repository of contemporary and archival footage. He explores the past and present worlds of nature and culture through the lenses of *Moby Dick*, Heathcote Williams' "Whale Nation," and Virginia Woolf's *To the Lighthouse*, a process that requires the viewer to consider the whaling industry, the slave trade, and today's refugee crisis as part of the "longer historic perspective of race, migration, and commerce."[20]

The imagery in *Vertigo Sea* is immersive; viewers see the ocean, ice floes, sea life including whales, dolphins, polar bears, fish, and birds diving into the water to capture their prey who exist just below the surface. Time is a component of this work, as it is in De Keyzers' and the *St. Elizabeth's Day Flood*. Perspective is also a component for *Vertigo Sea* shows an instant, a specific point in time when the boundary between, above, and below the surface is pierced by predatory sea life. Compare nature to the violence of man. The cruelty of whaling and slavery is revealed in the video's imagery, as is the turning-a-blind-eye to refugees, migrants, and political prisoners. Viewers are asked to contemplate the cost of human occupation, in general, as well as the relationship, or lack thereof, between migration in nature and the immigration of people. What can we take away from looking at the journey of eels and whales compared to the journey of immigrants? Is the fact that so much immigration occurs via the sea significant? Are those moving across and through the water doing so of their own volition? Is it

Kiki Smith, *Pool of Tears 2 (after Lewis Carroll)*, 2000

John Akomfrah, *Vertigo Sea* (film still), 2015

the beauty or the pain of the ocean that is reflected in the institution that is immigration?

Akomfrah's work is striking and relevant, for he addresses head-on issues of human liberty and those of race as they exist in the context of the sea. Is the sea indiscriminately cruel, or are the powerless subjected more often to its wrath? Akomfrah's work reminds his viewers that water divides the powerful from the subjugated and the emancipated from the enslaved. He demands that they consider class and the distribution of wealth, fairness, and inequality.

To look at Seurat's *Bathers at Asnières* (1884) is to understand leisure at the waterfront as it emerged as a concept in Baudelaire's Paris and Veblen's conspicuous leisure. What is depicted here are petite *bourgeoisie* suburban men enjoying themselves at the water's edge, leaving behind, on this particular day, their factory work, which is suggested in the stacks that appear in the background of the painting. What is the culture of leisure at water's edge? Who lounges at beaches and pools? What are the politics of water and class?

In the first half of the 19th century, it was the wealthy who traveled by carriage to Coney Island, but as advancements in transportation made getting there easier and cheaper, the place became less exclusive, drawing greater numbers of tourists. Around the time Melville worked on *Moby Dick* and visited Coney Island, signing the register at the Coney Island House, tourists traveled there by steamboats and railways. And when the destination could be reached by subway, Coney Island became a place where tenement dwellers took day trips, earning it the title "poor man's paradise" and "the people's Riviera."[21]

The crowds and gritty culture of Coney Island are well documented. The street photographer Weegee took an iconic photo of this waterfront leisure space in July of 1940 and said the following of it:

> *And this is Coney Island on a quiet Sunday afternoon... a crowd of over a million is usual and attracts no attention (I wonder who counts them)... it*

Weegee (Arthur Fellig),
Coney Island, July 22,
1940

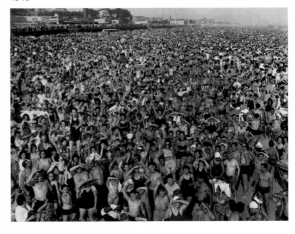

Georges Seurat, *Bathers at Asnières*, 1884

only costs a nickel to get there from any part of the city, and undressing is permitted on the beach.[22]

In 1937, just a few years before Weegee's photo of Coney Island documented its crowd, Robert Moses wrote in his report on "The Improvement of Coney Island, Rockaway, and South Beaches," that "The history of the beach at Coney Island is a sad commentary on the lack of foresight of the citizens of some of the communities now making up the City of New York. . . . There is no use bemoaning the end of the old Coney Island fabled in song and story. The important thing is not to proceed in the mistaken belief that it can be revived."[23] In this document, he acknowledges that most patrons who would visit would have "little money."

San Francisco also had its oceanfront retreat for working people. The Sutro Baths were developed by real estate magnate, engineer, and inventor Adolph Sutro, who, with his populist inclinations, opened the complex of pools and gardens, and also rebuilt the Cliff House in order to provide a day trip location for the middle and lower classes, for families, and for those from San Francisco's boarding-house culture. Sutro believed it was his role, as a wealthy citizen, to provide for the masses and, in fact, fought the Southern Pacific Railroad when it raised its fares. He said:

I had intended Sutro Heights as a breathing spot for the poor people as a benefit to the public. I felt grieved, and I chafed under the contemptible meanness of these people who, while I kept these places open here at a cost of $20,000 a year at least, and in some cases a good deal more, that they should get every nickel out of the people who visited.[24]

Sutro solved this problem by making his own steam railway to bring people to his complex.

Sutro's relationship to nature is worth considering. On one hand, the baths seemed to have engaged site fully. At Point Lobos, the waves crashed against the rocky shore and Sutro's buildings were set into its cliffs. Here, the ocean water was prohibitively cold, but Sutro invited it inside to fill his pools. On the other hand, Sutro was a master engineer who constructed roads, pipelines, and his own railroad. He confidently built wherever and whatever he chose in a way that challenged nature's power. One could argue that all zoos and aquaria are the manifestations of human control over nature and Sutro's collections are no different. He brought the cold seawater inside the walls of his complex but seeing the baths as a celebration of nature is only half the story.

The water for these is supplied by an ingenious use of ocean waves. A basin scooped out of solid rock receives the water that dashes over the top, thence it is conducted to a settling tank; by numerous small canals it makes its way into the various swimming tanks, of which there are six in all, the largest one containing the sea water in its natural state, the others being heated to different temperatures to suit the varying requirements of visitors. . . water can be forced in at 6,000 [gallons] a minute by means of a large turbine pump placed at sea level in a cave-like excavation hollowed out by the solid cliff and heretofore driven by means of a steam engine. . . The mere emptying of the tanks entails a difficulty. . . The refuse water is the main outlet into which all of

the tanks ultimately empty, piped hundreds of feet to the side of the head-lands, thence passed into the tidal currents away from the baths.[25]

The maintenance of Sutro Bath's complicated systems and extensive grounds, especially considering the effects of the site's harsh elements, had been a "Herculean task" which, after Sutro's death, became impossible.[26] Neglect and fire devastated the buildings and landscapes, and currently, they exist as a different type of place altogether. There is not a museum, or old cars, or diving boards, or beauty pageants, or trophies, or dances. But there are architectural relics at the edge of the sea that mark the place where a cultural icon once stood. Water still fills its pool foundations as testimony to its builder's relationship to the sea and this rocky edge.

Perhaps it was after the rise and fall of the Sutro Baths, when the masses had long occupied Coney Island, reaching their destination by subway, that my parents and I took our car to Robert Moses' Jacob Riis Park. Moses was an avid swimmer, having done so at Yale,[27] and he was a proponent of pools and beaches. In August of 1929, as Long Island State Park Commissioner, he opened Jones Beach State Park. And in 1936, using New Deal money, he opened Orchard Beach and Jacob Riis Beach, as well as 11 enormous outdoor pools. Only highway projects were granted more funding than public recreation projects during the New Deal.[28]

Which of these well-funded highways did my family take to get from our West Village home to Jacob Riis Park? Was it the West Side Highway that runs along the Hudson River just a few blocks from where we lived? Did we cross the Brooklyn Bridge and make our way to the Belt Parkway to travel through Brooklyn, parallel to the East River, with Governor's Island in the distance; past Fort Hamilton and the Verrazzano Narrows, and past all of Weegee's Coney Island bathers? Were they there in the wintertime too?

These highways were both conduits for getting to the water and physical barriers preventing city dwellers from it. It was the urban waterfront that still would be off limits while the suburban waterfront was accessible. To this end, Robert Caro, in *The Power Broker*, which chronicles Moses' rise to power and his efforts to modernize New York City for the auto-centric

Sutro Baths, interior, c. 1900

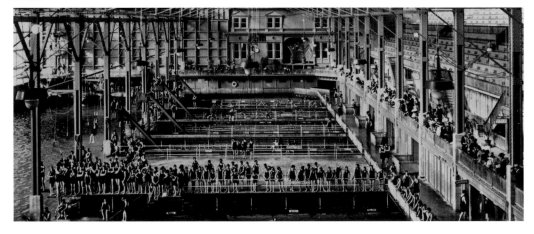

era, contemplates the inequality and exclusivity of car culture. Caro argues that Moses intentionally and explicitly kept low-income people and people of color from his beaches by enacting policies that favored the individual automobile over public transit modes that would have been used democratically. In an interview from 2016, Robert Caro says that Moses, the single person who had the most influence on New York's built environment in the 20th century; the builder of New York's parks, playgrounds, bridges, tunnels, and expressways; the person whose highways separated the urban fabric from the waterfront, "was the most racist human being I had ever really encountered."[29]

The pools Robert Moses made for New York and all others should be places of leisure, but since they became popular a century ago, pools "have served as flash points for racial conflict—vulnerable spaces where prejudices have intensified and violence has often broken out."[30] Consider the events of St. Augustine, Florida, in the summer of 1964, when a white hotel manager poured acid into a pool of mixed-race protesters. Consider the expression on the manager's face in the photograph that captured his action in order to glimpse the depth of his hatred. But what is the source of his rage? Is there something intimate in the act of being present in a body of water with another body? Why are these spaces so charged?

It is probably not surprising that the hurtful stereotype that "black people don't swim" is rooted in the country's institutionalized racism. Children of color are much less likely to know how to swim than Caucasian children. The USA Swimming Foundation reports that 64 percent of African American children, 45 percent of Hispanic and Latino children, have no or low swimming ability compared to 40 percent of Caucasian children.[31] A disparity exists in drowning statistics as well, for the CDC reports that African American children are more than 5 times as likely to drown in pools as white children their age.[32]

Motel manager pours muriatic acid into pool filled with mixed-race protesters, Monson Motor Lodge, St. Augustine, Florida, 1964

Swimmers, New York City, 1936

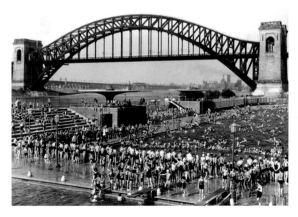

This risk to African American children can be attributed to segregationist practices limiting generations of children access to swimming places.[33]

It would not be surprising, however, if water activities were rejected by a community whose very existence on this continent was the result of the violent, Middle Passage from Africa, during which thousands suffered and perished at sea. A version of this story is told in Turner's *Slave Ship*, and another in Akomfrah's *Vertigo Seas*, and yet another when *Vertigo Seas* is told simultaneous with Turner's *Deluge* in *Sublime Seas*.

Could it be that water and its power hold a particular wrath against the disenfranchised? What about in the case of natural disasters? Are vulnerable communities allowed to fail because they are not regarded as significant? It is not surprising that the poorest populations in our country are relegated to live in the margins, in places most threatened by the storms of our climate crisis. Watch Spike Lee's *When the Levees Broke*: *A Requiem in Four Acts* to get a sense of who stayed and who evacuated New Orleans as Hurricane Katrina loomed.

That the poor are relegated to live in the margins is nothing new. Just one example of this type of spatial oppression during antiquity is that of the 16th-century Roman Jews who lived in ghettos adjacent to some of the most polluting and offensive work. Katherine Rinne, in her book *The Waters of Rome* writes, "A type of informal yet hierarchical zoning was clearly in place that required the smelliest and dirtiest industries to be placed in the more marginalized areas along the water's edge. Where else, in the logic of the day, would the Jewish population be located but next to the most redolent and vile industries of the city? As Jews were perceived as both polluted and polluting, the logic of placing them in this area must have seemed inevitable. Meanwhile, more prestigious and less malodorous work, such as printing and weaving, took place in residential neighborhoods away from the riverbank."[34]

One does not have to travel back in time or farther than the Midwest of the United States to bear witness to another type of oppression that has to do with our waterways. The citizens of Flint, Michigan, the majority of whom are African American[35] and 42 percent of whom live below the poverty line were ignored for 18 months while they consumed water contaminated with lead after the city redirected its water supply from Lake Huron, "a lake so deep and fierce that it once swallowed eight ships in a single storm," to the Detroit and Flint Rivers in an effort to reduce costs.[36]

What also has been sacrificed is the health of the earth's waterways. The NRDC reports that "Our rivers, reservoirs, lakes, and seas are drowning in chemicals, waste, plastic, and other pollutants." Almost half of the nation's rivers and streams are in "poor biological condition"[37] and about 40 percent of the nation's lakes are unfit for swimming, fishing, and drinking.[38] In addition, the earth's oceans are polluted by "chemicals, nutrients, and heavy metals". . . that are carried from "farms, factories, and cities by streams and rivers into our bays and estuaries; from there they travel out to sea," as well as by plastics, oil spills, and carbon emissions.[39]

What is the hubris of humans that make them think they can treat their water with such carelessness and without consequence? Melville knew that a darkness lurked beneath the nation's surface. Agriculture and industry have taken what they have wanted from the earth's water sources. And there is yet another infrastructural use for our oceans reported on by AbdouMaliq Simone in the *Harvard Design Magazine*'s Wet Matter issue. Simone writes:

> Under the ocean, in the depths where thousands of Africans perished during the Middle Passage from Africa to the Americas, technology corporations plan to bury the vast expenditures of energy necessary to cool the "cloud's" storage machines. The entombment of these harbingers of totalizing computation is an indirect but haunting reminder of both the absolute expendability of Black bodies and their absolute necessity to the economic ascendancy of America and all subsequent elaborations of a human-centered world.[40]

Consider now the double-edged sword that is progress.

Michael and I recently took a trip, first to Greece, and then to Tbilisi for the International Festival of Literature. In Athens, I took the opportunity to visit the National Archeological Museum and the *Artemision Bronze*, a sculpture with which I have been familiar for 50 years but had never seen first-hand. The story of this statue has many twists and turns, as does the complex story of water I am telling here.

The *Artemision Bronze*, which dates from the 5th century BCE, was recovered in the 1920s, off Cape Artemision in northern Euboea. The figure is elegant in its balance of dynamism and restraint as it depicts movements that are grand but graceful and controlled, and it is elegant in its scale which is slightly larger than human. There exists debate whether this classical figure is Zeus or Poseidon, but there exists no debate for me. The statue emerged from the sea after having been submerged beneath its surface for thousands of years. The Romans may have taken it from Greece intending to sail with it to their home. Perhaps, at some point, it would have been melted down for the value of bronze, like so many others from that time. Perhaps, the statue, in its sinking, avoided this fate.

Artemision Bronze,
c. 460 BCE

I gather then that the *Artemision Bronze* must be the God of the Sea because the sea does not protect just anyone. It does not protect those who lack the means to move out of the margins, away from the path of powerful storms. And it does not spare those who live at the edge by choice, those who possess the means but not the restraint to resist the draw of the water, living near it at any cost, potentially putting themselves and their property in harm's way.

And it does not spare those fleeing one shore for another as I was reminded by Akomfrah. I was reminded of this, too, in Greece, thinking back to the short film, *4.1 Miles*, in which Daphne Matziaraki tells yet another tale of suffering and death at sea, this time in the waters between Turkey and the Island of Lesbos. Matziaraki offers a glimpse into the refugee crisis, where people take to the water by choice paying smugglers to take them on ramshackle boats and rafts. But what choice? They select the lesser of two evils facing head-on the danger before them. Matziaraki reveals haunting images of bodies scattered in turbulent water and the threat of the sea and terror of those who have embarked on the journey across it. There is the round-the-clock work of the rescuers and the psychological toll it takes on them. This is not a tale that involves enslavement the way Turner's *Slave Ships* and *Deluge* do. But it is by no means a tale of freedom, and the viewer is left wondering what kind of horror existed before if the sea and all of its cruelty is the chosen passage.

The *Artemision Bronze* was pulled from one edge of the Aegean Sea, where it had been protected and sheltered under the surface of the water until its almost mythical salvation and rebirth; *4.1 Miles* embarks on a very different journey of human desperation and danger. These two works of art, one of antiquity and one of the now, together embody the duality that is central to this narrative.

Refugees crossing the Mediterranean from Turkey to the Greek Island of Lesbos, January 29, 2016, photograph by Mstyslav Chernov

Notes

1. "Chapter LVIII Brit," *Moby Dick*, op. cit, 363–4.

2. English Standard Version. Bible Gateway, www.biblegateway.com. Accessed 22 May, 2020.

3. As quoted by Linda J. Lear, *Rachel Carson : Witness for Nature*, 1st ed. (New York: Henry Holt, 1997), 219.

4. Rachel Carson, *The Sea around Us.*, Rev. ed. (New York: Oxford University Press, 1961), 14.

5. Much information on Rachel Carson was obtained from the American Experience film *Rachel Carson: She Set out to Save a Species. . . Us* (A 42nd Parallel Films Production for American Experience. American Experience is a production of WGBH., 2017), https://www.pbs.org/wgbh/americanexperience/films/rachel-carson/.

6. Herman Melville, *Moby-Dick ; or, The Whale*, The Library of Literature, 5 (Indianapolis: Bobbs-Merrill, 1964), 622–23.

7. "The Coney Island House Register: A Literary Mystery," January 26, 2012, https://www.bklynlibrary.org/blog/2012/01/26/coney-island-house.

8. WILLIAM HAMILTON, "MELVILLE AND THE SEA," *Soundings: An Interdisciplinary Journal* 62, no. 4 (1979): 417.

9. Andrew Delbanco, *Melville : His World and Work*, 1st ed. (New York: Knopf, 2005), 15.

10. Delbanco, 16.

11. "CROSSING BROOKLYN FERRY. (Leaves of Grass (1867)) - The Walt Whitman Archive," accessed January 13, 2020, https://whitmanarchive.org/published/LG/1867/poems/76.

12. David G. McCullough, *The Great Bridge: The Epic Story of the Building of the Brooklyn Bridge* (New York: Simon & Schuster, 2001), 32.

13. For information on use of steel as it pertains to the Brooklyn Bridge see "Brooklyn Bridge | ASCE," accessed January 13, 2020, https://www.asce.org/project/brooklyn-bridge/.

14. McCullough, *The Great Bridge*, 30.

15. Lewis Mumford as quoted by McCullough, on page 506 of *The Great Bridge*. From Lewis Mumford's *Sticks and Stones*, 1924.

16. "CROSSING BROOKLYN FERRY. (Leaves of Grass (1867)) - The Walt Whitman Archive."

17. Kevin Starr, *Golden Gate: The Life and Times of America's Greatest Bridge*, 1st U.S. ed. (New York: Bloomsbury Press, 2010), 187.

18. Hildegarde Hoyt Swift and Lynd Ward, *The Little Red Lighthouse and the Great Gray Bridge* (New York: Harcourt, Brace and Co., 1942).

19. Carroll, Lewis, *The Annotated Alice: Alice's Adventures in Wonderland & Through the Looking Glass*, Cleveland and New York: Forum Books, 1963, 40–41.

20. "Sublime Seas: John Akomfrah and J.M.W. Turner · SFMOMA," accessed January 14, 2020, https://www.sfmoma.org/exhibition/john-akomfrah/.

21. Brian J. Cudahy, *How We Got to Coney Island : The Development of Mass Transportation in Brooklyn and Kings County*, 1st ed. (New York: Fordham University Press, 2002).

22. Weegee, *Naked City* (New York: Essential Books, 1945).

23. New York (N.Y.), *The Improvement of Coney Island, Rockaway and South Beaches* (New York, N.Y.: Dept. of Parks, 1937), 4.

24. James P. Delgado et al., "The History and Significance of the Adolph Sutro Historic District: Excerpts from the National Register of Historic Places Nomination Form Prepared in 2000," n.d., 21.

25. Delgado et al., 19–20.

26. Delgado et al., 20.

27. Moses' dedication to swimming as a sport was commonly known but verified here: Paul Goldberger, "Robert Moses, Master Builder, Is Dead at 92," The *New York Times*, July 30, 1981, sec. Obituaries, https://www.nytimes.com/1981/07/30/obituaries/robert-moses-master-builder-is-dead-at-92.html.

28. "Robert Moses and the Modern Park System (1929–1965): Online Historic Tour : NYC Parks," accessed January 14, 2020, https://www.nycgovparks.org/about/history/timeline/robert-moses-modern-parks.

29. Christopher Robbins, "Robert Caro Wonders What New York Is Going To Become," Gothamist, February 17, 2016, https://gothamist.com/news/robert-caro-wonders-what-new-york-is-going-to-become.

30. Niraj Chokshi, "Racism at American Pools Isn't New: A Look at a Long History," The *New York Times*, August 1, 2018, sec. Sports, https://www.nytimes.com/2018/08/01/sports/black-people-pools-racism.html.

31. "Usa Swimming Foundation Announces 5–10 Percent Increase In Swimming Ability Among U.S. Children," accessed January 14, 2020, http://www.usaswimmingfoundation.org/utility/landing-pages/news/2017/07/13/usa-swimming-foundation-announces-5-0-percent-increase-in-swimming-ability-among-u.s.-children.

32. "Racial/Ethnic Disparities in Fatal Unintentional Drowning Among Persons Aged ≤29 Years — United States, 1999–2010," accessed January 14, 2020, https://www.cdc.gov/mmwr/preview/mmwrhtml/mm6319a2.htm.

33. Steven Roberts, "Most Black Kids Can't Swim, and Segregation Is to Blame," *Vice* (blog), August 30, 2018, https://www.vice.com/en_us/article/8xbyax/most-black-kids-cant-swim-its-not-just-a-stereotype-its-history.

34. Katherine Wentworth Rinne, *The Waters of Rome: Aqueducts, Fountains, and the Birth of the Baroque City*, 1st ed. (New Haven: Yale University Press, 2010), 27.

35. "U.S. Census Bureau QuickFacts: Flint City, Michigan," accessed January 14, 2020, https://www.census.gov/quickfacts/flintcitymichigan.

36. Anna Clark, "'Nothing to Worry about. The Water Is Fine': How Flint Poisoned Its People," The *Guardian*, July 3, 2018, sec. News, https://www.theguardian.com/news/2018/jul/03/nothing-to-worry-about-the-water-is-fine-how-flint-michigan-poisoned-its-people.

37. "Fact_sheet_draft_variation_march_2016_revision.pdf," accessed January 14, 2020, https://www.epa.gov/sites/production/files/2016-03/documents/fact_sheet_draft_variation_march_2016_revision.pdf.

38. "The National Lakes Assessment 2012," n.d., 2.

39. May 14 and 2018 Melissa Denchak, "Water Pollution: Everything You Need to Know," NRDC, accessed January 14, 2020, https://www.nrdc.org/stories/water-pollution-everything-you-need-know.

40. "*Harvard Design Magazine*: No. 39 / Wet Matter," accessed January 14, 2020, http://www.harvarddesignmagazine.org/issues/39.

Art

I first saw Turner's *Blue Rigi* at the De Young
Museum's 2015 exhibition *J.M.W. Turner:
Painting Set Free*. As I recall, there were several
versions of the painting, or at least several studies
of it, on view. Turner returned to the landscape of
the Rigi mountain massif and Lake Lucerne, which are
depicted in this painting, time and time again over the
years, making sketches, watercolor and oil paintings just
as I would return to his depiction of this landscape and to
his work, in general, time and time again after having first laid
eyes on it.

Following *Painting Set Free*, I made it my business to know all I
could about Turner. I had been familiar with his work but had not
studied it. I had not known that he had a profound interest in the
ocean and interest in life on the edge of the sea; that he lived in London
but spent time on Margate, on England's southeast coast. This makes
sense, of course, for the sea is the common thread uniting his most serene
scenes with his most horrific. He traveled extensively with sketchbooks
and paints in hand, documenting and fantasizing about what he saw. He

Joseph M.W. Turner,
Blue Rigi, Sunrise, 1842

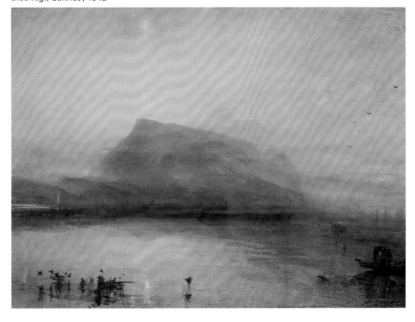

rendered water and light exquisitely, drawing us into his dramatic views with reflections and color.

In addition to painting waterscapes and scenes that documented some of the worst of imperialism, he, fascinated by technology and industry, chronicled the Industrial Revolution at the water's edge with a keen eye toward its power and liabilities. Turner depicted both continuity and progress; steamboats were a metaphor for modernity but lay among the sailing vessels of the past. He understood there was a price to be paid for industry and warfare but that the sea had an endless and continuous existence: "The ephemerality of civilization is a leitmotif of Turner's depiction of ports—by definition sites of human activity where the land, marked by the cycles of progress and decline, meets the water, unchanged by exploration, commerce, and battles that occur on its surface."[1]

I am returning to Turner and the *Blue Rigi* at this moment to make a specific point. I am past my Greenwich Village childhood, where my parents and their friends supported the culture of art that thrived there. I am well past any childhood drawing and painting; past pursuing clay and sculpture; past taking a college course in modern architecture for which I designed a house and small urban park called "Fat City Square." I am past seeking a career in architecture which I had not even known, that I, as a woman, was not supposed to pursue. And I am well past establishing my career in that field which was practical and realistic yet creative and intellectual; that was socially valuable and allowed me to pursue the greater good; that gave me the independence my father insisted I have.

But I am not past delving into research on Turner. I am not past learning all I can from him and his work. I take the position that designers are informed by their engagement with art, artists, and the production of art; that being a humanist who looks to art, literature, dance, music, theater, as well as to

Joseph M. W. Turner,
*Keelmen Heaving in Coals
by Moonlight*, 1835

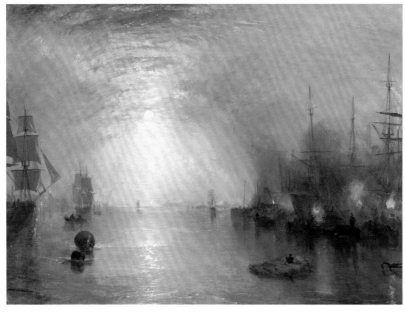

politics and history is essential to the practice of design. It is attending to the "other voice."

For this reason, art moves in and out and close to and away from the story told in this book. What do artists tell us? How is what they make a record of history, and in what ways does it mirror cultural attitudes? What can we learn from engaging with art? Can its transformative power be brought into design practice? Here, art is about the water because, for me, these two topics go hand-in-hand, both having shaped me as an architect, urban designer, and placemaker.

Paintings such as *Blue Rigi* have the power to evoke emotions that get close to those that exist for me when experiencing the sea first hand; there is neither happiness nor sadness but, in fact, a feeling of being overwhelmed and in awe, as though I have to capture and be present for each moment.

The visual arts also have served to register history and activity that has taken place at the water. What does Canaletto tell us about Venice in the 18th century? (p. 40) Who visited the water for leisure in Seurat's world? (p. 61) Or simply, what ship details were narrated in the soft, canonical light of Fitz Henry Lane? (p. 40) The information presented becomes a personal archive.

Paintings, drawings, and other forms of art depict the human perception of water, while three-dimensional works of infrastructure and monuments demonstrate these attitudes. The latter, as it was explored in Culture, exhibits the dynamism of engagement with the actual physical entity.

What's more is that when presented in distinctive environments, specifically in sites that engage water, art can heighten experience, so that it and the literal space in which it is shown become a continuum. At this moment when art and space come together, there exists the opportunity for art to honor and transform place.

Some works of art engage site as their specific and singular intention and when this engagement occurs in the space between city and sea, each individual piece calls out as if to say, 'I am about this place, this waterfront. You haven't been here. No one has been. But come here now to know me. See me with fresh eyes.' I am talking about art that draws on static, constructed form as it is inhabited by social and cultural networks, an art that is energized by water and its dynamic traits. This art, by way of its relationship with water, an element dependent on the moon, current, and wind, inherently takes on temporality and fluidity where land meets the sea. The phenomenon here is what is at the heart of the architecture to which I aspire.

Art that is about place serves to bring people back to the once-abandoned urban waterfronts, including those of San Francisco and New York. Examples in San Francisco call people to a waterfront that was once dominated by the military and where the public, therefore, had been prevented from visiting. On New York's Governors Island, the public had similarly been kept from the military waterfront but also had been separated from Manhattan's waterfront by industry and by the highway system that wraps around its edge.

Contemporary art that invites people to the edge has to do with passage and movement and, most recently, immigration. To know the histories of San Francisco and New York is to know that they were entry points, on the West Coast and the East Coast, from far-away places including Asia and Europe.

In San Francisco, the FOR-SITE Foundation is dedicated to art about place. In partnership with the Park Service and the Golden Gate Parks Conservatory, its projects exist on the waterfront at select locations in San Francisco's National Park, the Golden Gate National Recreation Area, including postmilitary coastal defense structures in the Presidio, the historic Civil War era, Fort Point, and the former federal prison, Alcatraz. The public is invited to these spaces to experience art and architecture while simultaneously considering the duality of the Bay Area's iconic waterfront where there exists both natural beauty, the spectacular feat of design that is the bridge, alongside the infrastructure of military defense and incarceration.

In 2016, the Foundation exhibited *Home Land Security*, a temporary, site-specific, multi-media installation that was staged in five US Army coastal defense structures at the Presidio's Fort Winfield Scott. *Home Land Security* showed multiple national and international artists who explored what home, safety, danger, paranoia, and defense mean during a time of cynicism and distrust.

The exhibit invited visitors to the edge of the San Francisco Peninsula, where obsolete military spaces previously had been off-limits. It brought visitors to experience the three curved concrete World War II batteries that exist half-buried above the ocean coastline, overlooking the southern anchorage of the Golden Gate Bridge. It brought them to spend time in the Fort Scott Chapel, a simple structure whose standard design was virtually identical to many base chapels across the country. It brought them to contemplate the banality of the Nike Administration Building, which is the former headquarters of the Cold War missile defense system.

Bill Viola, *Martyrs*, 2014

Michele Pred,
Encirclement, 2003

On the concrete floor of the Nike Administration Building, visitors would find Swedish-American Michele Pred's carefully arranged ring of items confiscated during TSA airport security screenings; scissors, lighters, nail clippers, corkscrews, and pocketknives all speak to the ritual of surveillance that occurs in the name of safety. Did the confiscation of these ordinary items, or the work that occurred in this ordinary space decades before, ensure anyone's safety? In another space, visitors witnessed the human ability to withstand torture and physical pain implemented by the elements—earth, air, water, and fire—in four of Bill Viola's videos called *Martyrs*. And in yet another, they experienced French-Iranian Yashar Azar Emdadian's "Disintegration," a video self-portrait of the artist, as he stands on an heirloom Persian prayer rug in Paris' Tuileries Garden shaving his torso and face. This frankly transgressive, private act performed in a beautiful historic public place gets at the paranoia of our time, the stripping of personal identity, and the invasion of privacy common to surveillance. And at the Battery Boutelle, at the edge of the Golden Gate, visitors encounter the video installation, *Exodus,* by Iranian-Turkish artist Mandana Moghaddam that depicted images of floating luggage, lost or abandoned at sea, an allegory of our era's refugee crisis and its human losses.

It is not that these works and the others featured in the exhibit were not powerful enough to stand alone, but that they are made more powerful, and their particular messages are made more potent when experienced together, and in these particular spaces. The visitor is asked to consider, while occupying obsolete structures of past, the human cost of contemporary conflicts, the looming of retaliation, and the fear of enemies, perceived and real, who possess a threatening otherness. The visitors, similarly, are asked to reconsider the structures themselves. What are their histories? What role did they play in war and in San Francisco's story, and in the story of the city's edge? What is the effect of using art to bring people to these structures? How did art transform them? As part of a celebration of the 75th anniversary of the Golden Gate Bridge in 2012, the FOR-SITE Foundation staged the mixed-media exhibition *International Orange* at Fort Point, a Civil War structure with seven-foot thick brick walls, an irregular shaped courtyard, and an interior of voided spaces that exists close to the water, directly

Madana Moghaddam,
Exodus, 2012

below the bridge, at the edge of the Golden Gate. The location of this fort structure close to the elevation of the water originally allowed cannons to be fired at invading enemy ships in order to defend the gate from an attack by the Confederate Army that never occurred.

Sound artist Bill Fontana was among those exhibited as part of *International Orange*. His *Acoustical Visions of the Golden Gate Bridge* captured the sounds of the Bridge's joints with speakers and a projected live video feed to document the forces that act on the structure. The audio and video environment provided the experience of speeding vehicles, slow moving traffic, thermal expansion and contraction, fog horns, seagulls' cries, and wind. Among Fontana's goals were to make heard the bridge's "inner voice" and to portray the bridge as a "living structure." The bridge, with its big and small movements, and the ambient noise of site that includes birds, wind, waves, honking, and horns together become Fontana's instrument.

Doug Hall installed *Chrysophylae* on a pair of screens at Fort Point that played video of the Golden Gate Bridge, and the water, land, and activity that surrounds it. The bridge is shown to be a feat of design and engineering but also, despite its grace and massiveness, diminutive in the context of the Marin Headlands, the Pacific Ocean, and in the context of the larger infrastructures of globalism, revealing that Hall's work is about comparisons and relationships. Specifically, it is a study of scale on multiple levels. The ocean that stretches thousands of miles to the west is implied in footage of tides and currents as they funnel in and out of the Golden Gate. The Marin Headlands are treeless landforms that form the northern backdrop for the mile-long suspension. Container ships possessing the wear of many travels and of exposure to the elements, including salt water and spray, pass under it and the viewer is asked to compare them, and their size and influence, to that of the bridge. Hall's aerial footage taken from the bridge's towers shows an endless stream of vehicles that are dwarfed by the bridge, the ships, and the gate. The people in *Chrysophylae* are in groups and alone; they and the seabirds appear so small, observing the spectacle before them. Hall's bridge is transformed into something that is more than a means of crossing a body of water and instead the bridge is a figurative measuring device, a tool that facilitates existential contemplation.

Two years after *International Orange*, Ai Weiwei's temporary exhibit *@Large* was installed in seven interior locations at Alcatraz that formerly were closed to the public. In these spaces, the Chinese artist placed multiple works, all

Doug Hall, *Chrysopylae*, 2012

Ai Wei Wei, *@Large*, 2014

with profound political perspectives on resistance, dissent, incarceration, and protest. These pieces were made in multiple media: *Refraction* was a metal sculpture made of fragments of Tibetan kitchen utensils; *With Wind* was an array of paper kites representing the world's political prisoners; *Trace* was an assemblage of large-scale Lego portraits of current day political dissidents. Ai Weiwei himself had been subject to detention in China that had made it impossible for him to travel to San Francisco to be a part of the installation at Alcatraz. His absence, however, along with knowledge of the history of Alcatraz, only lent itself to further the work's message, adding potency to the project.

To the later point, Alcatraz is a distinct waterfront site for it, as a federal prison on an island in the middle of the San Francisco Bay, existed as a place of punishment and hardship, where isolation, inaccessibility, and the particular architecture of incarceration reinforced the dichotomy that exists between the jailed and the free, the powerless and the powerful. But what about its location mid-bay, in the shadow of the Golden Gate Bridge, and its proximity to the Headlands and the coastline? In the way that this place is beautiful, Ai's work, although of incarceration and subjugation, is too. Ai's work calls for the public to come, experience beauty in this place, transforming it temporarily from one historically associated with danger to a work of art; art is afforded from contradiction. The dualities were overwhelmingly manifest: a drop-dead beautiful waterfront setting versus incarceration, punishment and surveillance; the bridge as an elegant metaphor of movement and connection versus the prison as an equally powerful, stark metaphor of separation and sequestration; the temporality of Ai's art installation versus the reality of the prison as a final, inescapable destination for many of its occupants; innocence versus criminality; radical thought versus murder. The work illustrates the power of art in a place like Alcatraz; in context it becomes an invitation for a broad audience to visit and learn about this waterfront site and its many stories, and equally to experience that site differently, through the immersive lens of protest and the eyes of one of our time's most important dissident artists.

Mark di Suvero's immigration to San Francisco in 1941, via ocean liner through the Golden Gate, had a profound impact on him. He said of this arrival in this specific place, "That's where I came with my family from China as an immigrant. . . And we arrived, and there was the bridge. I still remember it. I was 7 years old." [2] The importance of seeing the bridge upon arrival manifested itself in large steel sculptures—as tall as 50 feet high and as wide as 40 feet—that were installed as part of SFMOMA's 2014 year-long exhibition at Crissy Field. Crissy Field was an already popular waterfront park, but *Mark di Suvero at Crissy Field* drew an entirely new audience to the northern edge where the city meets the bay. Di Suvero's series of eight sculptures established a scale for this landscape; as big as his work was, it was minimized by the vastness of this 26-acre former army landing strip. A visitor walking underneath and among these constructions may have marveled at their magnitude but then would consider them in relation to the magnitude of the bridge itself and to the land and ocean beyond. When di Suvero passed underneath the Golden Gate Bridge for the first time, after traveling the vast Pacific Ocean from China, did he experience a sense of the greatness of the sea compared to the bridge, compared to his human size? 'Come to the waterfront and reconsider this place,' the work calls to visitors. And to the

bridge, the work says, 'I and all my parts reference your materiality and are assembled just like you'. 'Let my steel frame and reframe a view you may or may not know'. Di Suvero asks that each individual piece be considered on its own and then as a part of the collective whole; he requires that they be understood as part of the landscape and as other than the landscape, as emerging vertically from the ground that previously was known as flat.

This place at the far point of San Francisco that lies between ocean and bay, at the edge of city and water, where built meets unbuilt, is nothing short of remarkable and di Suvero's exploration of scale here is not unlike Doug Hall's. So much of each work honors this bridge that is occupiable as a passageway, large and static, but enabling of travel and flow. The entities are so vast: land, sea, occupation, tides, and movement that scale as a topic cannot be avoided.

This was not di Suvero's first exhibit on a former military site. Di Suvero had been a fixture in the New York art scene for decades by 2011, at which time his work was exhibited on Governor's Island in an exhibition titled, *Mark di Suvero at Governors Island: Presented by Storm King Art Center.* The island had a rich history: it had been a trading post for Native Americans; a strategic strong hold for the British; the home of Fort Jay and Castle Williams which helped fortify the new nation's coastline; a prison for Confederate soldiers; a U.S. Army headquarters; the site of massive fill from the digging for the Lexington Avenue subway; a D-Day planning station during World War II; and a base for the U.S. Coast Guard for approximately 30 years.[3] So, by 1996, when the coast guard had left Governor's Island entirely, the place was a "spooky relic" with dozens of decommissioned military buildings as well as what was essentially a small, abandoned town haunted by this past. How did it then become the lively weekend destination with families, bike rentals, hammocks, a slide park? How did this decommissioned military site become a park with a Public Space Master Plan? There were designations from the New York City Landmarks Preservation Commission, as well as the establishment of Fort Jay and Castle Williams and the acres of land that surrounds them as the Governors Island National Monument, but art, as an invitation, bringing people to places from which they formerly were restricted,

Mark di Suvero at Crissy
Field, 2014 (SFMOMA)

"has assisted the makeover" and di Suvero's show there, in 2011, had been the most high-profile to date. [4]

There existed, then, the perfect symbiotic relationship: Governors Island provided the setting just right for di Suvero's rough, industrial components for it was in the early phases of development, not too manicured, and di Suvero's work, along with others, called people to it.

This is not the first time art has advocated for place. Recall Joel Sternfeld's photographs that portrayed the elevated railway in a manner that convinced people not only to work to save the structure but to transform it into the High Line.

Also sited on Governors Island was one of four installations comprising Olafur Eliasson's *The New York City Waterfalls* that opened in 2008, after a rigorous study of the shoreline and subsurface of the East River. These waterfalls, located on the north side of Governor's Island, between Brooklyn's Piers 4 and 5 near the Brooklyn Heights promenade, on Manhattan's Pier 35 north of the Manhattan Bridge, and directly below the Brooklyn Bridge on the Brooklyn side of the East River, all could be seen simultaneously, an ensemble of falling water in threshold sites.

The New York City Waterfalls, one of the most ambitious public art projects realized in the city, faced numerous technical challenges that had to do with the conditions of the substrate, which was unpredictable and littered with large debris such as cars and boats, the protection of ecosystems, and the negotiation of three underground subway tunnels that cross the East River near the points of Eliasson's interventions. Eliasson had to consider the effects wind, traffic, and noise would have on the waterfall experience

Olafur Eliasson, *New York City Waterfalls*, 2008

while he calculated how to offset the energy used to pump water 100 feet into the air.

These pieces were constructed with ordinary scaffolding technology used frequently in New York City construction and, in this way, were familiar to the public. Then, transforming preconceived notions of how water behaves, and the river, and how the tidal estuary that is the East River moves, the waterfalls contrast the relative stillness of the existing condition by creating a cascading, falling water system. The verticality of the falling water contrasts the ebb and flow, the back and forth to which New Yorkers are accustomed. Think of the link between the force that makes Eliasson's water fall and the force that makes the tides on the East River. Consider what is natural and what is artificial. The *Waterfalls* invited the public to come to the river and told people that the river belonged to them. Again, recall Whitman and consider his experience compared to the one Eliasson creates:

> Flow on, river! flow with the flood-tide, and ebb with the ebb-tide!
> Frolic on, crested and scallop-edg'd waves! [5]

It is probably no surprise that the 'other voice' has called me to move beyond San Francisco and New York. Continuing to experience art, and to use the lessons of artists toward the goal of becoming a more complete person, and toward the goal of being an informed designer, has involved travel and the investigation of other cities and cultures and their art, artists, buildings, and traditions. I am summoned to these places, and Michael often is my companion, and I am his when he responds to his other voice, collaborating with international dancers, composers, and visual artists.

Having just retired from a formal position as a design principal, I traveled to Rome to be a Resident at the American Academy, with Michael in tow. The Academy is set on the Gianicolo, a hill that provides sweeping views of the city and a hill whose history includes the 1849 effort on the part of Garibaldi and his army to defend the Roman Republic. Like the Vatican to the north, the Academy sits on the west side of the Tiber, so to visit many classical, Renaissance, and Baroque sites, I would descend the Gianicolo, and pass the Spanish Academy, thinking of Moneo and the two years he spent there as a young architect, then pass San Pietro in Montorio, Bramante's Tempietto, and continue on through the Trastevere district. I would take this route and cross the Tiber on the Ponte Sisto, the 15th-century pedestrian bridge in order to get to Campo di Fiori and Piazza Navona. I remember crossing the Tiber at this point for the first time and being shocked by its condition and also by how few people occupied its quayside walkways.

The River Tiber had been Rome's source of water, the driver of its commerce, and the locus of its industries, but it was also a destructive force, periodically inundating the city throughout its history. In response to the flood of 1870, and enabled by the sophisticated construction of reliable aqueducts to provide clean drinking water to the city, 13-meter-high embankment walls were constructed along the river as it passed through Rome, in essence separating the life of the city from the Tiber. Katharine Rinne says the following:

> With the construction of the walls…the Tiber, a mighty god who had refused
> to surrender to emperors and popes, finally capitulated to the engineers. A

palimpsest of twenty-six hundred years was erased, and along with it the
Tiber's role as the backbone of Rome's economy. The river, it is hoped, will
never escape again. While Rome is now protected from flooding, it is com-
pletely alienated from the Tiber, which had sustained, nourished, and terror-
ized the city since its infancy.[6]

The river now flows far below the city, and stairways down to river level occur and are used infrequently. The streets at city-level are particularly busy thoroughfares and somehow this busyness, this constant stream of traffic, reinforces the disconnect between city life and river life. As Rinne points out in the passage above, this drastic vertical separation of city and river acts to sever ties with the city's past, reducing stories of a natural, flowing body of water to myth.

William Kentridge's *Triumphs and Laments*, sponsored by Treveterno, the ongoing multidisciplinary cultural project dedicated to reviving the forgotten Tiber through multimedia art interventions, opened in 2016. This work is composed of two parts, the first of which is eighty 10-meter high figures derived from Roman history that are etched on the western wall of the Tiber, and the second was the live performance of an opera titled, *Triumphs and Laments*. The figures, created by erasing the soot and grime that had collected on the walls over time, are not depicted in chronological order, nor do they adhere to a particular storyline, but instead suggest a reinterpretation of historical events in favor of memory. This structured rewriting of history allows for the juxtaposition of events of the distant past and those of more recent times. The distinct technique involved in making these images renders them ephemeral for they will fade as the atmosphere in Rome returns soot and grime to the wall. Also impermanent is the other part of this art piece; the opera with actors, musicians, and puppets was performed only two nights, with the Tiber as the foreground and Kentridge's images as the backdrop.

William Kentridge,
Triumphs and Laments,
2016

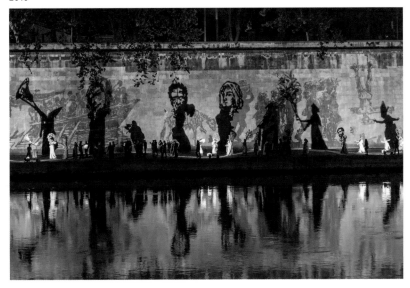

Kentridge's piece relies on site and the history of the site, and on time and the effects of time, and on atmosphere. Like other Treveterno events, *Triumphs and Laments* exists here because Rome turned its back on the Tiber. The work intentionally brought an audience to the river's edge and required this audience to question why the walls were built and to recall the river that once was physically and culturally integral to the city. It was only in the erasure of matter from the surface of the walls that two-thousand years of stories of Rome were revealed.

Michael and I have responded to the call of the other voice to go beyond San Francisco, New York, and Europe. In 2009, we traveled with Margaret Jenkins, a choreographer with whom Michael has collaborated for over 40 years, to Japan. Michael had been invited to participate in a poetry and dance festival in Tokyo and he, in turn, brought Margy and some of her dancers to perform. We then went to Kyoto so that Michael could be filmed for a Japanese television program, and from there, by train and ferry to Naoshima, in the Seto Inland Sea.

We stayed on this art island at Tadao Ando's Benesse House Museum that is perched on high ground above the sea where nature, art, and architecture coexist. Here, art is located in the building and throughout the seaside and forested landscape. Displayed on the tall concrete walls of the outdoor terrace are 12 black-and-white Sugimoto photographs titled *Time Exposed*. This terrace is like a gallery, but it is open to the sky and its concrete walls do not entirely enclose its space. Sugimoto's ocean horizons line up perfectly with each other, and the rhythm they create only is interrupted when the opening in the concrete walls occurs and the real horizon is revealed.

While the art at the Benesse House Museum and the building itself relate to their specific landscape with the utmost intention, Sugimoto's work is

Hiroshi Sugimoto, *Time Exposed*, 1980–1997

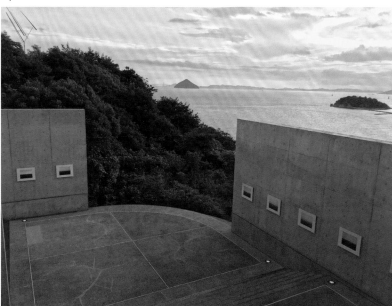

simultaneously every-place and no-place. Who could know the locations of these abstractions? The project in this setting is about both the specificity of place and the universality of the ocean. There is the landscape of this island where the sea is undeniable, present as it relates to the building and to the art of the place, including the *Time Exposed* photographs. The landscape in Sugimoto's photos, on the other hand, presents an anonymity of place for there is so little difference from one to the next, revealing only slight variations in the tone of water and sky. Sugimoto is asking if reality exists in his representations or if it exists where the terrace walls are left open, and the Seto Inland Sea is visible.

Ando's terrace would not be what it is without Sugimoto's photographs. Visitors to the place would ask a different set of questions and engage in a different experience. Here the art is the living entity that moves in built form for Sugimoto's perfectly framed and exhibited pieces are exposed to all of the elements of that seaside site, changing over time with this exposure. And so I am left wondering, as I write this, how *Time Exposed* has changed and therefore how the space has been transformed in the ten years since I have been there.

Notes

1. Joanna Sheers Seidenstein, "Inglorious Histories: Turner's Ancient Ports," in *Turner's Modern and Ancient Ports: Passages through Time* (New Haven: Yale University Press, 2017), 121.

2. "Renzo Piano," *Interview Magazine* (blog), May 12, 2015, https://www.interviewmagazine.com/art/renzo-piano.

3. "The Hills," Governors Island, accessed January 17, 2020, https://govisland.com/the-park.

4. Karen Rosenberg, "Soaring Nods to Industry, Camping on an Island for the Summer," The *New York Times*, June 2, 2011, sec. Arts, https://www.nytimes.com/2011/06/03/arts/design/mark-di-suvero-at-governors-island-review.html.

5. "Crossing Brooklyn Ferry, *Leaves of Grass*, 1867, The Walt Whitman Archive," accessed January 17, 2020, https://whitmanarchive.org/published/LG/1867/poems/76.

6. Katherine Wentworth Rinne, *The Waters of Rome: Aqueducts, Fountains, and the Birth of the Baroque City*, 1st ed. (New Haven: Yale University Press, 2010), 37.

Strategy

The past, work, culture, and art of the waterfront, which are explored in the first section of this book, provide a rich foundation to inspire thoughtful interventions that comprehensively engage place and possess agendas larger than themselves. This second section of *Occupation:Boundary* considers a corollary question: What are the tools employed by designers who occupy the boundary space between sea and city? My practice has been informed by all the history described in Past; the economies of the waterfront and their fluctuating worth as defined by our capitalist pursuits in Work; the complicated, dual role water has played in Culture and our consciousness; and the work presented in Art, as it has moved from depicting the threshold between land and sea to existing in it. A careful study of the work by my colleagues in architecture and landscape architecture, as they emerge with innovations at the waterfront, led me to believe that they have been enlightened by similar research. Measured reflections on the performative qualities of my colleagues' interventions, based on the topics earlier explored, are structured in this section by the establishment of four corresponding parts: Interpret, Invite, Rethink, and Transform.

Interpret considers the role of site history and exhibits projects where design ideas have been generated through the investigation and knowledge of a site's past. Invite explores how the establishment, in recent years, of cultural institutions at the water's edge has brought people to occupy this land that was once the site of industry and work and then left vacant. Acknowledging that water plays a sometimes-contradictory role in cultural traditions, and in our consciousness, Rethink puts forth the idea that all design done at the waterfront must engage the contemporary climate crisis. And finally, in the same way that art can change the space in which it appears, architectural interventions, at the scale of a building or the city, Transform the postindustrial landscape.

Here in Strategy, the themes and structure of Archive are sustained and activated through the design methods of my colleagues. While this framework exists as a tool to facilitate the discussion of what informs the design process at the critical boundary between the city and sea, the thoughtful designer simultaneously engages all of these strategies.

Interpret

The site was a palimpsest, as
was all the city, written, erased,
rewritten. . . Generations rushed
through the eye of the needle, and I,
one of the still legible crowd, entered
the subway.[1]
— Teju Cole

Does there exist anywhere on earth, a site
rural or urban or suburban that has not been
written, erased, and rewritten? The exploration
of the unexplored, the mapping of the unmapped is
what drives Americans and is what is at the heart of
the nation's Expansionist values. Think of the settlement
of New York; the move farther and farther west, past the
Mississippi River and through the Great Plains; the Gold
Rush and the settlement of San Francisco. Consider the coun-
try's colonies and the 1960s race to the moon. There is a pride
associated with being first, as though nothing before had existed
in that place: neither plants, nor soil, nor climate, nor other animals
or humans, as though all the past has been removed.

It should be common knowledge, at this point, that Henry Hudson and
the colonists were, in fact, not the first humans to settle and inhabit what
would become New York City, and that life existed in what would become
San Francisco before the Spanish and the Franciscan priests and their
Missions. By the same logic, the idea of virgin land is a myth and the pursuit
of it an outdated one that amounts to nothing more than a fool's errand. And
if there is no virgin land, what is, in fact, the history of our land?

Why is the past significant as a point of beginning for design? Forward-
thinking designers of my generation may have chosen to investigate the
site, looking for clues to interpret and a story to tell. But practitioners of
the present day do not have an option. They do not have the luxury to turn
their backs on the past. They cannot start from scratch, catering exclusively
to formal impulses, for it is they who bear the responsibility of years of
aggressive human intervention on the land. Their world is a post-industrial
one of polluted waters, soil, and air. The story of the land, including its nat-
ural history, and the history of its settlement and development is one that
needs to be told. History may be unavoidable, but it simultaneously provides
designers with something important to say. For what the past holds is a
complex intertwining of cultural values, a constant back and forth between
human interest and what existed before them. What emerges from this back
and forth, this balance of power, this struggle, is the richest of narratives.

Understanding that the natural world and the human world are bound is
what is at the heart of modern ecology. Working at virtually the same time
as Rachel Carson, who used terms such as "interrelationships" and "inter-
dependence," was Eugene Odum, who pioneered the holistic view that the

universe is composed of "biotic communities and their abiotic environment interacting with each other."[2] If "human society and nonhuman nature make up a single interactive system,"[3] then humans and their actions, that is the world they create or destroy, all fall within these parameters of ecosystem and ecology. Ecology is synonymous with neither nature nor environmentalism, for modern ecology, with Odum's emphasis on the whole, incorporates social responsibility into its meaning.

To that end, Kate Orff, in her book *Toward an Urban Ecology*, says that ecology "has exceeded the purview of the nonhuman to describe relationships and interactions between organisms and their constructed environment to include people, institutions, and even governance."[4] Decades before this declaration, however, Robert Smithson's writing and built work, such as *Spiral Jetty*, which marks the point where land and water meet and speaks to the vastness of nature and the ephemerality of art, questioned whether human life and nature were mutually exclusive entities and compared manmade interventions on the land to those, such as earthquakes, created by natural forces. For him, there was the "dialectical landscape"[5] where humans and land (and thereby nature) were always fused.

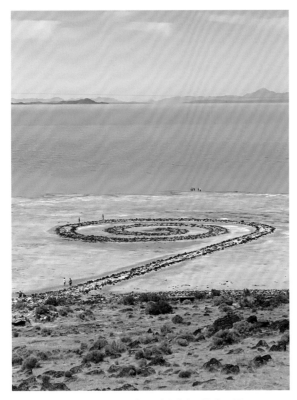

Robert Smithson, *Spiral Jetty*, Great Salt Lake, Utah, 1970

And there is JB Jackson, whose *Landscape* magazine bore the tagline "Human Geography is the Study of the Earth's Surface as Modified by Man the Inhabitant."[6] His concern was with not with protecting a nature too sacred for human life; nor did his concern have to do with establishing harmony between the human world and the natural world. In fact, in Jackson's seminal work, *A Sense of Place, A Sense of Time*, he refers to the "radical environmentalists"[7] and writes, "I have no great liking for wilderness and

forest."[8] His was a pursuit of the ordinary landscape, one where the vernacular takes on significance. Jackson's landscape includes mobile homes, trucks, and cars, and in *A Sense of Place, A Sense of Time* he even has a chapter called, "Roads Belong in the Landscape." A purist and an idealist, he was not. Jackson's message was that "landscape is a historic document that tells a story—actually, multiple stories—about the people who created the landscape and the cultural context in which that landscape was embedded."[9]

Human intervention and its visible and invisible byproducts are undeniable components of the contemporary world. The iconic smokestacks that line the New Jersey Turnpike at the ports of Elizabeth and Newark, where the water, soil, and air are notoriously polluted, mark this region's history as do the acres and acres of concrete, shipping containers, trucks, and railcars of the Port of Oakland. The asphalt highways that were financed by Eisenhower, authored by Moses, and admonished by Mumford are part of the nation's cultural landscape and ecology along with all the engineered waterways, culverts, manholes and other infrastructure associated with them.

Concrete beds, LA River

Consider the LA River, where little water flows during most of the year. Are its concrete beds natural? Are they part of the landscape? What about its banks lined with chain-link fence and barbed wire? Are these elements part of the region's ecology? Does this unnatural feature have a past? The current state of the river and its reputation undermine the role it played in the development of Southern California. "Three centuries ago, the river meandered this way and that through a dense forest of willow and sycamore, elderberry and wild grape. Its overflow filled vast marshlands that were home to myriad waterfront and small animals. . . So lush was this landscape and so unusual was it in the dry country that the river was the focus of settlement long before the first white man set foot in the area."[10] Settlers to the area established an agricultural village dependent on the river that would become the city of Los Angeles. It once flowed west rather than south, and its overflow formed marshlands in Hollywood and Beverly Hills. The author of *The Los Angeles River: Its Life, Death, and Possible Rebirth (Creating the North American Landscape)*, Blake Gumprecht, says: "In a city that is too often considered not to have a history, my realization that the river had a meaningful past was somehow reassuring."[11] But what a history! What a past! All that made Los Angeles, its source of life and settlement and food, is embedded in concrete. And the concrete is part of its story.

Are the Earth's extents significant enough, vast enough, wide enough that there are reaches unattainable by human networks? Are there places that human influence has not reached? The notion that that which is manmade and that which is natural are to be considered simultaneously might have overwhelmed those for whom purity in nature was part of the American or spiritual consciousness.

Nature, Ralph Waldo Emerson's best-known work that may have been read by Thoreau, or possibly even Fitz Hugh Lane, lays the groundwork for Transcendentalism in its argument that nature is a divine entity we can know directly. He writes that "Nature, in the common sense, refers to essences unchanged by man; space, the air, the river, the leaf. Art is applied to the mixture of his will with the same things, as in a house, a canal, a statue, a picture."[12] Emerson's description of nature is timeless, and his perception of human intervention on the earth is hopeful and one to which designers and architects and thoughtful place-makers aspire.

A pure nature, untouched by humans, a wilderness, and wild places were essential to the soul of John Muir. He wrote, "In God's wildness lies the hope of the world — the great fresh unblighted, unredeemed wilderness."[13] He was in search of the frontier for spiritual transcendence, not for conquest. He calls fellow mortals: "Come to the woods, for here is rest. Sleep in forgetfulness of all ill."[14] He was not an explorer in the same sense that the colonists were, and as such, his desire was not to be first, but rather, it was to be only; he found strength in solitude rather than in dominance. The nature he required had to be untainted, so much so that he rejected conservation, that is, using natural resources responsibly as a means of benefitting society, as compared to preserving natural lands for the spiritual qualities inherent in them.[15]

In the effort of preservation, Muir championed protecting Yosemite by establishing it as a National Park. In 1890, he published two seminal articles: *The Treasures of the Yosemite* and *Features of the Proposed National Park*. Wallace Stegner would chime in on the institution of national parks decades later saying, famously, "National parks are the best idea we ever had. Absolutely American, absolutely democratic, they reflect us at our best rather than our worst." Stegner sought to protect Muir's wilderness in his *1960 Wilderness Letter* in which he urged the federal protection of these places. Poor Wallace Stegner, whose life in the West was witness to the radical shifts of the 20th century, from "an agrarian to a high-tech economy."[16]

What story does the land tell about farming? Wendell Berry depicts an old-fashioned ideal of the farmer as a nurturer whose goal was the health of his land, himself, his family, his community, and then outlines how far from this ideal the farmer, controlled by the interests of agribusiness, has wandered. What exists now is a condition where the ownership of farmland is held by fewer and fewer people and where specialization in farming has led to the abandonment of the "ancient, proven principles of agricultural diversity . . . with its attendant principles of mixed husbandry of plants and animals and crop rotation."[17] He describes a disconnect between the consumer who purchases his food and the land; a disconnect that has resulted in abundant, institutionalized waste of food, as the consumer is less thrifty in his ignorance about production; waste by way of excessive food packaging;

Theodore Roosevelt and John Muir, Yosemite National Park, 1903

as well as wastes in topsoil, water, fossil fuel, and human energy.[18] And this without mentioning the loss of community and farming culture that had been central to the American character.

It has long been known that farming leaves its physical marks on the land. John Muir understood the damage it could do, and that was at a time that preceded the role farming now plays in the larger industrial complex. Agriculture, along with other development, has destroyed millions of acres of American wetlands. Chemicals, such as fertilizers and pesticides, that have been used in agricultural practice have led to the contamination of soil and water so that today, farms are among the top polluters of our waterways.[19]

Just as it is hard to imagine that there exists land beyond the vast network of human influence, where the human experience has not been incorporated as part of the history of a place, it similarly is hard to imagine that a site could be wiped clean so that anything that follows is detached from the past. Chicago's Great Fire of 1871 is given credit for creating a blank slate where American Modernism had the opportunity to take hold. Ross Miller, in his book, *The Great Chicago Fire*, writes, "The Puritan's tabula rasa was simply projected onto Chicago's cooling ashes."[20] How can something be built from nothing? Hadn't there been Native Americans whose lives were interrupted by European colonists and missionaries? Hadn't the place grown along with the railroad and at least in part because of its advantageous access to the Mississippi River and the Great Lakes? Was evidence of this growth not buried in the ruins of Chicago's landscape? Did its people have no memory?

The course of architecture in Chicago following this clearing of the slate was one of progress and retreat, and the Beaux Arts style World's Columbian Exhibition of 1892–93 was evidence of this regression. So confused were the planners of the World's Fair that they nostalgically returned to a past that was not even their own. Was it merely a coincidence or merely a reflection of what was popular at the time that, following the 1906 earthquake and fire, San Francisco's Civic Center and City Hall were rebuilt in the same Beaux Arts style? Or does catastrophe distort a community's sense of its past?

The existential condition dictates that every place has a history that cannot be erased even if that history is one of devastation or annihilation. And to the degree that it is futile to try to stop time and history, there are the lines in Michael's poem, "Una Noche:"

"You cannot stop time
But you can smash all the clocks." [21]

The idea of palimpsest, which literally is a manuscript that has been written and rewritten with erased layers still visible, as it applies to design, has been part of architectural discourse for decades at this point and is a frequent metaphor for considering site. Armed with this as a tool, the past, including the natural history of a site, and its culture, that is, how it was settled and developed, how it rose and fell, becomes embedded in the present. The past is particularly immediate in the boundary between land and sea, where the stories of both geographies shift and overlap.

James Corner in *The Landscape Imagination* writes, "A close reading of a particular site's attributes—its history, its various representation, its context, and its potentials—conspires to inform a new project that is in some way an intensification and enrichment of place. Every site is an accumulation of local forces over time. . . any significant design response must in some way interpret, extend, and amplify this potential within its specific context." [22] As interpreters of site, designers study this accumulation of forces. We want to know which natural ones made the land. What is the natural history? We ask: what is the morphology of the site? What are the physical layers that lie beneath the ground? Where is bedrock? Where is the water table? Where is the source of water, and where does it go? What is visible to us and what is concealed.

We consider manmade forces. We try to understand the spatial structure and character of sites in the contexts of their cities and regions by examining patterns and processes of development. What are the remnants of the built environment, and what stories do they tell? Are there pilings in the water? What type of structure did they support? Is there a concrete slab? Are there railroad tracks? Is there cobblestone? We want to investigate all that has happened. How has the land been used and worked? Has it been farmed? Has it been home to industry? Has it been host to a military presence? Is the soil polluted? Is the water polluted?

And at the water's edge, we interrogate the line that divides land and sea. We want to know if the line has shifted over time. Or if it has become a thicker threshold that negotiates the overlap of the manmade world and the natural world. What can we read in this mutable boundary?

Richard Haag said the following about his approach to site: "When I get a new site, I always want to know, figure out, what is the most sacred thing about this site?" Specifically, regarding Gas Works Park, which was surrounded by water, he describes the shoreline and the "buildings" and "towers" that existed there and which he would "go down to the wire to save."[23] The water surrounding the site was a polluted Lake Union, and the structures were industrial ruins of a plant that had long manufactured gas for the city and had long been the source of soil, water, and air pollution. [24]

Would Haag have been right in turning his back on the site's industrial past? Moving forward, should he have tried to wipe the slate clean, removing the structures to start from scratch? Is it ever possible to start completely anew? Rather, Haag "haunted the buildings and let the spirit of the place enjoin" him. He says, "I began seeing what I liked, then I liked what I saw — new eyes for old. Permanent oil slicks became plain without croppings of concrete, industrial middens were drumlins, the towers were ferro-forests, and the brooding presence became the most sacred of symbols. I accepted these gifts, and decided to absolve the community's vindictive feels towards the gas plant."[25]

I travel to Seattle four times a year to serve as a member of the Architectural Commission at the University of Washington, and it was one of these trips that I first visited Gas Works Park. Haag had been committed to repurposing this industrial site, and to interpreting the site's past in his park design. He was committed to providing a place, and it had to be this specific place, where people could look out to the water and city. As I write this, I realize that his approach to preserve industrial artifacts seems normal or even obvious to those practicing in the design fields today. But in the 1970s, it was radical.

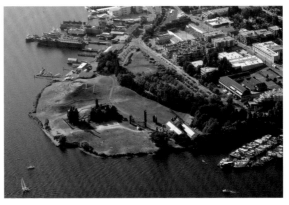

Gas Works Park, Seattle, designed by Richard Haag, 1971–75

That first visit took place on an overcast day in March, which gave the park, with its structures of a past time, a foreboding feeling, and I recognized the "brooding presence" Haag described. Linda Jewell, a landscape architect, and fellow commissioner, who had been close friends with Haag, was with me, and I remember arriving at the parking lot by cab and that a dense bosque hid the park. We passed through these trees to enter a landscape where there were few visitors besides ourselves. Haag's artifacts dominated my initial attention, but then there was also the obvious connection one felt to the water, with Lake Union in the foreground of the view to

the city. And there was the topography, the dynamic, undulating landforms with pathways and moments to rest. The park wanted to be occupied, its moments hidden, waiting to be discovered. I started to think of the way I moved through the site, and of the choreography of this vast space as being analogous to Haag's design approach. He managed the natural processes of the site, that is, the presence of water both visible and invisible, by circumstance or by intention, and he managed the dangerous industrial remains, which were artifacts that could not help but be visible, and the site's polluted water and soil, which were less visible. There is concealment here and control, more than one might think at first glance. And I wondered, on my second visit to the park, on a beautiful June day, if the people strolling and sunbathing knew of this concealment.

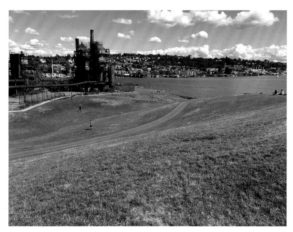

Topography containing contaminated toxic soil, Gas Works Park, Seattle

In her essay "Seized by Sublime Sentiments," Elizabeth K. Meyer relates Gas Works Park to another Haag project, Bloedel Reserve, for among the elements they have in common is "the pervasive flow of water through them."[26] The nature of these sites and the nature of their pasts have a particular link to natural hydrology.

Gas Works Park on Lake Union connects it horizontally via canals to both Puget Sound and Lake Washington. Its proximity to the lake also connects it vertically to the water table located close to the ground surface. This high water table has made the soil's toxic content even more problematic. Although it appears to be a dry, sculptured land form, the earth at Gas Works is watery, seeping, flowing—more aqueous solution than solid matter. The Bloedel Reserve is also a watery world. The high water table there is present every step on the ground—yielding, spongy, oozing with moisture. The ubiquitous presence of water at Bloedel—in the moss garden's earth folds that capture it in trickles and puddles, in the reflection garden where the water table is simultaneously contained and released through the excavation of a long, narrow basin, and in the bird marsh where dark, clear water is both habitat and mirror to the sky—challenges the visitor's conception of ground as solid earth.[27]

The very creation and existence of each of these parks represents yet another intervention on sites that previously have been altered by humans. The comprehensive history of both, up to and including Haag's work and

their access by the public, tells the story of human occupation of the natural world where water is present to varying degrees and capacities.

While the structures maintained at Gas Works are obvious, monumental reminders of the site's past, the evidence of 19th-century industry and human intervention at Bloedel may seem more understated. Here, tree stumps and trees scarred from logging are the relics, and they exist among the newer forest growth. The substory has been cleared selectively to reveal and highlight the plant combinations and textures. This, which Haag reveals, may have existed naturally, but the visitor is unsure and left to contemplate what is real nature and what is manicured. When the old and new, and nature and manipulated nature are side-by-side, there is an implied sense of the passage of time.

Moss Garden, Bloedel Reserve, designed by Richard Haag,
Bainbridge Island, Washington, 1983

I was moved by the markers of the exploitation, but even more moved by the restraint Haag demonstrated. Haag must have possessed an immense confidence, for he did not approach Bloedel to dominate it. Instead, he narrated nature's process and drawing from what had been ruined; he created new places for occupation by people, plants, and wildlife. In his subtle way, Haag did extensive work at Bloedel, designing the Moss Garden, the Garden of Planes, the bird refuge with its islands, and adding to Thomas Church's original Reflection Garden.

When I visited Bloedel, I was again with Linda Jewell but also with other people from the Commission, including Thaïsa Way, who since has published a monograph on Haag. Both narrated the visit with stories of Haag's process and even described how he himself drove bulldozers and earth-movers in order to shape the land just as he wanted.

We walked together through each of Haag's garden rooms, observing what was sacred in each. There was something particularly sentimental about the Reflection Garden where Thomas Church had installed a rectangular pool in a clearing until Haag intervened, wrapping three sides with dark coniferous trees. Now the pool, as an act of artifice, stands with nature manipulated around it. This is also a type of passage of time—one artist intervening on his predecessor's work. We walked through what once had been Haag's Garden of Planes, a geometric composition with carefully molded and shaped gravel

forms and few plants, and lamented that it had been considered too radical and was replaced. We walked through spaces where water is hidden and where it pools, where it drips and where it flows, until we got to the original Bloedel house, where the Puget Sound opened before us reassuring that we were, in fact, on an island, and that the Bloedel Reserve was, in fact, a place of water.

Reflection Pool, Bloedel Reserve, Richard Haag modification of the design by Thomas Church, 1970, Bainbridge Island, Washington

Garden of Planes (demolished), Bloedel Reserve, Bainbridge Island, Washington

For 12 years, in the 1990s and early 2000s, I was a member of the Board of Trustees of the Golden Gate National Parks Conservancy. This was an important time for the organization in terms of both defining its long-term mission and taking on ever-larger projects. After the transfer of the Presidio to the National Park Service in October 1994, a portion of the future park was allocated to the Parks Conservancy to steward. This area included Crissy Field, on the northern bayfront shoreline, just east of the Golden Gate Bridge. At the time, Crissy Field, which had been named for a historical grass airfield that once occupied part of the site, was almost entirely paved and was home to a series of single-story, dilapidated, and unoccupied buildings. But the Conservancy recognized the potential in this 130-acre waterfront site. There was potential in repurposing this place that had a long history. There had been a tidal marsh on this land that, in 1915, was filled to create a racetrack, then converted to become the Crissy Field grass airfield, the first of its kind on the West Coast, only to be covered again by asphalt and

concrete. It had been a military installation occupied by Spanish, Mexican, and American forces, from 1776 when the Spanish built the Presidio, until 1994 when it was closed as part of the larger process of decommissioning military bases throughout the country. The military had left behind a site with severely polluted soil and groundwater. But when the decommissioning was complete, the military presence gone, what also was left behind was a vast, mostly open landscape at the northern edge of San Francisco. Therein laid the potential.

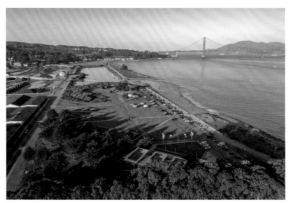

Crissy Field, designed by Hargreaves Associates, San Francisco, 2001

I was the only architect on the Board of Trustees and served as its design critic as we moved toward making this place—this city edge—accessible to the public. We hired Hargreaves Associates and together with that firm embarked on outreach to and workshops with multiple stakeholders, including dog walkers, sailboarders, bike riders, runners, birders, and historic preservationists, who all previously had gained informal access to the site. This interaction with the community was so extensive, the constituents so impassioned to hold on to their access to the water, that it overlapped with the rigorous design process that followed.

George Hargreaves says that his firm "has never seen a greenfield or 'natural' site for its work," and goes on to say, "Our sites are brownfields, often flat, devoid of any significant vegetation or other natural features, yet close to city centers."[28] In their approach to design, and in opposition to the formal concerns of Modern landscape architecture, George Hargreaves, along with partner Mary Margaret Jones, looked to the site histories, ecological processes, and phenomena, to construct a design narrative.[29]

For the central part of Crissy Field, Hargreaves Associates came up with two alternatives, the first of which was a 'dune project' that would feature the kind of dunescape geometric mounds and linear tree planting George loved to design in those days. The second, which spoke to the site's past, featured a large tidal lagoon intended to recall the wetland and marsh that had been the outflow of El Polin Spring, one of the two important natural water sources in the Presidio that had characterized the landscape before 1870, when it was occupied by the military and by industry.

I came to the project having spent my summers in Martha's Vineyard, where the ocean facing south shore is characterized by barrier beaches and often

by tidal ponds. I knew the particular beauty that exists when the sometimes unpredictable and turbulent and sometimes rhythmic ocean is contrasted with the tranquil, still waters of the ponds. I knew of the color of dark sea compared to the lighter, shallow water. For me, there was power in referring back to a past when the distinction between the ocean and the water systems on land was not so clear; where the line between the two meandered back and forth, making a blurry, thickened water edge of San Francisco.

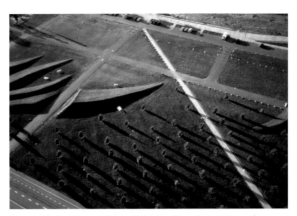

Geometric dunescape, Crissy Field, San Francisco, 2001

There was a particular meeting of the Board of Trustees of the Golden Gate National Parks Conservancy where I was in a position to make a compelling case for the 'tidal lagoon' scheme, despite the fact that an early cost estimate revealed it would be more expensive. I was able to tell my story about Martha's Vineyard and the poetics of walking between the constant movement of the ocean and the frequent staticity of tide ponds: the infinite and boundless compared to the definitive and comprehensible. So, my past gave me the voice to advocate for the site's past.

Hargreaves' approach at Crissy Field involved the re-creation of the site's conditions and the establishment of 'juxtapositions of the adjacent,' where a highly programmed space and a natural system were put in physical proximity in order to heighten the experience and awareness of both environments.[30] Earthwork on the site was central to achieving these adjacencies as well as to creating a landscape that references the past. Manmade topography, in addition to hidden fences, has allowed for the restoration of tidal marshland to occur next to active recreation sites. What's more is that fill from the excavation for the lagoon was used to make the airfield simulacrum; the grade change between these two features creates a tacit boundary that allows the former to thrive.

In the distinction between spaces, there is no attempt to synthesize the disparate interests of multiple constituents. There is picnicking on the West Bluff where the parkland narrows and where there exist remnant docks and part of a former seawall, a place for sailboarders on the East Beach, and spaces for passive recreation. There is the tidal lagoon that references a natural condition and the recreated airfield that is a nod to the site's human occupation. What exists among the multiple and diverse site features, program, and ecological communities, is the promenade that offers views to the San Francisco Bay and the San Francisco skyline.

Tidal lagoon at Crissy Field, San Francisco, 2001

While I continued at the Parks Conservancy and helped with other aspects of projects, I believe my most meaningful contribution to be advocating for the lagoon scheme, for what emerged, with that feature as central, was not an attempt to replicate nature, nor was it an attempt to conceal traces of military and industrial use. Instead, it is a place integral to the contemporary urban experience, where present-day users, along with the natural history of the site, and its history of human occupation together comprise the narrative.

I first heard Moneo lecture on the Kursaal in the early 2000s, as part of a series sponsored by AIA San Francisco and the San Francisco Museum of Modern Art. Moneo, a few years earlier, had completed the Davis Museum at Wellesley, a project for which I had been interviewed as a potential designer. I knew the site of rolling hills that had been created by glacier activity well, of course, and I knew that Wellesley's long tradition of campus planning had more to do with celebrating this natural history than with imposing Beaux Arts quadrangles upon it like so many New England institutions do. Moneo's Davis Museum is sited beautifully in the landscape and is positioned so that it is in constant dialogue with Paul Rudolph's Jewett Arts Center, a building that has been so important to me in many ways. But the Kursaal is different.

I admired it from afar until 2009, when I was invited to present my San Francisco waterfront work at a conference in San Sebastián on recovering port areas of cities, and took the opportunity to visit the project. I was lucky enough to do so with Ignacio Quemada, a local architect who had collaborated with Moneo on the Kursaal, particularly while it was in construction. We walked there from my hotel, the Maria Cristina, over the Urumea River through the streets of San Sebastián.

The Kursaal was extraordinary. We had just taken this walk and so I knew that the building had grown out of something other than the urban fabric of the city. I read the Kursaal to be of the waterfront, turning its back on San Sebastián, its two glass forms rotated to open and embrace the bay. Moneo himself considers these glass cubes to be rocks that reference Mount

Ulia and Mount Urgell,[31] which go back so much farther in time than the 19th-century buildings and city plan.

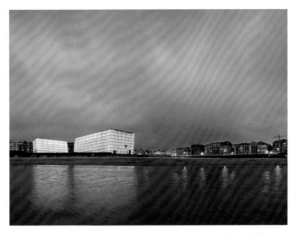

Kursaal Auditorium and Congress Center, designed by Rafael Moneo, San Sebastián, Spain, 1999

Is it fair to say that Moneo's volumes are part of the land rather than part of the city? Can they be of geological forces and hydrology if materially they seem to have nothing to do with the natural? I spent several hours exploring the exterior and interior of this building. There exist two 'glass masses' supported by steel structures, clad in double-layered, glass-paneled walls that house the auditorium and chamber hall.[32] The ribbed surface of the glass responds to the waves and marine light during the day and at night transform "dramatically into an alluring, mysterious light source."[33] These glass cubes sit atop a platform that houses exhibition halls, meeting rooms, rehearsal rooms, and service-type programs. There is ample interior space that is meant to be understood as public, and the warm, light-toned wood and broad staircase read as civic space. Select or limited views from the glass structures open up to the sea. The elevated position of the cubes is of paramount importance, resulting in residual spaces underneath them, in the podium. Outside, the perimeter walls, clad with random, unpatterned pieces of stone, that, again, reference site geology, partially enclose the waterfront plaza that ramps down quickly to a sandy beach.

If I stand at the water's edge and look back toward the city, there is beach in the foreground with Moneo's glass mountains in the distance. The beach-goers are casual and playful, but their play is short-lived for the tides will change and will cover the sand, driving the water right up to the manmade hard edge. The Kursaal will change too, albeit at a different pace. It will turn from an opaque mass at day to a glowing beacon at night, and the crowd at this point, at the edge of the city, at the mouth where two rivers meet the sea, will have been drawn inside to occupy the building. The harsh seafront conditions undoubtedly will begin to erode the cubes overtime, etching away at the formerly pristine glass just as these conditions would slowly erode rock.

The Kursaal could be nowhere else; it is tied to the mountains, the river, and the sea. It would not exist in the next town over or on the other side of the Urumea or one block farther from the water. It is a building about site that proves wrong any misconception that architecture is always associated

with the manmade, built environment. That misconception goes hand-in-hand with the idea that landscape architecture is associated exclusively with

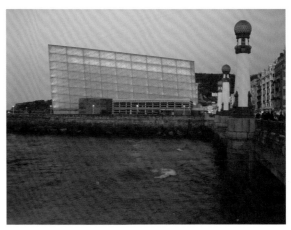

Cast glass façade, Kursaal Auditorium and Congress Center, San Sebastián, Spain

the pre-human, natural world. We know this to be untrue, too, for we look to Gas Works Park to see a project that speaks simultaneously to natural hydrology, and to 20th-century infrastructure. At Bloedel Reserve all that appears at first glance to be natural is really a story of human intervention. And what has been remade at Crissy Field references the natural history of the site along with the history of military and industry in that place. But the pursuit of the past is one that transcends the distinctions between the disciplines just as it transcends the distinctions between the natural world and the human world, demanding that they are interpreted as one system. The story, though, is on-going. For the building or landscape, being the manifestation of the interpreted past is simply one more episode in the accumulation of site truths.

Notes

1. Teju Cole, *Open City*, 1st ed. (New York: Random House, 2011), 59.

2. Betty Jean Craige, *Eugene Odum: Ecosystem Ecologist & Environmentalist* (London: University of Georgia Press, 2001), xii.

3. Craige, xiii.

4. Kate Orff, *Toward an Urban Ecology* (New York, New York: The Monacelli Press, 2016), 10.

5. Robert Smithson, *The Writings of Robert Smithson: Essays with Illustrations* (New York: New York University Press, 1979).

6. Marc Treib, "J.B. Jackson's Home Ground," *Landscape Architecture* 78, no. 3 (1988): 53.

7. John Brinckerhoff Jackson, *A Sense of Place, a Sense of Time* (New Haven: Yale University Press, 1994), vii.

8. Jackson, 95.

9. Peirce Lewis, "The Monument and the Bungalow: The Intellectual Legacy of J.B. Jackson," in *Everyday America*, ed. Chris Wilson and Paul Groth, 1st ed., Cultural Landscape Studies after J. B. Jackson (University of California Press, 2003), 86, https://www.jstor.org/stable/10.1525/j.ctt1ppdt3.11.

10. Blake Gumprecht, *The Los Angeles River: Its Life, Death, and Possible Rebirth*, Creating the North American Landscape (Baltimore: Johns Hopkins University Press, 1999), 2.

11. Gumprecht, 5.

12. Ralph Waldo Emerson, *The Annotated Emerson* (Cambridge, Mass: Belknap Press of Harvard University Press, 2012), 30.

13. John Muir, *John of the Mountains: The Unpublished Journals of John Muir* (Madison: University of Wisconsin Press, 1979), 317.

14. Muir, 235.

15. John M. Meyer, "Gifford Pinchot, John Muir, and the Boundaries of Politics in American Thought," *Polity* 30, no. 2 (1997): 267–84, https://doi.org/10.2307/3235219.

16. Philip L. Fradkin, *Wallace Stegner and the American West*, 1st ed. (New York: Alfred A. Knopf, 2008), 279.

17. Wendell Berry, *The Unsettling of America: Culture & Agriculture*, First Counterpoint edition. (Berkeley, CA: Counterpoint, 2015), 41.

18. Berry, 42.

19. "Water Pollution: Everything You Need to Know," n.d., https://www.nrdc.org/stories/water-pollution-everything-you-need-know#whatis.

20. Ross Miller, *American Apocalypse: The Great Fire and the Myth of Chicago* (Chicago: University of Chicago Press, 1990), 38.

21. Michael Palmer, *Company of Moths* (New York: New Directions Book, 2005), 57.

22. James Corner, *The Landscape Imagination: Collected Essays of James Corner, 1990–2010*, First edition. (New York: Princeton Architectural Press, 2014), 342.

23. As quoted by Thaïsa Way, *The Landscape Architecture of Richard Haag: From Modern Space to Urban Ecological Design* (London: University of Washington Press, 2015), 150.

24. Way, 147.

25. As quoted by Way, 150.

26. Elizabeth K. Meyer, *Richard Haag: Bloedel Reserve and Gas Works Park* (New York: Princeton Architectural Press with Harvard University Graduate School of Design, 1998), 6.

27. Meyer, 6–7.

28. George Hargreaves, *Hargreaves: The Alchemy of Landscape Architecture* (London: Thames & Hudson, 2009), 6.

29. Hargreaves, 6–8.

30. George Hargreaves, *Hargreaves: The Alchemy of Landscape Architecture* (London: Thames & Hudson, 2009), 6.

31. José Rafael Moneo, *Rafael Moneo: Remarks on 21 Works* (New York: Monacelli Press, 2010), 380.

32. Moneo, 381. Moneo refers to the "glass mass."

33. Moneo, 383.

Invite

This was the idea that a museum must be a place for people. If you are not a cultivated person, you will become one, because that's what art makes. Art makes a miracle. I'm not talking about artists; I'm talking about art. When you are in front of a piece of art, it's about the untold; it's about something almost mysterious. There is something coming out, something that causes you to dream or think in a different way. Art and beauty switches on a special light in your eyes. You think differently, almost meandering. This is why art makes people better. It makes people more curious, more demanding.
— Renzo Piano, Discussion between Renzo Piano and Mark di Suvero,
 May 12, 2015

For so long, the waterfront had been off-limits to people like me, people who grew up blocks from the water but were unable to go to its edge. In Manhattan in the 1940s, we were landlocked on an island. The waterfront was for work, industry, manufacturing, and production. It was for ships and railroads—a threshold through which products and people new to the nation passed. I had no business there. I was to go to Long Island or Cape Cod or Maine for my waterfront. I was to go to places where the city was not—where the grit produced by the overlap of the sea and city didn't exist.

What happened when this work left the city? Who said: 'The condition of the threshold has changed: Come back to the water!'? Allowing the space between sea and land to be occupied was difficult, for what existed when industry left the historic port was the infrastructure that had been built as a physical and cultural armature; it kept us from the water's edge. And so, the warehouses, piers, buildings, bulkheads, shipyards, and railroad tracks along with all the unnamed interstitial spaces that slip between these structures and features, and go unnoticed until they become part of an abandoned whole, existed at the edge, separated from the social systems of the city and its networks of activity.

Recall the paradoxes of water: It was used for work, that is, for industry at the city's edge, but also as a source of purification. It can be dangerous, and in its danger bestows upon us a sense of unparalleled thrill. It provides us with amazement and won- derment, with a sense of unboundedness and mystery. Is it possible to make new spaces at the edge, where the city meets the sea, that are accessible and acceptable to a contemporary public yet still possess all the wonderment and excitement of the unknown? What are the results of waterfront spaces where design is driven by prescribed factors that, for example, replicate rather than evoke the past, as though

history were a style? Where is the wonderment of these invitations to the waterfront? Where is the danger and the thrill? Where is the purity?

The industrial waterfronts of cities such as New York and San Francisco long had existed without the presence of cultural institutions. In the threshold between sea and land, many practices thrived: shipping, manufacturing, and production; the exchange of goods, people, language, culture, and ideas. But it was not home to art. That is until art institutions were strategically located in the threshold and called people to occupy this edge.

The Whitney Museum's move from uptown to downtown in New York tells the story of a city whose relationship to the waterfront has changed. It reveals something about how cultural attitudes and indicators of wealth have been transformed and how expectations of where and how art should be experienced have shifted. While during the post-World War II boom, wealthy New Yorkers may have moved outside of the city to the suburbs, the social elite upper class remained on New York's Upper East Side.[1] And it is in this context of social elitism that Breuer's Whitney was built on Madison at 75th Street, just east of the Museum Mile.

In "Breuer's Ancillary Strategy: Symbols, Signs, and Structures at the Intersection of Modernism and Postmodernism," Timothy M. Rohan argues that the 1966 Whitney and, in particular, its west facade and entry sequence, mediated between "the public life and commerce of the avenue and the enclosed, private, nonprofit world of high culture."[2] While the social elites may have resided on the Upper East Side, a newer generation of advertising and commerce occupied Madison Avenue for business; the Whitney would align itself distinctly with the former. The world of advertising could have International Style glass buildings that stepped back from the street per zoning, in the typical ziggurat style, for the Whitney would be other than that in both its materiality, its monumentality, and in its relationship to the street.

Met Breuer, formerly the Whitney Museum, designed by Marcel Breuer, 1966

Breuer's building was massive and perceived as aggressive and foreboding with the reversed ziggurat that made its dark granite structure seem to loom over Madison Avenue. What's more is that its entrance with a concrete bridge and a canopy that extends over the sidewalk acted as a tiny portal, a selective passageway through which only the few could journey. This building signified exclusivity and privacy, the separation of art from the life of the street and the city: an invitation to the public it was not. Breuer did not want the museum to "look like a business or office building, nor should it look like a place of light entertainment."[3] It was removed from anything common. It was more dignified than commerce, striving to establish itself and all it contained, as elite and removed from quotidian life of the city.

The story of the Whitney continues as its downtown building was opened in 2015 on the edge of New York City, just at the point where Gansevoort Street meets the West Side Highway. Renzo Piano was explicit in his intention to make a place where art and culture were accessible to the public; his building would be a civic institution, not "an elitist one."[4]

For whom is art made? Who is the audience? What shifts in culture have occurred and are evident in Piano's attitude compared to Breuer's? What shifts have occurred that resulted in the museum's move downtown?

In 1900, 250 slaughterhouses and packing plants operated in the Meatpacking District, as did the elevated freight rail that was part of the 1929 West Side Improvement Plan. By the early 2000s, before the 2015 Whitney was built and before the High Line opened its first segment in 2009, the Meatpacking

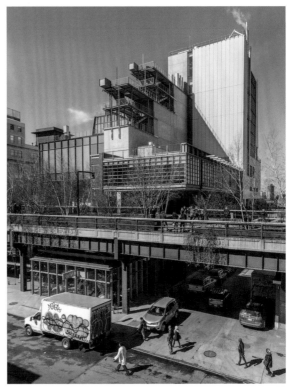

Whitney Museum, designed by Renzo Piano Workshop in collaboration with Cooper Robertson, New York, 2015

District already had become one of New York's most fashionable neighbor-hoods. But fashionable is not synonymous with elite, and the selection of the site was deliberate. Piano states: we "chose the space between the High Line, the urban park created on a disused spur of the New York Central Railroad that has become the city's biggest tourist attraction in recent years, and the expressway that runs along the Hudson."[5] The site is activated by all that is not exclusive; it is subjected to a public presence and squeezed by infrastructure. It is confined in a wedge by multiple lanes of movement: the Hudson's up-and-down tidal flow; the West Side Highway's consistent traffic; the New York Central Railroad's movement of cargo in the past and the High Line's movement of people in the present.

Whereas there was no exterior public space at the street associated with the uptown museum, the downtown Whitney calls to visitors and in its companion relationship to the High Line, acts more like a public park in its beckoning than like a cultural institution of previous decades. There is no portal-like entry here. Merely follow the Gansevoort Street sidewalk toward the water and resist the downward slope to end up in Piano's outdoor lobby, tucked neatly underneath the overhead structure. It is as if Piano is responding to and then extending the underside of the High Line, recog-nizing the experience of that place at street level. Piano says: ". . . visitors will see through the building entrance and the large windows on the west side to the Hudson River beyond. Here, all at once, you have the water, the park, the powerful industrial structures and the exciting mix of people, brought together and focused by this new building and the experience of art."[6]

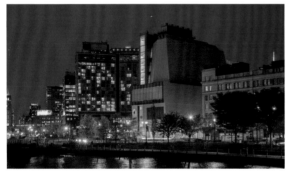

Whitney Museum at night, New York

Once inside, there exist exhibition spaces and terraces that face east, toward the High Line. From these spaces the building calls: 'Come closer! Come closer to the edge of the water. Occupy this space. You weren't wel-comed here for so long. But now you are invited to bring all the life you can to know the art that fills these walls.' The building's bulk leans to the west, and double-height windows of the third level open over the pier that will soon be converted to a park designed by James Corner of Field Operations and will include an artwork by David Hammons titled *Day's End*. This thin steel post frame of the Hammons' piece recalls the industrial structure that was edited by Gordon Matta-Clark in 1975 and torn down to make way for the Hudson River Park. The art at Piano's Whitney, including *Day's End* that will extend into the water from Pier 52, calls across the Hudson to New Jersey. It calls past Hoboken and past Jersey City until its invitation reaches

the industrial port that moved there, abandoning Manhattan's waterfront in the preceding decades, as if to say 'Come back! Do you recognize me now?'

David Hammons, *Day's End*, 2017

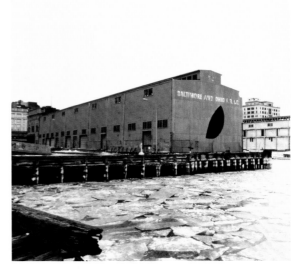

Gordon Matta-Clark, *Day's End*, 1975, Pier 52, Manhattan

It was at this spot, where on the northbound side of the West Side Highway, between Gansevoort and Little West 12th Streets, in December of 1973, that the elevated roadway collapsed and was never to be rebuilt. Would the Whitney have been located and would the High Line have been reconstructed if the elevated West Side Highway had remained? To what end was the elevated highway structure an impediment to accessing the water? What physical barriers need to come down to bring people to the water's edge? Also, does it take a disaster such as a road collapse or an earthquake to remove these barriers?

The story of San Francisco's revived waterfront is directly linked to the demise of the double-decker Embarcadero Freeway, which had been built in 1958 to allow traffic to travel between the Golden Gate and Bay Bridges without entering the city. The elevated structure disrupted the historic street grid which had been laid out to end at the water, obstructed the

views of the Bay and the Ferry Building, and severed the downtown from the port, acting as a physical barrier for public access to the waterfront.[7]

The 1989 Loma Prieta earthquake damaged the Embarcadero Freeway thereby giving the city an opportunity to reconsider its relationship to the waterfront. Among the amenities of the reconstruction, the following were included: "a new alignment for the Embarcadero boulevard that incorporates bicycle lanes and an exclusive right-of-way for an extension of the F streetcar line from the Ferry Building to Fisherman's Wharf. . . ; a water-side pedestrian promenade that runs from Fisherman's Wharf to China Basin Channel...; an extension of MUNI's light-rail system south of Townsend Street along an exclusive right-of-way in the center of the Embarcadero. . . ; an underground MUNI switching yard that was originally to be placed under the elevated freeway; several open-space improvements;" in addition to the planting of palm trees. These elements together "changed the character of the northern waterfront from an industrial service corridor to an outdoor living room for San Franciscans."[8]

In addition to this was a large civic plaza that acknowledges the importance of the Ferry Building and connects it to Market Street and the Embarcadero Center. The overall effect of the damage to and removal of the freeway and the subsequent projects associated with it was to reunite the city with its waterfront allowing for spaces such as Pier 24 Photography to open along the Embarcadero, at the base of the Bay Bridge, as it did in 2010. The industrial scale of this space and its remodeling intervention allow it to exist someplace between a warehouse and a gallery but invite visitors to experience art in the context of the Bay's contemporary waterfront landscape. This somewhat modest attempt was relatively early in bringing art and culture to the waterfront in San Francisco and was followed by others, for example, The Exploratorium at Pier 15.

Kevin Starr, in his book on San Francisco's Golden Gate Bridge, references another port city, Sydney, Australia writing that when Sydney "wished to express its coming of age as an urban entity, along with the coming of age of the new nation it served, it also built a bridge, the Sydney Harbour Bridge (1932), the widest long-span bridge in the world, which in time would frame the Sydney Opera House (1974), both structures becoming leading icons of a new world city."[9]

Nine sites were considered for the Sydney Opera House and the one on Bennelong Point, just east of the Harbour Bridge was not the most obvious. While it is true that the geography and topography of the site would make a building highly visible, it is also true that the industrial landscape of a working harbor was not necessarily expressive of the city's coming of age to which Starr referred. The harbor was a productive one as it was deep and protected, with stable land surrounding it. Bennelong Point, specifically, had been a rocky island, filled to become a defensive military post, and later replaced with a tram depot that still existed when Jorn Utzon's scheme was selected in 1957.[10]

What should exist on a site such as this that is surrounded by water on three sides? Should it be home to industry, closed off from the rest of the

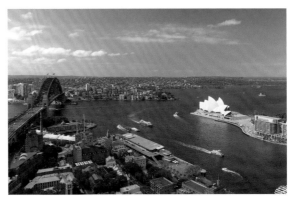

Sydney Opera House, designed by Jørn Utzon, 1974

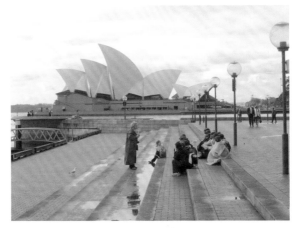

Sydney Opera House, designed by Jørn Utzon, 1974

city or home to a cultural institution, inviting patrons of the arts to the water's edge?

Once constructed, life flowed in and around Utzon's waterfront work.

> *Equally impressive [as the architecture] was the teeming life—of tourists and locals—playing out across the platform. People were sitting and gazing back to the city or out across the harbour, photographing each other, jogging, striding towards the entrance or wandering apparently purposelessly about. . . Not the least of the Opera House's merits. . . is that the great platform is arguably the only major public space created in the 20th century to rival in aesthetic power and popular appeal the great piazzas of Italy.[11]*

The project was to have been constructed in three phases: the foundation and promontory, the shell structure and the outer shells, then the interior. The shells derived from sections of a sphere were made of a ribbed system of precast concrete and were designed to resemble large white sails that opened up to the water.

While the project was plagued with conflicts, budget, management, and constructability problems, and while Utzon resigned in 1966, the draw of the building had been so great, so immediate to achieve "emblematic success," that thousands of petitioners signed on to bring Utzon back.[12] So moved

were the people of Australia by Utzon's invitation to the water that they demanded his return.

What was it about this project that had such a draw? Why did it become an icon? Utzon's Opera House is one of the most celebrated structures of modern history; its worldwide recognition is compared to works such as the Eiffel Tower and the Taj Mahal.[13] And later, after all the conflict, rebuilding, and additional cost, the building would be declared a World Heritage Site, and Utzon would be awarded the Pritzker Prize. Was the project's invitation to occupy a spot at the harbor surrounded by water part of what has made it so enticing?

Or was the design of the building simply so distinctive that it provided the draw? It certainly was ahead of its time. Forty years existed between the Sydney Opera House and Frank Gehry's Guggenheim Bilbao, and that time gave Gehry the advantages of computers to help him realize his forms. Gehry, as a juror for the Prizker Prize the year Utzon received it said, "Utzon made a building well ahead of its time, far ahead of available technology . . ."[14]

As if prophetic of the success Gehry's building would have and as if willing it to become a symbol for Bilbao and the Basque region the same way the Sydney Opera House had become a symbol for Australia, the Guggenheim committee in Bilbao, in its interview with Frank Gehry, supposedly said, "'Mr. Gehry, we need the Sydney Opera House. Our town is dying.'"[15]

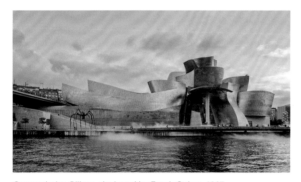

Guggenheim, Bilbao, designed by Frank Gehry, 1997

The first part of Bilbao's story is one that is familiar. The presence of the Nervion River, which discharges 10km away at the Bay of Biscay, allowed for the city's rise as a center for the iron, steel, and shipbuilding industries and it was these industries that occupied almost the entire left bank where the Guggenheim would make its home years later. Also familiar is that Bilbao, like so many other industrial cities, suffered an economic recession following the downfall of manufacturing and was left in a state of environmental degradation; in particular, its main waterway, the Nervion River, had been heavily polluted. Post-industrial Bilbao was home to derelict, abandoned buildings, sites with contaminated soil, and obsolete infrastructure. What's more is that the industry of areas such as Abandoibarra, where the Guggenheim would be sited, while active and in its abandonment, was a physical barrier cutting off the center of Bilbao from the river.[16]

But the image of Bilbao as a dirty and unappealing city was transformed, its transformation the result of factors including the investment of public money in both public and private projects; investment in infrastructure, such as a new metro system and water sanitation system; as well as the investment in high profile development by architects including Calatrava, Moneo, Foster, and Pelli. And there was, of course, the phenomenon that is Frank Gehry's building for the arts.

What about this phenomenon? Approximately 100,000 tourists per month visited the museum during its first year, and in the following years, the number of visitors, mostly from outside the region, remained relatively steady, representing a good portion of the region's income.[17]

The city name itself is synonymous with the museum and it, like the opera house is for Sydney, is the symbol of Bilbao, its diagram appearing on all forms of propaganda. Is it possible to cultivate the identity of a place based on global image? Shouldn't identity derive from vernacular landscapes and activities and from local people?

Hal Foster, who makes an appearance in Sydney Pollack's *Sketches of Frank Gehry*, writes in his book *Design and Crime*, that "Bilbao uses its Gehry museum literally as a logo: it is the first sign for the city you see on the road, and it has put Bilbao on the world-tourist map."[18] In contemporary culture, where brand identity and equity are of paramount importance to clients, architects, such as Gehry, who "can deliver a building that will also articulate as a logo in the media," have an advantage. A building, Foster claims, must be a "spectacle" in order to be heard above the noise of culture.[19]

Since Gehry's building is the symbol for Bilbao and the region, and therefore a symbol of its stability and journey from urban crisis, it is no surprise that other cities look for an equivalent, distinct gesture or intervention to generate recovery. If there were ever doubt of the building's influence, consider that the "singular economic and cultural impact felt in the wake of its opening in October 1997. . . has spawned a fierce demand for similar feats by contemporary architects worldwide."[20]

So what if it has made a spectacle of itself? Even if it has been over-photographed, has it really been reduced to a mere image? Does it matter if it is louder than the noise of the post-industrial city? Is it surprising that other cities in crisis want synonymous projects? In his chapter on Bilbao in the book *The Ethics of Sightseeing*, Dean MacCannell considers these issues and argues for the project having assessed its artistry. Its integrity, he concludes, is the generator of renewal:

> *The Frank Gehry building is a global attraction... its origins, context, and form constitute an ethical strategy of symbolic representation for tourists on a grand scale. The Guggenheim Bilbao is the embodiment of creative risk taking, human exigency, and persistence in the face of uncertainty— all qualities required to meet the symbolic head on. It did not avoid difficulty by reducing itself to the cut and dried, repetitious, routine, ignorant, happy, and banal. The building marks an absence, acknowledges its incompleteness, and symbolically reminds us of our collective responsibility perpetually to renew our social contracts. Independent of its functionality as a museum, or lack*

thereof, it "works" as an attraction by instructing us about the potential of the symbolic.[21]

How could the building not be an effective invitation to the water? There it sits, just at the river's hard edge, shining in titanium cladding, glass, and limestone amidst remnants of the site's industrial past.

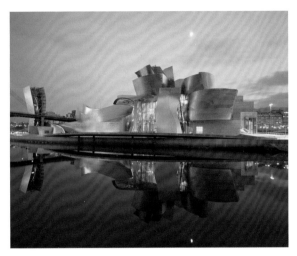

Guggenheim, Bilbao, designed by Frank Gehry, 1997

The railroad tracks still exist as part of its plaza on the south side, where it meets the city grid and incorporates street noise and traffic. Rather than turn its back on the concrete, cables, and metal of the Salve bridge, the building wraps itself around it, identifying more closely with it than with the city's residential high rises. The traffic continues over the water. And with its curved walkway and water feature, the Guggenheim takes in the damaged river.

The barriers of industrialization and its aftermath have come down and have been replaced by this expressive sculpture of a building with complex, curving forms and an aggressive distinctiveness. Some say its tumbling forms and shapes reference a ship, intentionally recalling the city's maritime past and that its metal cladding references the long-gone steel industry. Others say that from above, it resembles the petals of a flower peeling off. But maybe it is more self-indulgent than derivative. There is no question that its forms are forceful, although it curves gently along with the bend in the Nervion. And there is no question that this building has something to say about the manipulation of form and light and the malleability of material as the dented titanium ripples and the glass catches the sunlight in a way the Nervion should have all along.

Gehry's Guggenheim intervenes in the past and the present and asserts itself into the texture of the city and into the life of the river and its crossings. It not only invites people to the edge of the Nervion River but says art and architecture are about places like these, places where rivers have been used for ships and passed over by bridges and cars. It says art and architecture have to do with fragments of old railroads, the hard edges of waterways, and the ships that docked in them.

The development of the Oslo Opera House at the edge of the city and the fjord landscape is an act that embraces the fact that harbors were and still can be points of entry and exchange not only for goods, but also for ideas and culture. The Snøhetta team that worked on the project wrote, "The dividing line between the ground, <<here,>> and the water, <<there,>> is both a real and a symbolic threshold. The first element in our design dealt with the threshold, which is realised as a large, ritualized wall on the line of contact between Land and Sea, Norway and The World, Art and Everyday Life. It is at this line that the public meets art."[22]

This portion of the city's industrial harbor at Bjorvika peninsula had been overlooked since the demise of break-bulk shipping and had been severely polluted. The site for the building had been cut off from the city by a system of roadways, and to the extent that the development of the project was also part of a larger plan to revitalize the waterfront, this roadway system was tunneled. The development of the Opera House had been just one part of the "comprehensive urban transformation of the city's waterfront."[23]

I visited Oslo in the fall of 2016, after a trip to the Netherlands to study Dutch resiliency and urbanism. In late October, Oslo was losing daytime quickly, and when I walked from my hotel to the Opera House, the light was fading. But the whiteness of the building contributed to its allure in the twilight, as did the audience gathering to occupy it for an evening performance. It has been said that the Opera House, just like Gehry's Guggenheim, resembles a ship, but that analogy is a simple one based on the location of both buildings at the edge of the water.

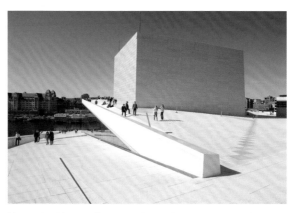

Norwegian National Opera and Ballet, Oslo, designed by Snøhetta, 2008

There is a sequence in the approach to the Opera House in Oslo that draws you closer to the waterfront, and the building's association with the natural features of the site is part of its invitation. The Opera House is detached from the land, requiring its visitors to cross a narrow bridge to get to it. This compressed passage, however, merely reinforces the building's association with the fjord. Then there is the artist-designed roof that slopes down to the water to form the expansive Carrara marble planes. These planes, or "carpet" is accessible to all, "inviting people to this edge, to the water, inside the building;"[24] the public may ascend and occupy this broad ramping roof that connects sky to the water.

Looking back at the Opera House from the fjord during specific conditions, one can hardly tell a manmade structure exists; when ice gathers on the surface of the water, the sloped roof, covered by snowfall, is merely its extension. Then, from a slightly different perspective, still looking back toward the Opera House with the city beyond, there are these sheets of ice in addition to glass verticals that glow from within to reveal something of the warm interior. This is part of the sequenced invitation, too, for the interior space beyond the glass and sloped roof, is open to the public.

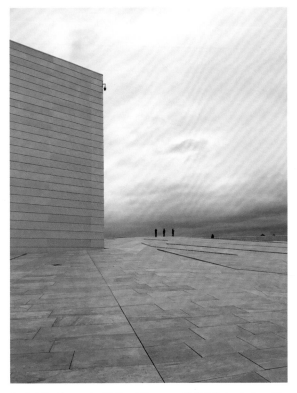

Roof at the Norwegian National Opera and Ballet, Oslo, designed by Snøhetta, 2008

In my notebook, on that day in October, I wrote, "Come in from the cold, from the white stone and water world." And then, referring to the small portal that accents the grand public interior, I wrote of the "compression into warmth . . . into the warm yellow reflected light of the lobby where the high vertical space opens up w/continuous views out to city and fjord." The sequence is a pattern of small entries to broad spaces: narrow bridge to vast carpet, small door to bright lobby. The public space inside and out are about the fjord landscape and the interior wood that encloses the three performance halls represents, I believe, the threshold, the "ritualized wall" the Snøhetta team described.[25]

The Opera House provides a meeting place for the public and art, and in addition to performance halls and all the backstage costume and set design associated with it, there are also eight art projects by 17 different artists. Much of this featured artwork is integrated into the building and masks back-of-house and service functions, including the internally lit, patterned *The Other Wall*, by Olafur Eliasson that is part of the lobby.[26]

Snøhetta conceived of the working parts of the building as a "factory" that systematically catered to the needs of the hundreds of performers and workers who inhabited the building for opera, ballet, and orchestra during rehearsal and performance times. On my second day in Oslo, before again returning to explore the Opera House in daylight, I visited the Snøhetta offices where I met Simon Ewing, a senior architect on the project who described it as "a factory and an icon." There was the practical role it played, and then there was the role it played as a monument and cultural destination in the city.

At first glance, the Opera House can be viewed as the "latest manifestation of the trend for European cities to use cultural projects as development tools." It is, after all, admittedly part of the effort to revitalize this area of Oslo. The distinction, however, lies in the following: unlike projects, such as the Guggenheim Bilbao, which explicitly were "conceived as iconic," where the goal from the outset was to create 'another Sydney Opera House,' tourism and branding for the Oslo Opera House were secondary, the benefits of the former considered a positive byproduct of successful placemaking, architecture, and urban design. The primary goal of the development of the Oslo Opera House had to do with having Norwegian people experience opera. It was to provide them with a great public space in their country's capital. It was to "reconnect the city to the sea." The Opera House is more than a spectacle or an object to view from a distance; people go there to occupy the site, to "connect with the fjord, to bathe, to relax or simply to gather." The form of the building with its space for public access both outdoors and indoors, its accessibility and openness, as well as its connection with its natural environment, reflect particularly Norwegian values rather than global ones.[27] "The opera is accessible in the broadest sense of the term. It is not a traditional sculptural monument; it is instead a social monument. . . The site is, in a sense, returned to the city."[28]

There are triumphant moments when engineering and art are simultaneous and harmonious, and so it is far too simple to consider some bridges invitations in their literal capacity alone. In addition, bridges represent the passage from one world to the next. The Golden Gate Bridge, for example, is practical, allowing movement from one landmass, over a body of water, to another, but it also invites all that is urban in the city of San Francisco to meet the natural world of Marin County.[29]

As the Sydney Harbour Bridge expressed the rise of its city and nation, the Golden Gate Bridge and the Brooklyn Bridge before that represented the American imagination and American achievement. The Golden Gate Bridge, like the Sydney Opera House, Guggenheim Bilbao, and the Oslo Opera House became iconic invitations, recognizable symbols that draw us closer to the water's edge.

Were the towns of Gateshead and Newcastle chasing the Bilbao effect when they invested private and public money into Foster and Partners music center, the Sage Gateshead? What about when these towns invested in the conversion of an old flour mill into the BALTIC Contemporary Art Gallery? If so, this pursuit continues, for there are plans to further develop the area between the Sage and the BALTIC into a larger art and entertainment district.[30]

Both Bilbao and Gateshead-Newcastle were industrial centers located in river valleys where bridges help to negotiate the landscape. To that end, the existing Salve Bridge became part of the Gehry project, while the investment in Gateshead-Newcastle included the development and 1998 construction of the Gateshead Millennium Bridge to provide access over the industrial Tyne to the center of the art district. This pedestrian and cyclist bridge, designed by architects WilkinsonEyre Architects, is made of a pair of rigid, connected, steel arches and suspension cables that tilt to allow ships to pass underneath it. When the bridge is opened for foot traffic, the stabilizing arch rises into the air while the deck, parallel to the water, curves in a parabola from one side to the other. As the bridge opens, the two arches rotate back so that neither is parallel to the water and large boats can pass underneath.

Gateshead Millennium Bridge, Newcastle upon Tyne, designed by WilkinsonEyre, 2001

It was a spectacle from the start as thousands of viewers watched the initial opening of the bridge[31] and people still are drawn to the water to see how this tilting bridge works. It can be recognized as a third piece in the initial phase of developing this arts district, along with the BALTIC and the Sage, and is an example of how bridges can play a role in the development of place identity and image.

UN Studio intended its Erasmus Bridge to become an icon from the start. In an extensive interview on the project, Ben van Berkel and Caroline Bos disclose how this project unfolded. "From the beginning, this bridge was to be more than a simple connection. It was intended to have an iconic status, to act as an attractor for new development to the riverfront."[32]

The literal intention of the bridge, which was part of a larger redevelopment project for Rotterdam, was to connect the extensively developed, older north-side of the River Maas to the prospective development of the city's post-industrial south. And in this era of growth, the project would take on and reflect Rotterdam's optimistic tone, drawing on "without directly mimicking" the cranes and general industrial character of Rotterdam, and maintaining "the feeling of the riverfront."[33]

Its steel pylon tower, along with its cables and stays, is a landmark visible in the sky from within the network of city streets. Its power is to provide orientation, locating the river for both sides of Rotterdam. Then it beckons, calling into the dense streets: 'Come venture over the open water! Come by

foot, bicycle, car, or tram.' Paths for all of these reach into the fabric of the city, inviting all types of movement to its steel deck.

Erasmus Bridge, Rotterdam, designed by Ben van Berkel, 1996

In 2010, I was in Rotterdam, accompanying Michael while he participated for the second time at the Rotterdam Poetry Festival. During this visit, I explored the northern side of the Maas but did take a ferry to Kinderdijk, a site known for its 18th-century windmills, that left from a dock at the base of the Erasmus Bridge. In 2015 I visited the city again, this time to review some post-industrial development projects. I stayed across from the River Maas in the Kop van Zuid and walked across the Erasmus Bridge many times, choosing to do so over taking the metro, even though a stop had been added to serve the newly developed area. In 2016, when I returned to the city again, I stayed in OMA's De Rotterdam at the southern edge of the River Mass, in Kop van Zuid, and paid extra to get a room that overlooked the bridge. Each night I was there, I kept my drapes open to allow the bridge into my room.

The former mayor of Rotterdam, Bram Peper, had this to say regarding the building of the Erasmus Bridge: "The long and short of it is that we have discovered the river. Until then, we had always seen the river as an artery over which goods flowed but which was not actually part of the city. Now we've discovered that instead of being a dividing line, the river could act as a link that would draw the two shores together.[34]

There is power in operating in the space where land meets the water, for it is in this boundary, this margin, this edge that the mystery and excitement of water begins. But there is additional power when access to this mystery has been denied, making the waterfront all the more coveted. During the span of my lifetime, I have been both kept from the water's edge and invited to it. While in the 1940s I would struggle to catch even a glimpse of the river that I knew flowed just beyond the industrial waterfront of Manhattan, partway through my career I would travel the world to investigate projects that were being built in this threshold with the specific intention of drawing people to the city edge. And I, myself, was building such projects with the same intentions.

Cities and cultural institutions had become wise to the power that lies in this threshold. They had caught on to the thrill that water brings, but more than

that had caught on to the thrill that exists where access has been denied. And adding to that, they caught on and cashed in on the phenomenon created when art is presented in this charged environment where the known meets the unknown, where the human world meets the natural world, and where, more often than not, obsolete structures and polluted soil and water are testament to an industrial past. The Whitney, which now finds its home just blocks from where my family had lived, the Sydney Opera House, the Guggenheim Bilbao, the Oslo Opera House, and all the bridges that do more than connect one shore to the next are just the beginning. There is also the earlier Snøhetta waterfront project, the Bibliotheca Alexandrina in Alexandria; the Delugan Meissl EYE Film Institute in Amsterdam; Jean Nouvel's Louvre in Abu Dhabi; along with the Lundgaard & Tranberg Royal Danish Playhouse, and Kengo Kuma's competition winning cultural center, both in Copenhagen, to name a few. Will these projects be met with doubt and skepticism? Will they be criticized for having intentions related to boosting a city that has fallen on hard times? Will they be criticized for creating a spectacle of themselves, for being so obvious about their mission to revitalize or to generate profit? Do architecture and art always have to be more pure than that?

I keep coming back Snøhetta, who understood as well as anyone the power that lay in this threshold: simple words to negotiate complexity in the same way its architecture does. Land is "here" and water is "there." And right at that spot, where these words are pointing, is now where Everyday Life should go to find Art.

Notes

1. Clifton Hood, *In Pursuit of Privilege: A History of New York City's Upper Class & the Making of a Metropolis* (New York: Columbia University Press, 2017), 279–80.

2. "Breuer's Ancillary Strategy: Symbols, Signs, and Structures at the Intersection of Modernism and Postmodernism," in *Marcel Breuer: Building Global Institutions* (Zürich: Lars Müller Publishers, 2018), 307.

3. As quoted in "Breuer's Ancillary Strategy: Symbols, Signs, and Structures at the Intersection of Modernism and Postmodernism," 307.

4. Renzo Piano, *Renzo Piano: The Complete Logbook, 1966–2016*, Revised and expanded edition. (London: Thames & Hudson Ltd, 2017), 348.

5. Piano, 346.

6. "The Building," accessed February 7, 2020, https://whitney.org/About/NewBuilding.

7. M. Jasper Rubin, *A Negotiated Landscape: The Transformation of San Francisco's Waterfront since 1950*, Second edition. (Pittsburgh, PA: University of Pittsburgh Press, 2016), 187.

8. As quoted by Rubin, 252.

9. Kevin Starr, *Golden Gate: The Life and Times of America's Greatest Bridge*, 1st U.S. ed. (New York: Bloomsbury Press, 2010), 11–12.

10. Françoise Fromonot, *Jørn Utzon: The Sydney Opera House* (Milan: Electa, 1998), 13–14.

11. Richard Weston, "Monumental Appeal: Reflections on the Sydney Opera House," in *Building a Masterpiece: The Sydney Opera House* (Burlington, VT: In association with Lund Humphries, 2006), 26.

12. Weston, 6.

13. Weston, 21.

14. As quoted by Fred A. Bernstein, "Jorn Utzon, 90, Dies; Created Sydney Opera House," The *New York Times*, November 29, 2008, sec. Arts, https://www.nytimes.com/2008/11/30/arts/design/30utzon.html.

15. As quoted by Rowan Moore, "The Bilbao Effect: How Frank Gehry's Guggenheim Started a Global Craze," *The Observer*, October 1, 2017, sec. Art and design, https://www.theguardian.com/artanddesign/2017/oct/01/bilbao-effect-frank-gehry-guggenheim-global-craze.

16. *Phoenix Cities: The Fall and Rise of Great Industrial Cities* (Bristol: Policy Press, 2010), 199–211.

17. Naomi Stungo, *Frank Gehry* (London: Carlton, 1999), 20.

18. Hal Foster, *Design and Crime: And Other Diatribes* (London: Verso, 2002), 29.

19. Foster, 27–29.

20. Frank Gehry, et. al., *Frank Gehry, Architect* (New York: Guggenheim Museum, 2001), 161.

21. Dean MacCannell, *The Ethics of Sightseeing* (Berkeley: University of California Press, 2011), 158.

22. *Oslo Opera House* (Oslo: Opera Forlag, 2009), 44.

23. *Snøhetta Works* (Baden, Switzerland: Lars Müller Publishers, 2009), 9.

24. *Oslo Opera House*, 45.

25. *Oslo Opera House*, 44.

26. "About the Opera House," accessed February 11, 2020, http://operaen.no/en/about-us-oslo-operahouse/about-the-oslo-opera-house/.

27. Andrew Smith and Ingvild von Krogh Strand, "Oslo's New Opera House: Cultural Flagship, Regeneration Tool or Destination Icon?," *European Urban and Regional Studies* 18, no. 1 (January 1, 2011): 93–110, https://doi.org/10.1177/0969776410382595. The authors conducted stakeholder interviews and this paragraph relies heavily on the conclusions.

28. *Snøhetta Works*, 10.

29. Starr, *Golden Gate*, 16.

30. "Vision for HOK-Designed Gateshead Quays Development in England Unveiled," HOK, November 5, 2018, https://www.hok.com/news/2018-11/vision-for-hok-designed-gateshead-quays-development-in-england-unveiled/.

31. "Tilting Bridge Opens Eye to the World," September 17, 2001, http://news.bbc.co.uk/2/hi/uk_news/1545986.stm.

32. *UN Studio: Erasmus Bridge, Rotterdam, The Netherlands*, Source Books in Architecture ; 4 (New York: Princeton Architectural Press, 2004), 24.

33. *UN Studio*, 34.

34. As quoted in *UN Studio*, 135.

Rethink

"The silence as the waters rise..."
— Michael Palmer, "Broad
 Waking," in *Thread*, 2011

Sixty-five years before President Obama
entered the US in the Paris Agreement
with more than 190 other countries,
Rachel Carson's *The Sea Around Us* became
renowned for the beauty of her writing on
the topic of the natural ocean world. But what
became known to her during her research, and
what she made public in *Silent Spring*, was that
human existence posed a threat to the natural world,
including the world of the sea that she loved so much.
Silent Spring did not call for sweeping change to policy,
for Carson knew that the government and its close ties
to industry were part of the threat. Her message to readers
was to rethink traditional power structures and to reconsider
humans as part of nature rather than master of it.

In 1963, Carson testified in front of Congress and said, "When we
review the history of mankind in relation to the earth we cannot help
feeling somewhat discouraged, for that history is for the most part that
of the blind or short-sighted despoiling of the soil, forests, waters and all
the rest of the earth's resources."[1]

Activist and author Rachel Carson testifying before a Senate
Government Operations Subcommittee in Washington, D.C., June
4, 1963.

Her critics in the farming industry, in an effort to protect their interests,
worked to attack her personally and to discredit her claims. In 1962, *TIME*
magazine referred to her "mystical attachment to nature," and "her emo-
tional and inaccurate outburst" in *Silent Spring*.[2] Make no doubt that these
attacks were gendered; she was mocked and portrayed as a hysterical
woman, overcome with emotion rather than as an informed scientist driven
by facts. And fifty-five years after the publication of *Silent Spring*, President

Trump withdrew the US from the Paris Agreement after having mocked it and the science of human-caused climate change.

I do not recall reading Rachel Carson in *TIME* in 1962, but I do remember a *LIFE* magazine article from sometime during my childhood that told the story of the formation of the earth and included information on atmospheric and climatic shifts. The graphic representation of this was lavish, in color, and spread across multiple pages. There was an oversized setting sun looming largely on the horizon. And at the edge of land, red fire lava existed where I had anticipated seeing water. The message to me was that the earth was getting hotter and hotter and would eventually incinerate. The sight of these images brought me to tears, and my parents had to reassure me that this catastrophic ending to the earth was not realistic. But I was frightened.

I am frightened now, too. Every day I am frightened. Our children and grand-children will be inheriting a despoiled planet and will experience a loss of beauty of the natural world that has been so important to me. Michael writes in his poem *Nighthawk and sun-bird:*

> *Nighthawk and sun-bird*
> *Beauty of the world beauty of the*
> *world*
>
> *How can one write beauty of the*
> *world?*[3]

My daughter and grandsons possibly may witness mass extinctions that no one of my generation has ever known and that no one of my parents' gener-ation could have imagined. The rural and urban coastal areas where I have lived, worked, and spent summers are disappearing and in this I feel a loss of security and safety. Everything that I thought was predictable no longer is. Rachel Carson and this issue of *LIFE* are evidence of the fact that the assault on the earth has been a long time in the making. And they are also evidence of the fact that the threat to the planet has long been known. But I am par-ticularly fearful now for any progress that has been made toward protecting the environment is under attack. Of particular relevance to this text is the Trump administration's recent repeal of the landmark 2015 regulation put in place to protect streams, rivers, and wetlands.

Across cultures, the earth's waters are perceived and portrayed as neither exclusively good nor exclusively evil. Still, they exist as an entity with a para-doxical character that evokes emotions of pleasure and wonderment as well as fear and anger. Given that this complicated human perspective exists, it may seem the planet's waterways would be cherished or feared but either way, revered and protected. This has not been the case. In fact, human work and play, actions, and lifestyles, within American borders and beyond, have exhibited a disregard for the health of the environment and oceans, rivers, and wetlands, specifically.

Industry and manufacturing took place in the threshold between sea and land, exploiting natural resources and leaving behind polluted water and soil. Recall the ground and water that became Crissy Field, the Nervion and the

soils of Bilbao, and the Bjorvika peninsula of the Oslo Opera House, to name a few. Consider the widespread effects of the General Electric dumping millions of pounds of PCBs into the Hudson River over the course of 30 years and that PCBs have been found in sediment, water, wildlife, and humans as far south as New York Harbor;[4] that the Hudson River near Tarrytown, NY would change color depending on the paint used that day at the General Motors plant.[5] In San Francisco, some of the most harmful contaminants found in the Bay, such as mercury, date as far back as the Gold Rush era and as far back as the time immediately following the 1906 Earthquake, when debris containing lead paint was dumped into the Bay contaminating its sediment at the Port.[6] But damage in San Francisco has also been caused by generations of irresponsible agricultural practices, and by industry, and by the military who for decades used the Bay as a dumping ground.[7]

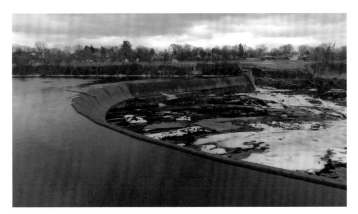

The Hudson River as featured in a film still from *Source to Sea*, directed by Jon Bowermaster, 2001. The film addresses the consequences for humans and wildlife of dumping toxic chemicals into water sources.

The American dependency on the automobile was something that Lewis Mumford, in the 1950s, predicted would occur. He understood the impacts the car would have on the geography of our cities: how highway systems divided cities and cut city dwellers off from, for one, the waterfront. But could he have predicted the environmental impact emissions from cars would have on the environment? Did he know that cars, trucks, and buses would be major contributors to air pollution and are a major source of the emissions that cause global warming?[8] Did he know that our highways and car culture would create a vast landscape of impervious surfaces where runoff would collect oil, grease, and chemicals like salt and deposit them into our waterways making nonpoint source pollution the leading cause of water pollution in the United States?

In light of this, it is appropriate to ask: What is the current state of the environment? While air pollution is considered the largest environmental threat to public health worldwide,[9] there are several threats directly related to our waterways. Literally millions of tons of plastic waste enter our oceans from coastal regions each year inflicting harm on life there and the 3.5 billion people who depend on the ocean as a primary source of food, not to mention the animal life, which is even more dependent on it.[10] Global warming will cause a decrease in food production and clean water supply. Sea levels are rising at an alarming rate, as is the occurrence of extreme weather

events. What's more is that entire populations of climate refugees may exist in the next decades as a result of rising sea levels displacing them from their homes and livelihoods.

How has the earth found itself in this state? Its inhabitants have thickened its atmosphere by burning fossil fuels that emit carbon dioxide and other gases. This thickened atmosphere traps the Earth's heat and causes the oceans to warm up, expand, and move higher up its shorelines. Increased temperatures melt the Earth's glaciers, and this melted glacier water flows eventually to the ocean contributing to the rise of sea level. The ocean now starts at a higher level when the force of a storm acts on it, thereby flooding larger areas.[11] In addition, warmer temperatures heat the surface of the ocean, causing increased evaporation into the atmosphere. This increase in evaporated water comes down in the form of rainstorms of increased intensity, meaning large storm events are occurring more frequently in certain locations, while drought affects others.

Cities are particularly vulnerable. While places outside of cities have cool nights, dark roofs and asphalt pavement keep cities hot. Historically, people have clustered in cities to take advantage of resources, such as deep harbors that allowed for the easy movement of goods around the world. But there exists now a massive migration from rural to urban areas. In China alone, "about forty thousand people per day make the trek from country to city, and most will never return."[12] How could this be? I had to read and reread this number, unable to comprehend its magnitude. How can cities accommodate this increase, especially considering their particular vulnerability?

There is only so much land at the edge of cities that can be developed, however, cities have modified the coastline, "replacing beach and wetland with cement and building right up to the edge of the water."[13] Urban expansion of this type seems to have no regard for the fact that wetlands are our most productive ecosystems where a vast range of plant and animal species thrive; that they mediate tidal flow and attenuate wave action; and that they naturally filter pollutants from the water. What's more is that where development is not present, mostly outside of cities, water infiltrates through forested and planted landscapes. Water does not, of course, infiltrate the hard surfaces of the post developed condition, making pipes, pumps, and sewers the obvious solution for drainage. This extensive and rigid infrastructure contributes to the limited resiliency of our modern cities.

But the traditional approach to protecting cities is to increase the building of this very infrastructure, that is, laying more sewer lines, pumps, and pipes to combat flooding and building more walls to keep the sea out of the city as the levels rise. The problem with this approach is that traditional infrastructure solutions are designed to suit specific, quantifiable problems that do not exist in the unpredictable world of climate change.[14] Business-as-usual, Army Corps of Engineers solutions to problems will not accommodate the post-industrial, post-development climate.

How should designers respond to climate change? While the downtown Whitney Museum was under construction in October 2012, Hurricane Sandy flooded the site with 5 million gallons of water, prompting a member

of Piano's studio to respond: "Do we have to completely rethink our infrastructure? Do we have to completely rethink everything?"[15]

Just as for Eugene Odum, ecologists bore responsibility for the environment, today's designers are charged with the task of building toward resiliency. Contemporary design responses must be comprehensive, taking into consideration all aspects of water's existence on earth and in the atmosphere. The response will expose rather than hide urban infrastructure, recognizing it to be a didactic tool that possesses the power to remind Earth's inhabitants of the systems that allow for their existence. The components of the climate story all come to a head at the water's edge where city dwellers struggle to uncover or recover any last bit of land that remains.

New ways of approaching the edge between the sea and land have to do with creating a city flexible enough to endure the unknown challenges that climate change may bring. Contemporary cities need to be able to "be stressed and bounce back rapidly when damaged."[16] Spaces in these cities are to be designed and programmed for multiple uses. And frequently, teams with practitioners from multiple fields are assembled to combat the complex problem that is climate change, allowing "nature to exist as part of the architecture design vocabulary."[17]

Making wet land habitable has long been part of Dutch life and culture as the country exists at the very edge of the continent where the jagged coastline is erratic and unpredictable and where water makes its way inland as far as possible. The Dutch understand that these conditions make their land among the most vulnerable in Europe to climate change threats and, specifically, to rising sea levels, and have recognized this condition as an opportunity for a paradigm shift in terms of design. That climate change is no longer debatable or even hypothetical is in contrast to the position taken in the United States: "While the Trump administration withdraws from the Paris accord, the Dutch are pioneering a singular way forward."[18]

The Dutch design approach involves an acceptance of water's course in the age of rising sea levels. Design there has begun to incorporate the sometimes presence of water as a point of beginning for design rather than as a restrictive parameter. There is no mastering of nature here: no dominance or hubris of man driving design. Extensive, traditional infrastructural approaches that seek to keep water and land separate so that urban design and architecture can exist perfectly without acknowledging the existence and force of water are no longer viable in the climate of now.

The Dutch project *Room for the River* (2012–2019) attempts to undo measures that restrict river flow. Solutions in 30 locations throughout the country are site-specific and include moving dikes inland to allow broader floodplains, excavating floodplains to give more square footage to water flow, and giving more area to the water by deepening riverbeds. The floods that occurred in the Netherlands in the 1990s "were a wake-up call to give back to the rivers some of the room we had taken . . . We can't just keep building higher levees, because we will end up living behind 10-meter walls". . . "We need to give the rivers more places to flow."[19]

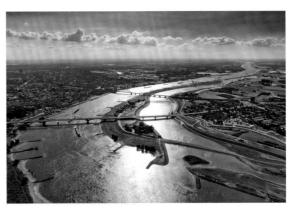

Room for the River, the Waal River between the cities of Nijmegen
and Lent, the Netherlands, photograph taken 2016

In 2016, I helped organize a group of Bay Area architects, landscape architects, and engineers to travel to the Netherlands specifically to look at contemporary Dutch water infrastructure solutions. At the time, and perhaps even now, *Room for the River* was considered among the most radical of approaches, and so my group traveled by bus to Nijmegen, an ancient city on the Waal River in southeast Holland, near the German border, to see an example of a landscape edited as part of the project. What existed there was the vast, newly created area to hold flood water that was part of a larger water management effort, three new bridges that span the Waal, a newly made island in the river, and a new linear, Urban River Park, that speaks to the additional goal of the *Room for the River* project, which is to improve the quality of life in the immediate project areas. And what's more is that the river has now become part of the city's public life.

For the Dutch, the responsibility of environmental resilience falls to the entire community, including the individual. What has stuck with me from my visit is that the process of enacting *Room for the River* in Nijmegen was done seamlessly despite the fact that it involved displacing 50 households and 20 businesses. The project had won support because the community was educated, involved, and understood that preventative measures for flood protection were imperative. Considering this, I am left wondering how successful such a program would be in the United States.

As part of this trip, the Bay Area group also visited Rotterdam and was given a tour of that city's Water Square Benthemplein by a representative from De Urbanisten, the research, design, and landscape firm behind that project. At Water Square, water is considered a design element, permitted to inundate hardscape, an approach that came about following failed efforts to restrict its flow with traditional barriers. The Water Square fluctuates between being a recreational plaza when the weather is dry and a retention area during and following a storm event. In October 2016, it had rained, but was not raining while we were there. The two shallow basins that collect water from their immediate surroundings whenever there is any storm were empty, while the deeper basin that collects water from a larger area around the square as well as the overflow from the shallow basins was still partially full, not having yet drained into the ground or nearby canal.

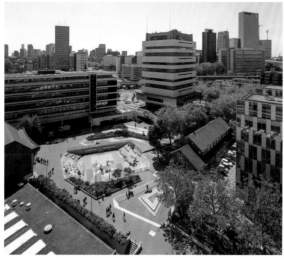

Rotterdam Water Square in Benthemplein, designed by Ossip van Duivenbode for DeUrbanisten, 2013

When dry, the Square is activated by people playing ball, performing, bike riding, and skateboarding, while during a storm event, the space is activated in its transformation from human occupation to water occupation, but also in the literal filling of the basins as water is conducted from buildings and pavement. This process is not hidden in an underground sewer system, but rather the trip water makes in this urban environment is on display. In the plaza, one can read the storm event, according to how full the site is.[20] The Water Square is didactic, and to this end, explanatory graphics that chart the passage of water and its disposition accompany the site's features.

The space making here isn't clean or pristine; when natural systems are involved, there is no room for anything too precious. But what natural systems bring is a promise of constant change and motion. A site whose use depends on nature is a flexible one and, in its flexibility and adaptability, ensures dynamism.

The precise results of architecture are never really known even though drawings and models can be made to help predict outcomes. This, too, is the case with predicting the results of climate change. How is it possible to consider these two unpredictable factors at once? How is it possible to design for circumstances that are uncertain or that have not ever occurred? Designers and others have participated in workshops, exhibits, and competitions that involve research and attempts to predict future conditions; the goal of this work is to get ahead of a potential catastrophic event, making recommendations for resiliency rather than responding to devastation.

The 2010 *Rising Currents* exhibit at the Museum of Modern Art was an effort to address rising sea levels in New York City, to create public awareness of this impending threat (Hurricane Sandy was not too far off, at this point), and to put forth artful and even playful solutions that were alternatives to the typical hardening of the edge between land and sea. This effort was also, however, a deliberate move to incorporate social responsibility and advocacy as part of design and architecture, and to set the trend for cultural institutions to engage in global challenges. As part of the *Rising Currents*

workshop, exhibit, and subsequent catalogue, five interdisciplinary teams were asked to "reinvent urban infrastructure in the face of the effects of rising sea levels on the world's great cities, many of which are situated in low lying coastal areas."[21] Each team was assigned a location in and around New York Harbor where it was to rethink the city edge between land and sea in light of rising sea levels. The historical account of New York's transformation from natural harbor to reconfigured port as told in *On the Water: Palisade Bay* by Guy Nordenson, Catherine Seavitt, and Adam Yarinsky served as a starting point for these teams.

In general, the *Rising Currents* solutions are soft and closer to models of nature inserted on the City's manmade and remade edge than to architecture. Without the knowledge that teams are interdisciplinary, one could guess it from the solutions, for they speak more to the subtlety of landscape architecture than to the frequent boldness of architectural responses.

The programmatic components proposed by the teams include bicycle and pedestrian paths, transit terminals, housing developments, greenmarkets, a biofuel plant, kayak launches, farms, transit terminals, and oyster reefs among topographical adjustments to the sites that create berms, swales and folds, and extensions of the land that result in increases to the length of the shoreline. Many or all of the proposals put forth ways of moderating water action with manmade barriers based on those found in nature. And the projects make the transition between land and sea an extended one, where use is determined by water level and where human occupation is based on the presence of solid ground.

With this exhibit, the message is clear that the world today is different for designers, planners, and cultural institutions. These entities now must address issues beyond immediate ones; the site does not end at the property line, and art must extend beyond museum walls. And with the support of this specific institution, MoMA, the message is clear that the source of the new modern is more outward looking than introspective and while its product may seem softer and more subtle, it is far more urgent than that of the past.

In the spirit of *Rising Currents* where research and collaboration among disciplines were integral to the workshop process, the United States Department of Housing and Urban Development in partnership with nonprofits, the Rockefeller Foundation, and other philanthropic organizations, launched the Rebuild by Design competition, as a specific response to Hurricane Sandy and with the goal of devising solutions toward resiliency.

The SCAPE team participated in both *Rising Currents* and Rebuild by Design. For the former, the team proposed Oyster-tecture, a living oyster reef to help support marine growth, attenuate waves, and filter water, then expanded this project into Living Breakwaters for its Rebuild by Design submission. Living Breakwaters is a three-part approach to shallow water coastal resiliency, as suggested in "Ecology, Risk Reduction, and Culture" where habitat is enhanced, and infrastructure techniques are employed that give the community greater access to the water's edge. The establishment of a series of breakwaters and reefs, which would provide much-needed habitat for shell and finfish, and for marine mammals. At the same

time, these reefs will dissipate wave action on the exposed south shore of Staten Island. This barrier infrastructure would be just one layer, along with, for example, dunes that exist on the beach, to reduce the rate and force of water as it hits the shore, protecting and allowing for the generation of ecosystems as well as the replenishment of the beach. An integral aspect of the project was to build community engagement and renew cultural and physical connections to the water. To this end, onshore "Water Hubs" were proposed as stations where the community and schools could get down to the water's edge and learn from project partners such as the Governor's Island Harbor School and New York's Billion Oyster Project.

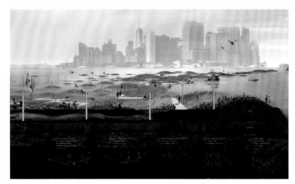

Rendering of Oyster-tecture, designed by SCAPE, commissioned by the Museum of Modern Art, New York, 2009

Bjarke Ingels' "BIG U" proposal was also an entry in the Rebuild by Design competition and calls for a protective system to wrap around Manhattan from 57th Street on the west side, around The Battery and back uptown to East 42nd Street. The team divided the downtown edge into three distinct "compartments" and addressed each based on existing conditions, neighborhood typology, and programmatic need. A specific type of flood protection was proposed for each compartment as was a specific type of social occupation of that infrastructure, for at the heart of the project is Ingel's position that sustainability does not have to be a sacrifice. He asked what would happen if taking measures toward sustainability actually increased our enjoyment of cities. To this end, he proposed building a berm in the East River Park compartment that would both protect the neighborhood from storm surges and offer a waterfront space for socializing, recreating, and viewing the river; a wall for the Two Bridges neighborhood and Chinatown compartment that would be designed by artists and that could be deployed from the underside of the FDR Drive to mitigate flooding; and for the Brooklyn Bridge to the Battery, a berm with paths and new maritime museum.[22] A component of this proposal, and one that speaks to the necessity of flexibility when responding to the unknowns of climate change, is that each compartment of the BIG U can stand on its own or act as part of the larger system, giving ease in its implementation in terms of funding and phasing.

Paralleling the east coast models of workshop and design competitions, in 2017, constituents in San Francisco launched the Resilient by Design Bay Area Challenge (RbD). Several colleagues from my 2016 trip to the Netherlands became board members and leaders of RbD, and I was involved peripherally as an advisor, who could could bring a design perspective as

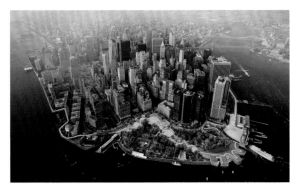

Rendering of BIG U scheme, designed by Bijarke Ingels and Starr Whitehouse, winning entry for the Rebuild by Design Competition, New York, 2014

the only practicing architectural designer on the team. Just as the solutions produced in the *Rising Currents* workshop and the post-Hurricane Sandy Rebuild by Design suggested a rethinking of the way we treat and design the coastal edges of New York, the RbD reimagines a Bay Area resilient to natural forces and the effects of climate change—earthquakes, rising sea levels, fires, droughts, and flooding—while simultaneously making it socially resilient by addressing urban issues such as access to affordable housing, transportation, and healthcare, especially as they pertain to environmental equity. While the response to this challenge put forth ideas that have to do with the specific characteristics of the Bay Area's unique hydrology, specifically, its complex and intertwining systems that make it a truly rich and productive ecosystem, it was the goal of RbD to devise solutions that can be applied universally. Integral to the Resilient by Design Bay Area Challenge was the exchange of knowledge and generation of ideas, innovation, and inspiration; a main goal was to activate and involve communities within the Bay Area's nine counties so that issues of climate change and resiliency became present and paramount.

Experts predict that flooding will occur in topographically low-lying shoreline areas of the Bay while at the same time the regional watershed as a whole will suffer from water shortages for there is less snow in the Sierras than in the past, and the melting of what's there occurs earlier in the season than it had previously. The predictions are that winter floods will be warmer, larger and more frequent, straining poorly maintained traditional infrastructure and that summers will be hotter and drier, with soils retaining less moisture for optimal or even adequate farming conditions. In sum, the water cycle in California is becoming more intense with wetter wet episodes and drier dry episodes. "This year's 100-year flood is tomorrow's yearly high tide."[23]

As part of the Resilient by Design Bay Area Challenge, the Field Operations team, working in San Mateo and Santa Clara counties, devised the "Sponge" concept, which calls for the use of natural systems as a primary device for building resiliency in the South Bay. Remnant marshland, restored salt ponds, and newly constructed wetlands would comprise the sponge, which would become a key component in the regional flood protection system, absorbing and filtering the intense wet episodes predicted for the near future while additionally promoting habitat diversity. The "sponges" simultaneously

would foster the region's identity of place as they reference both the historic role marshlands played in protecting the area as well as recent efforts to restore the area's salt ponds.

Rendering of the South Bay Sponge scheme, designed by Field Operations, entry for Resilient by Design Competition, San Francisco, 2018

There are three methods that support this effort in the South Bay and Silicon Valley which are low-lying and particularly vulnerable to sea level rise. Field Operation's Soil Swap calls for an excavation of soil from low lying areas for use as fill to build up higher ground. This higher ground is protected for new development, partially by the excavated areas, which become the wetland and tidal marsh sponge as well as by reinforced infrastructure. The Land Use Swap changes the pattern of low-density areas by concentrating development of higher density on higher ground, thereby making open space out of larger, continuous areas of coastline land where sponges can occur. What results is an urban texture with a soft, thickened edge. And third, creeks would be widened and softened to increase water storage and infiltration capacity, a concept reminiscent of that in *Room for the River*, as they make their way through neighborhoods to the bay. The enhanced creeks would become linear parks and, as they approach the bay, merge with the sponge to create microdeltas for an entirely thickened new type of urban edge and a new way to inhabit the bay.[24]

There were other notable Resilient by Design Bay Area Challenge entries. There was the Tom Leader Studio's Grand Bayway team that considered the fragment of Sonoma Baylands that still exist in San Pablo Bay in terms of the floods and rising sea levels that threaten to inundate this ecologically critical landscape in the upcoming decades. And there were submissions from SCAPE and Bjarke Ingels, as well. The existence of these types of workshops and competitions, that is *Rising Currents*, Rebuild by Design, and Resilient by Design, on both of this country's coasts, and the participation in them by nationally and internationally renowned firms, speak to some level of commitment on the part of regional leaders and the design professions to exchange knowledge and generate ideas toward the future.

The south shore of Martha's Vineyard faces only the vast Atlantic Ocean with no natural or manmade barrier to protect it from any weather or storm or rising sea. While hurricanes travel from the south, they typically turn to strike the east coast or head out farther east into the ocean, raining down on the Vineyard's edge as a tropical storm. And, of course, there are the Nor'easters that hit the island throughout the winter and

early spring bringing hurricane-like winds, the highest of tides, and heavy sustained downpours.

Rendering of the Grand Bayway scheme, designed by Tom Leader Studio, entry for Resilient by Design Competition, San Francisco, 2018

My father had a friend who lived at a house at Windy Gates, the historic Chilmark community on the island's south shore cliffs far above the ocean. This house once sat at the very edge of the cliff but as the years passed, the force of storms and tides and the sea wore down this edge so that the house had to be moved back 60 feet. We know where the house once stood for the remains of its septic tank mark the original location; it's funny what artifacts tell a story. But the forces continue to barrel down on this shore, and this house in which my father's friend once lived again will have to be moved.

While many of the beaches on the south shore of the Vineyard are characterized by low dunes, the Lucy Vincent Beach had a great looming cliff called Lion's Head as a backdrop. Located toward the west of the south shore, I think of the Lucy Vincent Beach as *my beach*, for we have been going there since my daughter Sarah was five years old. When she was little, we would pass around the cliff to get to a quieter spot in the sand. Like a peninsula breaking off as an island, the edge of the cliff now stands independently, and since the erosion of Martha's Vineyard continues at a fast pace, I suspect that sometime when Sarah's sons visit, the Lion's Head will be entirely gone.[25]

While the south side of Martha's Vineyard faces the ocean, its northern tip sits just a few miles from Cape Cod's coast, an edge like so many that

The Wequobsque Cliffs, "Lion's Head," Lucy Vincent Beach, Chilmark, 1990s

The Wequobsque Cliffs, "Lion's Head," Lucy Vincent Beach, Chilmark, 2019

has been altered and eroded by increasingly fierce storms and increasingly higher sea levels. It is at this point, though, at the very farthest southwest reach of the Cape, in Woods Hole, where Rachel Carson would first lay eyes on the ocean, more moved by it than most. She would return to Woods Hole throughout her life to work and research, for it was here where she would be inspired by the sea and where she would come of age as a biologist and as a writer, referring to the place as the genesis for *The Sea Around Us*.[26] It was here also that the ocean would teach her about the interconnectivity of all earthly things, a lesson that she would attempt to impart to the world.

Notes

1. "Rachel Carson's Statement before Congress 1963," *Rachel Carson Council* (blog), accessed February 18, 2020, https://rachelcarsoncouncil.org/about-rcc/about-rachel-carson/rachel-carsons-statement-before-congress-1963/.

2. "Biology: Pesticides: The Price for Progress," *Time*, September 28, 1962, http://content.time.com/time/subscriber/article/0,33009,940091-4,00.html.

3. Michael Palmer, *Thread*, (New York: New Directions, 2011), 75.

4. "Hudson River PCBs," Riverkeeper, accessed February 19, 2020, https://www.riverkeeper.org/campaigns/stop-polluters/pcbs/.

5. "How Is the Hudson Doing? — NYS Dept. of Environmental Conservation," accessed February 19, 2020, https://www.dec.ny.gov/lands/77105.html.

6. "Toxic Pollutants and Chemicals of Concern | San Francisco Baykeeper," accessed February 19, 2020, https://baykeeper.org/our-work/toxic-pollutants-and-chemicals-concern.

7. "Our Poisoned Bay / Despite End to Direct Piping of Sewage, Pollution Worse Now than 30 Years Ago - SFGate," accessed February 19, 2020, https://www.sfgate.com/news/article/Our-Poisoned-Bay-Despite-end-to-direct-piping-2914964.php.

8. "Cars, Trucks, Buses and Air Pollution | Union of Concerned Scientists," accessed February 19, 2020, https://www.ucsusa.org/resources/cars-trucks-buses-and-air-pollution.

9. "Cars, Trucks, Buses and Air Pollution | Union of Concerned Scientists."

10. "We Depend on Plastic. Now We're Drowning in It." accessed February 19, 2020, https://www.nationalgeographic.com/magazine/2018/06/plastic-planet-waste-pollution-trash-crisis/.

11. Michael Oppenheimer and Barry Bergdoll, "Climate Change and World Cities," in *Rising Currents: Projects for New York's Waterfront* (London: Thames & Hudson, 2011), 33–34.

12. Oppenheimer and Bergdoll, 33–34.

13. Oppenheimer and Bergdoll, 34.

14. Oppenheimer and Bergdoll, 34–35.

15. John Whitaker, "How the New Whitney Museum Was Designed to Resist Climate Change," The Atlantic, May 27, 2015, https://www.theatlantic.com/entertainment/archive/2015/05/new-whitney-hurricane-sandy-climate-change/394100/.

16. Judith Rodin, "Preface," in *Rising Currents: Projects for New York's Waterfront*, ed. Barry Bergdoll (London: Thames & Hudson, 2011), 9.

17. Barry Bergdoll, "Rising Currents: Incubator for Design and Debate," in *Rising Currents: Projects for New York's Waterfront*, ed. Museum of Modern Art (New York (London: Thames & Hudson, 2011), 26–27.

18. Michael Kimmelman and Josh Haner, "The Dutch Have Solutions to Rising Seas. The World Is Watching." The *New York Times*, June 15, 2017, sec. World, https://www.nytimes.com/interactive/2017/06/15/world/europe/climate-change-rotterdam.html, https://www.nytimes.com/interactive/2017/06/15/world/europe/climate-change-rotterdam.html.

19. As quoted by Kimmelman and Haner.

20. B. Cannon Ivers, *Staging Urban Landscapes: The Activation and Curation of Flexible Public Spaces* (Basel: Birkhäuser, 2018), 224–29.

21. Glen Lowry, "Foreward," in *Rising Currents: Projects for New York's Waterfront*, ed. Barry Bergdoll (London: Thames & Hudson, 2011), 7.

22. *Social Infrastructure: New York*, Edward P. Bass Distinguished Visiting Architecture Fellowship (Series); 8. (New Haven, Connecticut: Yale School of Architecture, 2015).

23. This passage relies heavily on the following: Ariel Rubissow Okamoto, *Natural History of San Francisco Bay*, California Natural History Guides ; 102. (Berkeley: University of California Press, 2011), 288–89.

24. Information on the various components of this competition entry were gleaned from the firm's short film: *South Bay Sponge | The Field Operations Team | San Mateo & Santa Clara County*, accessed February 20, 2020, https://www.youtube.com/watch?v=YZrqJxq7XzQ.

25. During the course of this book's editing, the Lion's Head did actually erode, in April 2020.

26. The author recounts the important role Woods Hole played in the life and career of Carson, and paraphrases her referring to it as the "genesis" of *The Sea Around Us*. Linda J. Lear, *Rachel Carson : Witness for Nature*, 1st ed. (New York: Henry Holt, 1997), 120.

Transform

The relationship between art and place is a symbi-
otic one for art can be transformed by its context while
simultaneously it has the power to transform place. At
what scale can this potential be released? A significant
building can transform a district, and the development of
a district can transform a city. At the same time, the way
a city is built, how it is planned, designed, or spontaneously
expanded, is pivotal to the role it will play in history: architecture
and urban design are tools for change.

Where water and land meet, there is a constant need to negotiate the
boundary between them, and in this negotiation exists the opportunity
to transform place. Sites of all scales, that is, nations, regions, cities, dis-
tricts, city blocks, and parcels consumed by water, constantly remake them-
selves because the water and its force demand it.

Consider what has happened in the Netherlands, a country that teeters
at the very edge of the continent where Europe meets the North Sea; a
country that is so topographically low that a significant percentage of its
land actually falls below sea level. Consider the history and design of that
place. Could the Netherlands possess a character that is derived from any-
thing but its relationship with water?

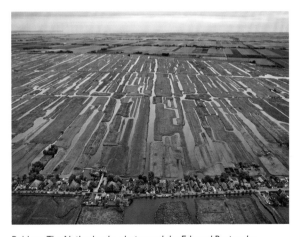

Polders, The Netherlands, photograph by Edward Burtynsky

My recent observations of the Netherlands are that the people there lead vibrant lives, that they are comfortable, and that there is, in general, a feeling that things are good. They are creative and humorous and confident; they take appropriate risk while simultaneously being practical. All of this culminates in a positive, appealing attitude that is present as the Dutch approach most things, including the design and the development of their cities. Design is important to them, and they build, often through competition, in order to ensure quality. And they confront obstacles such as rising sea levels and polluted sites head on, turning what could be seen as restrictive parameters into catalysts for thoughtful solutions.

It has been my experience that Europeans, but the Dutch in particular, who practice and oversee design in the public realm, are open and generous about sharing their knowledge and time. During 2015, Laura Hakvoort, an urban designer and researcher for the city of Amsterdam, took me on a day-long bike tour. And in 2017, Ton Schaap, the Amsterdam city architect, invited me to his home at the end of the Sporenburg peninsula, which sat vertical and tall at the edge of the water. His first floor was used as a study and filled with books, and so I felt comfortable right away, reminded of the stacks of books and papers in my own house. Wet bathing suits hung in the bathroom, for it is possible to swim in the small park just across his street. He and I climbed the stairs to the rooftop terrace where we could look out to the IJ, then took his tiny car for a driving tour of IJburg, the ongoing development of reclaimed land, which began in the 1990s and exhibits some of the most innovative, contemporary thinking in waterfront housing design. Its architects have experimented with a range of types, including floating houses, each iteration examining the relationship of structure to water and ground. IJburg, over time, has emerged as a workshop, each phase of building and design influencing the next. What's more is that the housing there is mixed-income and there has been a specific intention to make no distinction between that which is social and that which is market rate.

Floating Houses, IJburg, designed by Marlies Rohmer Architects and Urbanists, 2011

These encounters, and in particular the driving tour with Ton Schapp and his partner Herman Ruow, taught me a great deal about the Dutch perspective on water and climate; their bold attitude toward innovation and toward trying new things in general, but specifically in terms of design and building, as well as their stance on social equity as a critical component of place making.

The Italian writer, Edmundo de Amicis, gave an account of the Netherlands in his 1847 *Olanda:* "At first sight one could not say whether the land or the water have the upper hand here, whether the Netherlands belongs to the mainland or to the sea . . . The Netherlands is a prize won by men from the sea; it is an artificial, a 'made' land; the Dutch made it; it exists because the Dutch defend it; it would disappear if the Dutch left it."[1] What is embodied in the translated term "defend" certainly is not associated with a military threat, but rather an existential threat, one posed by water.

And at the scale of the city, there is Amsterdam, whose specific history has been determined by its negotiation with the water around it, a fact represented even in its naming of the Amstel, the river that runs through it from south Holland to the Bay of IJ.

The initial phase of the transformation of Amsterdam occurred as soon as the city was settled and had to do with the way in which the balance between land and water was manipulated for development. When its first inhabitants settled along the area's streams and peat bogs, they transformed the land, embarking on an ongoing and large-scale civil engineering project of installing ditches for drainage, in an effort to dry out the ground well enough to be farmed.[2] However, there existed a constant desire for more land to be developed as the population of Amsterdam grew. In order to accommodate this growth, the manipulation between land and water continued; the banks of the city's namesake river were filled to make room for more and more village, moats were constructed, and even the early drainage ditches were filled to make solid ground for building. In 1480, a wall was built around the city. Still, as the success of Amsterdam as a port continued, particularly from the 16th to the late 18th centuries, and specifically with the success of the Dutch East India Company, the conditions within the walls became even more dense.[3]

The second phase of Amsterdam's transformation is associated with the 17th-century establishment of the canal rings. These rings set up a spatial structure for the city where water, as it was controlled by human engineering, was a constant presence. The rings are recognizable easily in plan and aerial photography despite the fact that they vary in size and function for the driving force behind their design was formal. The canal plan, with its many bridges and elegant tree-lined quays, was the world's first example of urban planning on a city scale.[4] The canals provided the infrastructure necessary to manage the city's abundance of water as well as the infrastructure for intra-city movement. They created premium waterfront sites for wealthy residential properties which were served by the businesses on intersecting streets. What's more is that the initial canals and those that followed, together with the streets, plazas, and parks formed a rich network—a richly textured fabric—that would define Amsterdam's character centuries later.

So powerful is the urban landscape in defining the character of Amsterdam that it can be compared to the iconic opera house in Sydney and the Guggenheim in Bilbao, and to that end, the ring canals were added to the UNESCO World Heritage Site in 2010. Amsterdam's historical, picture-perfect center has made it a global tourist destination whose permanent population is anticipated to grow over the next 25 years, and there

exists already a high demand for new housing, infrastructure, energy, and data networks, according to my Dutch colleagues, Laura Hakvoort, Ton Schaap, and also Kees Slingerland, the former director of Advanced Mobility Solutions at the Amsterdam Institute for Advanced Metropolitan Solutions. Any contemporary expansion, like those in the past, from the earliest moment of settlement in the Netherlands, will have to consider the water.

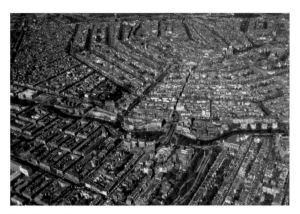

Canal Rings, Amsterdam, present day

I first traveled to Amsterdam for what was a brief visit in 1990 and then several times, for longer stays, after the year 2000. During some of these trips, I traveled to other cities in Europe first and then took the train into Amsterdam, arriving at the central station. As if to tell a story about the city and its evolving relationship to the IJ, in 1990, the central station faced only the historic city, its back purposefully turned on the 'second class' body of water, but during my later visits, the city's attitude had changed, and the station was edited and opened to face both its original center and also the IJ.

Considering the IJ had been home to the city's working harbor, rail yards, and industry, how would expansion and development here unfold? The Eastern Docklands had been manmade at the turn of the 20th century to protect Amsterdam's edge from storms. The area flourished with port activities until that city's port moved west, closer to the North Sea, leaving the port buildings and infrastructure of the Eastern Docklands abandoned and eventually, occupied by squatters, nomads, and artists. This occupation, albeit subversive, contributed to the idea that manmade land, way out in the water, that had been used for industry and as a buffer to the sea, could be part of the city's sanctioned and planned expansion. [5] But what would be the process of transformation? How would it be possible to connect the formerly industrial, subsequently abandoned waterfront with the center of Amsterdam? Fred Feddes, in *The Millennium of Amsterdam: Spatial History of a Marvellous City*, explains that the development would be phased: "Manageable sections are individually redeveloped one after another, according to contrasting urban planning concepts in striking architecture, with the water as the connecting factor."[6] The geography of the islands of Amsterdam's northern waterfront allowed for this type of development, where each building project could be constructed independently of the others.

Michael and I visited an initial phase of the development of the eastern harbor islands early on. We walked from the historic center, for what I remember as being a long way, to find development that followed an urban renewal approach and lacked the vibrancy that would come in later phases, which from a planning and architectural perspective, was more bold.

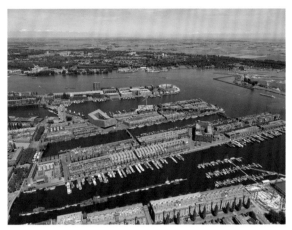

Eastern Docklands, Amsterdam, 2017

In the 1990s, Java Island was cleared for a master plan conceived by architects Soeters van Eldonk, which featured dense, mid-rise waterfront housing blocks with central common green spaces. As part of this plan, narrow houses, designed by young Dutch architects to reference the traditional building in Amsterdam's historic center, were built along four new canals, which are linked by pedestrian and bike bridges designed by the artists Guy Rombouts and Monika Droste. On Java, the inner road that faces the center city invites pedestrian traffic, while the Sumatrakade, zoned for vehicular traffic, faces the IJ.

Java Island Townhouses, Amsterdam, 2000

Later that decade, architect and urban planner Jo Coenen devised the master plan of KNSM, which was home to the then abandoned, former headquarters of the Royal Dutch Steamship Shipping company, and subsequently supervised its implementation. Coenen's plan, unlike that at Java,

called for select historic structures to be preserved among the new super-blocks. New insertions, with a central street running between them, were distinctly different from the tradition of building in the city proper, for they deliberately referenced the former shipyard, in terms of scale.

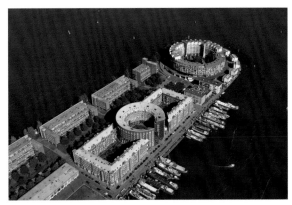

Koninklijke Nederlandse Stoomboot-Maatschappij (Royal Netherlands Steamship Company) (KNSM), Amsterdam, designed by Jo Coenen, 2013

Adriaan Geuze and West 8 won the competition for Borneo-Sporenburg with a plan of high-density, low-rise housing blocks that line the water, a diagonal park as a central feature, and three large landmark buildings. West 8 also designed two red steel pedestrian and bicycle bridges that connect Borneo and Sporenberg, across the internal canal. The geometry and the scale of the park, and the small-scale buildings, exist in contrast to the large-scale development on KNSM and to the canal houses that line the waterfront on Java and reference Amsterdam's historic city center. West 8's plan exhibited site-conscious planning strategies within limited dimensional parameters, calling for houses that included patios, roof gardens, and direct links to the water. Guidelines to ensure the presence of natural light within each house were established; on one side, the individual canal houses face an internal residential street with carports, garages, porches, and entrances; in contrast, on the other side, the houses face the water directly. With this relationship established between building and water, these structures are contemporary versions of canal houses where water is the open space for residences.

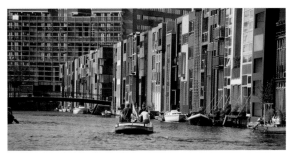

Borneo-Sporenburg Townhouses, Amsterdam, designed by West 8, 1999

The results of this development were, according to Feddes, "robust blocks from Coenen, sheltered 'rooms' and newly dug canals from Soeters, and a 'sea of houses' from Geuze."[7] Feddes goes on to point out how the development on the eastern islands is connected to the center of Amsterdam by the

Rietlanden and Oostelijke-Handelskade where the city intended to establish a series of public buildings that would act as cultural and community anchors, segmenting the riverbank into distinct urban sectors, each atmospherically different from the next. Among these are the OBA library and the Conservatory of Amsterdam, and Renzo Piano's NEMO science museum.

But all of this is reflective of the Dutch attitude toward the water, toward expansion, and toward design. They have embraced the idea that the water is inherently part of their lives, moving toward it rather than retreating from it as their cities evolve. The fact that these eastern islands had been home to industry is no obstacle for the Dutch. And while there are many cities where waterfronts have been reoccupied in the last few decades, in Amsterdam, design at the scale of the district and the building stands out. The planning approach to each island was different from the next, and the design that occurred on each proceeded with different degrees of prescribed parameters, creating a type of design laboratory for redevelopment. What emerged from this systematic method was an atmosphere of controlled creativity that resulted in an entire district where the urban design and architecture are simultaneously unified and diverse.

Earlier transformation in the history of Amsterdam had to do with the renegotiation of land and water as more land was needed to accommodate the expanding city. During those times, when the pressure of expansion was put on the city's boundaries, the IJ waterfront represented the one to the north and the IJ itself was considered the body of water north of Amsterdam's limits. During the most recent transformation of Amsterdam, however, a spatial repositioning of sorts occurred for now even the northern bank of the IJ is considered part of the city.[8] On the sunnier, northern IJ waterfront, where vast industrial sites were positioned for development, residential buildings were constructed, including one as early as 1980 by Koolhaas, and institutions, such as the EYE film center, on a former Royal Dutch Shell oil property, and the NDSM cultural center, on a former ship wharf, were established. That a free, 5-minute-long ferry ride from Centraal Station connects the southern shore across the IJ confirms the previous point that the entire northern shore has been annexed and activated as part of Amsterdam.

The transformation of the IJ waterfront represented a change in mindset for the people of Amsterdam; the water that is everywhere in this city was being recognized as an amenity. And that the development along the IJ includes public buildings of cultural significance, such as the EYE, the conservatory, and the library, as well as private residences, is testament to the fact, according to Amsterdam architectural writer Sabine Lebesque, that the waterfront is a resource for all.[9] But this is not the first time this city has remade itself: piece by piece a new Amsterdam emerges, one project affecting change on the next, as the city moves toward a new era.

As Amsterdam is a city beloved because of the transformations it has undergone, HafenCity, a district south of central Hamburg, is praised for being "one of Europe's most outstanding urban development projects" where the goal was to transform the former port district by developing it in the spirit of an urban city center.[10] The port district of Hamburg has remade itself multiple times in recent history, first with the pioneering Speicherstadt

Warehouse district and more recently, with the development HafenCity, where there has been a self-aware, forward-thinking process born from a tradition of innovative, contemporary urban design, architecture, and place making.

EYE Filmmuseum, Amsterdam, designed by Delugan Meissl Associated Architects, 2012

Before the development of HafenCity began, its leaders were careful to preserve the work of a previous generation that had brought about the transformation of the industrial warehouse typology. In 1991, more than five years before plans for HafenCity were made public, the brick warehouses of Speicherstadt, and its canals, bridges, and customs building were marked as a historical area,[11] and then later, just like Amsterdam's distinct urban canal landscape, Speicherstadt and the adjacent Kontorhaus district along with the Chilehaus building were made part of the UNESCO World Heritage List.

Built between 1885 and 1927, the Speicherstadt warehouses, which include 15 blocks and six ancillary buildings, are unique in that they are supported by thousands of oak pilings on a series of small island at the edge of the Elbe River; that they were both port and warehouse, a consolidation of use made necessary since duty-free trade was limited to the port, exclusively; and that they are connected to each other through a network of canals, streets, and bridges that allowed for access from both land and water so that storage buildings and ships could be loaded and unloaded directly from piers. The warehouses supported the most up-to-date transport methods of the time; goods were brought via barge, held without tax, then transported to their final destinations by road. "The Speicherstadt featured a new type of warehouse building that drew on the forms of older Hamburg warehouses, but was higher and more compact, with the various storage levels stacked one above the other," making the period of the duty-free storage particularly efficient.[12] The systemization here is both the root and byproduct of Hamburg's 19th-century dominance in industry. Global trade and the attention given to the decorative facades of the dark, brick warehouses, that is, the Gothic style gables, turrets, and parapets, reveal something of the wealth generated by this production.[13]

Like so much of Hamburg, parts of the Speicherstadt were destroyed during the 1943 bombing, Operation Gomorrah, and needed to be rebuilt. But by the time the rebuilding of the warehouses was complete, in 1967, so much

about global shipping had changed as containerization replaced break-bulk shipping, making the Speicherstadt obsolete.[14]

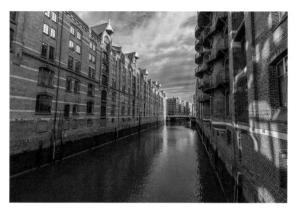

Speichertstadt, Hamburg

Although there were master plans, as late as the 1980s, to fill the river basin and expand industrial practices in Hamburg, progressive officials, just following German reunification, recognized that "centrally located docklands and industrial zones needed a change of usage" and bet on the growth of the media and IT sectors as dominating the new economy.[15] The transformation that was to occur at the edge of the flood-prone Elbe River to accommodate this new economy was kept from the public until 1997 when plans for a new dockland city were announced and design competitions were held for the new mixed residential, commercial, and cultural district that would occupy the river's northern waterfront.

Recall how in Amsterdam, the most recent transformation involved a taking back of land across the IJ, and a rethinking of border and boundary so that the city center's edge was no longer where the land stopped but rather included the body of water itself and the land on the other side. Here, in HafenCity, a "spatial repositioning" similarly took place. The development of HafenCity as district would make it so that Hamburg would not end where its industrial relics began, but rather, it would stretch all the way to the Elbe and include the land that had been dedicated to the port.

But the River Elbe was prone to flooding. Considering this, why go closer? Why not put pressure on another of Hamburg's boundaries if expansion is imminent? Because the character of the new "port city" depended on its physical relationship to the water and its former life, its past, as an industrial center. The plan would link the historic Hamburg city center to the Speicherstadt, HafenCity, and therefore the Elbe by way of small-scale, mixed-use development and green spaces such as promenades, parks, and plazas.

It was clear from the beginning that the open space plan by the Barcelona architect Benedetta Taglibue needed to include a strategy to address the flooding that occurred at the edge of Hamburg several times a year. However, rather than employ hard engineering solutions such as bulkheads or dikes, at HafenCity, plinths of compacted earth were constructed to elevate foundations, roads, bikeways and walkways above sea level while buildings that already existed at a lower elevation have undergone significant

floodproofing, with watertight windows and doors.[16] The vertical transition from the lower, city-facing portion of the development to the higher ele-

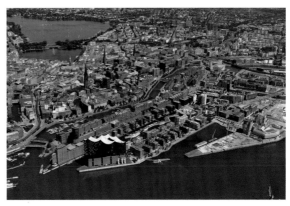

HafenCity, Hamburg

vations has lent itself to innovative design responses. The transitional area was programmed as open public space and allowed to flood during storm events. This 10.5 km shoreline promenade was built in sections by multiple designers to ensure diversity of schemes and user experience. The park spaces range in scale from large, open, piazze to intimate sitting areas with views of the harbor. So thoughtful are the solutions that the pedestrian may climb several meters at a time, engaging the vertical transition, without even knowing it.

HafenCity's major public terraces and piazzas are located at the heads of its historic harbor basins. Each of these is distinct, possessing its own specific vocabulary and condition, combining the negotiation of topographic change with program so that terraces, ramps, and steps are simultaneously social spaces, rest spaces, floodable as necessary.

Taglibue gives a comprehensive description of the building at HafenCity:

> The new urban planning brings the public in a fluid movement from the new housing blocks down to the water, making for everyone's enjoyment a new artificial landscape that is inhabited by natural elements: water and plants.
>
> A system of ramps, stairways, and catwalks connect the three different levels: Water level (±0,00) A big floating platform provides access to small boats, sport boats and ferryboats, as well as leisure areas. Special floating elements provide the presence of greenery and trees on the water level.
>
> Low promenade level (+4,50) This level is mainly for pedestrians, host small cafes and permit a relax promenade overlooking the water. This level will be flooded only on specially bad days on an average of twice or three times a year.
>
> Street level (+7,50) We provide pedestrian and playing places also at street level, introducing here, as well as in the lower levels, the presence of water, of trees and green, of playing areas and promenades, indicated by pergolas.

Hamburg has always been a city which recognised and worked with the conditions of the surrounding. This is why the river Elbe was never controlled by locks, and the floods were accepted, by integrating the natural conditions from the beginning, in order to guarantee a sustainable planning of the area.

The flooding protection strategy is to give water space rather than contain it, in order to protect the rest of the city. Two thirds of the new public spaces are floodable. It is consciously accepted that they will be flooded, and they have been designed in consequence. They are not useless remaining spaces, but usable and liveable. The city is at a higher level, always protected from the water.[17]

The process of designing and developing buildings within the HafenCity framework is a rigorous one driven by design competitions and requiring adherence to strict guidelines regarding scale, height, and use. For example, one guideline dictates the height of ground floors and requires that "social zones" exist at this level of each building to create a "metropolitan look" that would always be interesting and lively for the pedestrian. The intention was that HafenCity's use be a mix of residential, commercial, and cultural buildings and that a diversity of "household types, income groups, protagonists, scenes and user groups."[18]

While the Speicherstadt speaks to Hamburg's past and the development of HafenCity demonstrates the agility of its officials and the forward thinking of its people, Herzog & de Meuron's Elbphilharmonie tells a comprehensive story of place involving history, defeat, and multiple phases of transformation. Of all the places in the series of islands that are Speicherstadt and HafenCity, the Elbphilharmonie sits at the district's western-most point, way out in the River Elbe, inviting all of Hamburg and its visitors to this place where

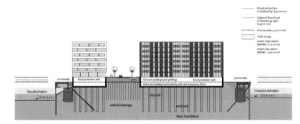

Flood zone and protection diagram, HafenCity

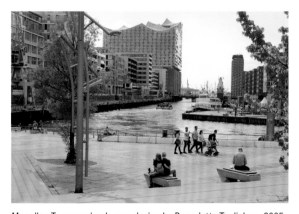

Magellan Terraces, landscape design by Benedetta Tagliabue, 2005

the edge has become a new city center. The Elbphilharmonie, with its multiple and varied uses, is like a little city; it includes three concert halls, in keeping with and perpetuating Hamburg's long history where music is at the heart of culture, as well as a restaurant, bars, apartments, a hotel, parking facilities, and a terrace with views of Hamburg and the harbor.[19]

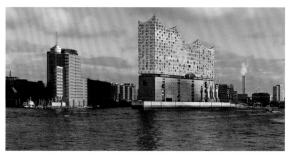

Elbphilharmonie, Hamburg, designed by Herzog & de Meuron, 2016

The new Herzog & de Meuron intervention rests on top of the 1966 Kaispeicher cocoa warehouse so that the older phase of postwar rebuilding serves as a literal base for the new. While 19th-century industrial structures referenced the features of Hamburg's historical architecture, mimicking the size and layout of windows even when use did not dictate their presence, the Kaispeicher was a component of the rebuilding effort, and although in terms of its materials, that is its brick facade, it blended into the traditional cityscape, the occurrence and pattern of windows make the building read as abstract and ahistorical.

The new Herzog & de Meuron addition emerges out of the old and changes itself in the process of projecting. The glass-clad building rests on top of the Kaispeicher, mimicking its footprint, and then expands upward until the top level has an undulating topography of wave-like curves. The small, u-shaped waves of the glass facets give texture to the four elevations, and this texture is embellished by the actual reflection of the Elbe River that occurs when the light is just right. There is no mistaking that the elements of this building reference the water that surrounds it.

The extrusion at Elbphilharmonie reaches 100m making it present from all points; it is viewed against the backdrop of the sky, a symbol of the rebirth of Hamburg's city center. It calls to the people of Hamburg to come to its dramatic, promontory site, then brings them up to an elevated 62,000 sf public plaza to look back at their historic city and its familiar spires, out to the contemporary Port of Hamburg that drives the region's economy, and over the water with a birds-eye-like view.

This is neither the first nor the last time Herzog & de Meuron have operated at the scale of a building to transform place. It was not an isolated incident that that firm work at the water's edge, called people to it. Nor is it unusual for Herzog & de Meuron to intervene on an existing structure with a significant past, the result being a transformation.

London's Bankside Power Station sat abandoned on the Thames, just across from St. Paul's Cathedral, looming largely with its symmetrical, horizontal

mass and its huge central chimney and windows, as a deterrent for redevelopment of the south side of the Thames.[20] The building was a simple brick shell with a series of steel columns dividing the vast space in two, and there were "no normal floors, no staircases, no interior walls: everything inside had been built as part of machinery, not part of the building."[21]

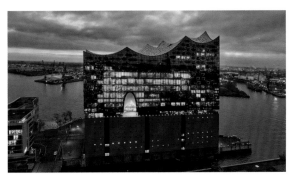

Elbphilharmonie, Hamburg, designed by Herzog & de Meuron, 2016

In the 18th century, Bankside and Southwark had been a manufacturing area dominated by working-class residents; in the 19th century, it was overcrowded and poverty-stricken; by the 20th century these conditions were, to some degree, alleviated by social programs and deindustrialization. The Thames has played a dual role in the history of London for it was both a conduit for trade and access to the rest of the world but also a divider of the city, barring those on the south side from the power and status of those on the north.[22] It was no surprise then that London's power station, its utility, its backdoor was located on the south side rather than the north side of the river.

Locating Tate Modern, which was to be a center for modern art worldwide and which, from the beginning, aimed to be a landmark for the city and nation, represents a transformation in mindset. Does art belong solely to the 'haves,' to be viewed safely within the boundaries of prescribed white walls or now does it move across the river, presumably existing for all, and in the process, impacting the development of an area that had been barred from art, wealth, and power for so long?

The huge ramp that begins outside the building's west facade and continues across the turbine hall as a street at full height for the length of the building responds to this question. The platform, which extends from the building to meet the promenade along the Thames, moves visitors inside and outside, back and forth. While the turbine hall is an immense space, essentially stretching the height and width of the structure, the galleries facing it are of varied size and proportion. The translucent beam that hovers above the mass of the structure, lets daylight into the galleries and turbine hall, and at night glows for all of the north side to see.

Tate Modern would change London when it first opened in 2000. "Herzog & de Meuron transformed the derelict Bankside Power Station into a home for the UK's collection of international modern and contemporary art, sparking local regeneration and creating a new landmark on the Thames."[23]

Earlier that same year, I was working on a project with Richard Rogers' London office when a colleague announced that he could take people to see the nearly completed Tate Modern. But 2000 was only the beginning, for with phase two, which opened in 2016 and added 60% more space to the museum, Herzog & de Meuron intended to complete "the site's transformation from a closed, industrial ruin to an open, public space."[24]

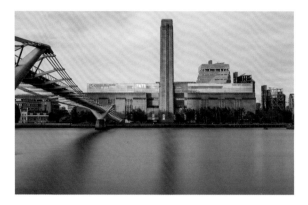

Tate Modern, London, designed by Herzog & de Meuron, 2000

Just as the Elbphilharmonie was built on the Kaispeicher, using its mass as a structural foundation and its design as a starting point for something new, the ten stories added to Tate Modern in 2016 were erected on top of three underground cylindrical tanks that served as a literal and figurative base. On top of these tanks, the new Switch House twists to form a shell for the diverse gallery volumes inside, culminating in a roof-top terrace that offers views of the city.

Louise Bourgeois, *Maman*, in the Turbine Hall at the Tate Modern, 2008

The development of the Tate Modern goes hand-in-hand with ARUP's and Foster's Millennium Bridge, and is in constant conversation with the 18th-century St. Paul's that lives across the river. In that way, the transformation on the Thames is comprehensive, taking place on both of its banks and including the passage over it. The phenomenon cultivated by the design of the bridge is one of civic engagement, civic participation, and of connection.

I do not recall exactly when I first visited the Tate, not the Herzog & de Meuron building on the south side of the Thames, but the one in Millbank

that houses British art from the 1500s to the present. But I know that when Michael was teaching at Cardiff University in 2000, I spent a week with him in Wales, then spent a week in London where he joined me. It was on this trip that we together saw a show at the Tate called *Ruskin, Turner and the Pre-Raphaelites*, an exhibition marking the centenary of Ruskin's death. Ruskin had been an enthusiastic supporter of Turner and I remember the show was an extraordinary view into Ruskin as a critic, lover of art, and as a human being. But for me, the show was all about Turner.

It was after seeing this specific exhibition that Turner became one of my central pursuits; he would stay with me for years, and continues to be with me. I felt somewhat of a kindred spirit when I was introduced to the work of John Akomfrah, who, upon emigrating to London from Ghana as a boy, would escape to the Tate to see Turner, and I know Turner's work has influenced his greatly. I wonder if Akomfrah returned to see the exhibition on Turner and Ruskin. I wonder if he saw the blood-red sky and the hands of drowning slaves breaking the surface of the water from below in Turner's *Slavers*.

I am back to Turner in this conversation because my pursuit of him that started in Millbank at the Tate is not unlike my pursuit of architecture that here has ended in that same city. In the Netherlands and in Amsterdam I recognize the power that exists in the ability to manipulate the line between water and land.

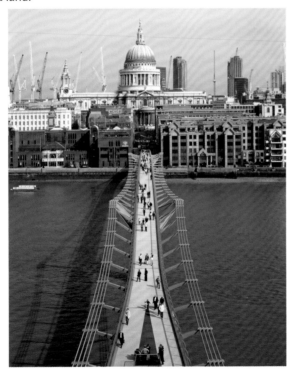

Millennium Bridge, London, designed by Foster + Partners with ARUP, 2000

In the development of the IJ and in the development of HafenCity, I recognize this power, especially when water functions as a boundary. And along the IJ and the Elbe but also along the Thames, I take lessons on how to make open and free places that had been used and abandoned. Here, the farthest

edges of Amsterdam, Hamburg, and London are integrated into the fabric of their respective cities. These newly connected edges speak to the relationships of manmade and nature-made, of periphery and center, and of past and present, always looking toward the next transformation.

And in Turner, I recognize a power so great it can be compared to the innovation that occurred in these places, for this work, in its own way, provokes thought and possesses the potential to shift perspective, a potential to change minds so great that it is tantamount to the transformation of spirits. Ruskin once owned Turner's *Slavers* and of it, in his *Modern Painters*, Vol. 1, Sec V, "Of Truth of Water" wrote:

> *I believe, if I were reduced to rest Turner's immortality upon any single work, I should choose this. Its daring conception—ideal in the highest sense of the word—is based on the purest truth, and wrought out with the concentrated knowledge of a life; its color is absolutely perfect, not one false or morbid hue in any part or line, and so modulated that every square inch of canvas is a perfect composition; its drawing as accurate as fearless; the ship buoyant, bending, and full of motion; its tones as true as they are wonderful; and the whole picture dedicated to the most sublime of subjects and impressions— (completing thus the perfect system of all truth, which we have shown to be formed by Turner's works)—the power, majesty, and deathfulness of the open, deep, illimitable Sea.[25]*

Notes

1. This specific quotation and its translation was provided by: Fred Feddes, *A Millennium of Amsterdam: Spatial History of a Marvellous City* (Bussum: Thoth Publishers, 2012), 9.

2. Feddes, 12.

3. Feddes, 66.

4. Spiro Kostof, *The City Shaped: Urban Patterns and Meanings through History* (London: Thames and Hudson, 1991), 112, 136–38.

5. For information on this part of Amsterdam's waterfront, I relied on the following sources: Sabine Lebesque, *Around Amsterdam's IJ Banks: From Architecture and Art to Green and New Development Areas* (New York: Available in North, South and Central America through D.A.P./ Distributed Art Publishers, 2011), 140–60; Ton Schapp, *Around Amsterdam's IJ Banks: From Architecture and Art to Green and New Development Areas*, ed. Sabine Lebesque (New York: Available in North, South and Central America through D.A.P./Distributed Art Publishers, 2011), 587–61; and "Along Amsterdams Waterfront: Exploring the Architecture of Amsterdam's Southern IJ Bank / Compiled and Written by Sabine Lebesque. Princeton University Library Catalog," 296–322, accessed February 20, 2020, https://catalog.princeton.edu/catalog/5314267.

6. Feddes, *A Millennium of Amsterdam*, 284.

7. Feddes, A Millennium of Amsterdam, 332.

8. Lebesque, *Around Amsterdam's IJ Banks*, 11–12.

9. Lebesque, 12.

10. *HafenCity Hamburg: neue urbane Begegnungsorte zwischen Metropole und Nachbarschaft = Places of urban encounter between metropolis and neighborhood* (New York: Springer, 2010), 7.

11. Dirk Meyhöfer, *Hafencity Hamburg: Waterfront : Architekturführer = Architectural guide*, 1. Auflage. (Hamburg: Junius Verlag, 2014), 14.

12. Meyhöfer, 191.

13. Meyhöfer, 191.

14. I relied on two sources for background on HafenCity. One is the city website ("HafenCity Hamburg - On Historic Ground," accessed February 21, 2020, https://www.hafencity.com/en/overview/on-historic-ground.html.) and the other, an unofficial, English translation of

Jorn Walter's, "Städtebau und Urbanität en der HafenCity," in *HafenCity Hamburg: das erste Jahrzehnt: Stadtentwicklung, Städtebau und Architektur*, Reihe Arbeitshefte zur HafenCity; (Hamburg: Junius, 2012).

15. Meyhöfer, *Hafencity Hamburg*, 13–18.

16. "HafenCityProjekte,"63, accessed February 21, 2020, https://www.hafencity.com/upload/files/files/HafenCityProjekte_March_2017_english.pdf.

17. This description has been published in various online locations including this one: "HAFENCITY PUBLIC SPACES | Miralles Tagliabue EMBT," Archello, accessed February 21, 2020, https://archello.com/project/hafencity-public-spaces.

18. Walter, "Städtebau und Urbanität en der HafenCity," 7.

19. "Herzog & de Meuron Elbphilharmonie," *A+U Architecture and Urbanism* 2017:3.

20. Tate Modern (Gallery), *Tate Modern: The Handbook* (London: Tate Publishing, 2016), 14.

21. Tate Modern (Gallery), 14.

22. Tate Modern (Gallery), 25–26.

23. "Tate Modern Switch House / Herzog & de Meuron," ArchDaily, May 23, 2016, http://www.archdaily.com/788076/tate-modern-switch-house-herzog-and-de-meuron.

24. Tate, "New Tate Modern Opens on 17 June 2016 – Press Release," Tate, accessed February 21, 2020, https://www.tate.org.uk/press/press-releases/new-tate-modern-opens-on-17-june-2016.

25. Ruskin, John, Modern Painters 1, "Section V, Of Truth of Water, Chapter III," Freeditorial Press PDF, 332.

Occupation:Boundary examines design at the urban waterfront and looks closely at the context in which this design takes place. The essays in this book consider why the threshold space between the sea and the city fabric has been ripe for development and the ways in which it has been activated by my colleagues in architecture and landscape architecture. In this final section, work from my own practice is presented through drawings and images that appear with essays prepared by critics John King and Justine Shapiro-Kline. The intention is to illustrate how certain cultural preoccupations and cities have provided me the most stimulating framework for design and opportunity to activate the public realm. While the history of the city and the topics of Archive are always present for me as I work on the urban waterfront or within the city fabric, inland of the water's edge, so too is art. Art runs as a theme throughout this book, for it is a means of depicting and recording the urban waterfront but is also an instrument in transforming it. And these transformations derive from various forms and methods, as demonstrated by my colleagues in Strategy. In my own work, art telegraphs through, revealing itself in sometimes-intangible ways and perhaps most notably in the influence it has had on my development into a designer sensitive to the contexts in which built interventions appear. You may ask yourself why an architect is so concerned with site and so consumed by the extensive fabric of the city. Isn't she crossing into the domain of landscape architects and planners? How does this pertain to her building? Doesn't she recognize boundaries? Why the city? Our major cities offer expanding populations that form complicated and intricate networks of people to activate the static nature of buildings. Conversely, our smaller cities have presented the condition of dwindling populations for decades, leaving policy makers, planners, urban designers, and those generally concerned with the state of equity and democratic access to opportunity distressed.

Our cities are and have been centers for commerce and industry. Past looked at how industry at the waterfront evolved, giving them a gritty, distinct identity, and then at how the devolution of the industrial complex left these places abandoned and cut off from the productive urban fabric. Work considered new economies at the waterfront and how waterfront park development has given life to real estate at this threshold. The shift described here has taken place rapidly, during the course of my lifetime. It is this shift in culture and in the physicality of place that beckons me. How could I not work here, at the urban edge, when this dynamism is present?

To say that culture exists in cities as opposed to suburban and rural areas is not fair as it would require a definition of culture that excludes traditions unknown to me or simply unrelated to the life I have led. But to live in a city is to be constantly charged by external stimuli. Art, music, food, politics, social engagement, and people of different backgrounds are all present, all the time, and are both the research and the subject of my placemaking.

Another case for the city is more concrete: public and private institutions frequently are developed in cities. These institutions, such as museums and opera houses described in the <u>Strategy</u> section of *Occupation : Boundary*, have audience in cities and, as stated in <u>Invite</u>, draw people to them as they become destinations. They have a broad impact and possess the power to reinvigorate neighborhoods and entire cities.

I would argue that the physical characteristics of a city's architecture are a demonstration of its social relationships, its hierarchies, and its values. The buildingscape tells the story of place and the people in that place in a visible, long-lasting manner.

For all of these reasons, it is in cities where I have chosen to work. I want my projects to be based in intricate pasts; to reflect the exhilaration that goes hand-in-hand with explosions of large city populations and economies or to embody the sadness that accompanies the absence of this substance in our evaporating small cities; to be of the complicated social networks that will occupy them; to be informed by the culture from which they emerge; to reflect a broad vision of what public means; to be transformative of place for anyone who inhabits them; and to manifest a set of values that reflect urban life and my life.

To this end, my approach to architecture is to turn my back on the standard ideas of where a project starts and ends. I look beyond the confines of two-dimensional survey drawings that show existing walls and property lines but fail to tell the story of place at all. I ask the following questions: How do you locate a project in the world, and what are its physical, programmatic, cultural, social, and political contexts? Where does a project end? At what line do I cease to gather information? Is a wall a boundary? Is a property line a boundary? Is the hard, engineered sea wall a boundary? Or, are these merely thresholds to the next place, part of a sequence of space that supersedes notions of ownership, rules, government, and logic? My understanding of the built environment and how I may be entitled to alter it is informed by research at a large scale. My process is external as I am constantly looking beyond one boundary and the next. And the questions that I pose here about edge and boundary and beginning and endpoints are not merely rhetorical but rather those that I grapple with as I take on any commission.

My practice has been concerned with looking as far back in time, into the past, as possible; there are no temporal boundaries. What are the characteristics of a current site, and what do they let me glean about the past? The work I am interested in producing has not been limited by time; my goal is that all of my work exudes a timelessness. My hope is that the work ages and changes and gets old and stays young and that my designs for buildings and spaces take on this temporality. Being "current" does not interest me as design that caters to style has a date of expiration and guarantees that at some point it will be rendered no longer relevant.

What makes cities so ripe for design, so appealing to architects, is that they are a complicated and contradictory combination of structure and form that is hard and slow to change and social, political, and cultural forces that are fluid. Cities are hubs of interaction as people from different backgrounds

arrive while others leave. This type of flux means the social demands of cities are constantly changing and, therefore, so is the demand for diverse types of institutions hosting multiple and varied programs.

While buildings are by nature static, architecture in cities must be flexible to receive these fast-paced social and cultural networks. A designer in the city must anticipate that her buildings' use will transform over time. Spatial integrity, programmatic specificity, materiality, and detail all go into making architecture, and landscapes that will endure and become our most beloved landmarks.

The transformation, reuse, and preservation of buildings deepens the experience of being present in the city. Architecture here is activated by layers of the past. A mixed-use public marketplace is richer when its regenerated structure reveals that it was a great transportation center one-hundred years earlier. The source of inspiration for a housing development may come from its once having been an abandoned hospital. A cultural establishment that has been an industrial, waterfront warehouse might be the catalyst for the revitalization of an entire city neighborhood.

My work could be considered "contextual," meaning that I seek a larger truth in terms of site and will interpret with a client and the community. This interpretation is without reiteration, mimicry, or pastiche. Rather, it seeks to provide a critical response by means of a voice informed by circumstance. I would never research the past and a wider and wider site context for something as trivial as style. Rather, I seek to have a sense of place before I alter it; to be informed before I am so brazen as to progress; and to understand the contemporary condition before I set out to write the most recent temporal episode in the biography of a city.

Maybe this seems personal, but I try to make it not. I have resisted imagery that relates exclusively to me and my experience, although I have indulged and described it here in this book's texts. But it should not be left unsaid that this imagery, whether garnered from time spent in the presence of art or generated by experiences in places around the world, most certainly has participated in the formation of the design approach I describe. I have tried to avoid the idiosyncratic in order to make my work accessible; it has been my role in my own practice and at Perkins & Will to consider that which is practical. What is the program of an urban project? What is its budget? I would argue that significant urban architecture and placemaking involves both a conceptual understanding of the essence of cities as well as methodical procedure in order to assure an outcome that bears civil impact and urban significance.

What follows this introduction is an exhibit of my work. Nearly half of these projects exist in the seam condition between the sea and the city that I have described and examined throughout this book. The others exhibit similar qualities in that they negotiate various urban forces—be them social, political, or cultural—so that all eleven exhibited projects possess an agenda relating to integration with context and creation or the restructuring of the public realm. In a broader sense, taken together, the projects honor place in their relationship to it and in this way their agendas become larger than themselves.

In my work, I have been conscious of the slow procession from one space to the next. Linger in the landscape outside my building. Move inside, and once there, proceed vertically from one level to the next. In this procession and with ease in shifting levels, your motion will suggest that something is going to happen but that it hasn't yet happened. It is my intention that to experience my work is to anticipate the unfinished moment. I hope that my buildings are a study in the continuum of time and movement. I expect for you and for time not to stand still but that you, my visitor, bring the action and the speed of the city, the street, and the surrounding world inside and upstairs and throughout the architecture, making my spaces fluid.

And this idea of bringing the city inside has little to do with formal aspirations, as you surely have gleaned. But really, it has to do with the desire to locate and establish common ground for the community. Whenever possible, I have brought the urban public inside, eager to present an interior realm where everyone is welcome, thereby blurring the lines between what is public and what is private. Of course, I care about what the press and the critics think but ultimately, my work is for you, the user who inhabits it and is, knowingly or unknowingly, affected and hopefully delighted by color, pattern, and the materiality of things, among the many other tools that a designer deploys to realize the built environment.

Nudging the City

John King

No matter how rigid the walls or settled
the mass, buildings live multiple lives. Not
even the most acclaimed civic icons stand
alone. Rather, the architectural forms around us
exist as sources of endless potential, malleable
to whatever vision might be brought to bear. There
are the aspirations of the architects and the inten-
tions of the client. The society in which a structure is
conceived and the time in which it flourishes, or falls
into decay. The symbolic role that a high-profile building
might perform in popular culture, or the artistic imagina-
tion, or what we conjure up when we stand inside and wince
or gape or shrug.

The common thread in Cathy Simon's architecture, be it intricate
works of adaptive preservation or in proudly contemporary struc-
tures where people work and learn, is her appreciation of its com-
plexity. She is sensitive to the relationship between structures and their
settings that make architecture resonate in a way that's distinct from
other arts. The ambition seen in her work is less about stylistic flourishes
than finding ways to engage the urban landscape, what it is, and what it can
become.

This is no easy task, especially if you're the head of a woman-owned firm in
a trade that professes rarified values but too often defers to the caricatured
tradition of all-powerful men, a la Frank Lloyd Wright. Not that SMWM
avoided the male-dominated fray. There was never an interest in small
"boutique" buildings, rarified creations for deep-pocketed clients. Instead,
as the firm evolved, its leader sought out civic-scaled projects ranging from
cultural institutions and schools to district-wide planning efforts. These
include disciplined yet transformative urban design work on Mission Bay,
a plan for former San Francisco rail yards that was conceived in the 1990s
and is now almost complete. Or new frontiers like Treasure Island—the
makeover of a manmade island facing San Francisco's Embarcadero from a
military base into a pedestrian-centered neighborhood that eventually will
include upwards of 8,000 homes and a topography elevated to withstand
sea level rise.

Others were more focused, and all the more tantalizing for that. Consider
one of Simon's most inspired conceptions, the San Francisco Ballet Pavilion,
a vision that remains potent though it never was built.

The tantalizing what-if dates back to the mid-1990s when the San Francisco
Ballet realized it needed to find a place where it could perform while

the Civic Center's War Memorial Opera House went through needed seismic upgrades. Simon, whose small firm was wrapping up a collaboration with Pei Cobb Freed & Partners on the San Francisco Main Library in Civic Center, drew up a scheme for a temporary pavilion building that could hold seventeen-hundred people, with a stage on the scale of the one in the Opera House.

The drawings and model that survive are beguiling. They show an outer shell intended to serve as an enormous scaffold comprising a double-steel seismic frame, an envelope large enough to encase a three-story glass lobby softened by furls of fabric, as well as an auditorium with tiered seating and corrugated metal outer walls. "A dialogue between transparency, shadow and structure," Simon wrote at the time, rightly so.

But again, buildings do not stand alone. What makes the vision linger vividly even now is that Simon placed the ballet pavilion on Market Street, alongside the planned entrance to the then-young Yerba Buena Arts District. While the San Francisco Museum of Modern Art was finishing construction and the grass of Yerba Buena Gardens was still taking root, Simon saw the binding potential of what we now call pop-up or tactical urbanism, 25 years ahead of its time.

The location pushed by Simon was across from where Grant Avenue meets Market, where the Four Seasons Hotel was erected a few years later. Imagine how different today's Market Street would be if culture blurred the lines of commerce, a portal of the arts rather than an ultra-luxe hotel. For a part of me believes that if this spark of Simon's had caught fire (there was enough institutional interest that the plan was discussed seriously in the San Francisco Chronicle), the district we know today would be much different. Instead, Simon left her mark on the emerging area in another way, more than 15 years later, with the restoration of the genuinely iconic Pacific Telephone Building at 140 New Montgomery Street. Designed largely by Timothy Pflueger, who went on to become one of San Francisco's most revered architects, the 26-story tower with gleaming white terra cotta walls opened in 1925. A work of sheer ebullience on what was conceived as the southern flank of the Financial District, it was left stranded when the Great Depression hit and the economy receded.

By the early 2000s, Pacific Telephone had been absorbed by what now is AT&T, and the tower's claim to fame was that it shared two alleys with SFMOMA, its neighbor directly to the west. Then a local developer purchased it, Wilson Meany, and hired SMWM to summon it back to glory. She did so with reverence and verve—emphasizing the fastidious restoration of such Jazz Age elements as the lavish black-marble lobby but also stripping the upper office floors bare to reveal their surprisingly muscular bones, a move that since has become much more common in such older high-rise structures.

Simon had already worked with Wilson Meany on another project, one that has had every bit the cultural impact that the Ballet Pavilion could have had: San Francisco's Ferry Building.

That project not only restored one of San Francisco's truly vital landmarks, but imbued it with a sensibility that tied the 1896 structure into the still-changing waterfront and city around it. The 245-foot-tall clocktower is as commanding as ever, to be sure. The 660-foot-long wall of arches that face the city remain as dignified as before. Equally important, though, there's no effort to fetishize the past or treat it like some preciously atmospheric stage set. Instead, the past is honored but then added to with a deft understanding that people want to navigate today's city on their own terms.

Case in point: the lone structural addition to the landmark's exterior is a clean metal-and-glass extension to the second floor that extends the entire length of the bay-facing façade. The design, responding to the standards set by the Secretary of the Interior, is understated, no big deal—except that it frames the passage from dense city to open waterfront, a shallow colonnade that blurs the two realms.

This combination of architectural practicality and urbanistic strength, I suspect, is inseparable from Cathy Simon's life—growing up in still-industrial New York and being influenced by written culture and the visual arts every bit as much as formal design instruction. Charles Sheeler paintings crystalized for Simon the acceptance of a waterfront's "hard engineered edges"; Herman Melville's fiction illuminated the underlying reality of what lay beyond, "the devilish brilliance and beauty" that waited to stir mass imaginations if twentieth-century Americans were only given the chance.

These realizations, sensing the link between daily life and larger potentials, are hardly unique to Simon; many of us weigh aspects of experience and insight in our minds. Cathy, though, made this a defining aspect of her career, the quest to try and knit architecture into the urgencies of contemporary life, while respecting the realities of place.

Look at the apparently straightforward Chou Hall, an expansion of the Haas School of Business at UC-Berkeley, which opened in 2017. At first glance it isn't far different from other academic buildings of our day and age, complete with such sustainable touches as extensive sunshades integrated into the façade. In fact, there are two very powerful existing conditions to relate to: a steep forested topography on the eastern edge of the Cal campus, and the powerful if theatrical postmodernism of the original complex for the business school, one of Charles Moore's last buildings.

Simon and her team didn't try to upstage Moore, wisely. Instead, they turned their hefty six-story structure into an inviting counterpoint to Moore's flourishes (complete with an enormous ivy-covered arch connecting two of his building's wings). Instead of cupolas, the rooftop offers a shaded terrace for students that overlooks the campus and the distant bay. Below, Chou Hall navigates the terrain with one level offering access to shaded paths through campus and another that turns the largely inaccessible courtyard conceived by Moore into a communal quad—levels that meet inside the building with a vast stair-framed and glassy space that functions as a lobby but encourages students to linger.

Chou Hall was completed after SMWM merged with Perkins & Will in 2008. So was one of the last large projects she led—the Bay Area Metro Center at 375 Beale St. on San Francisco's Rincon Hill, one short block from the Bay Bridge. Unlike such visual treasures as the Ferry Building or 140 New Montgomery, the structure consisted of an eight-story hulk of concrete that was built during World War II as a military supply depot. The acre-plus floor plates then spent 40 years in service to various government federal agencies, ending up as a U.S. Post Office distribution center.

A building like this might seem to offer little room to maneuver, yet it reopened in 2016 as a shared home for regional agencies that wrestle with such challenges as environmental sustainability in a metropolitan region of more than 7.5 million people.

Rather than suggest building a new structure, recycling the debris to add a green veneer, Simon and the team she oversaw embraced the reality of this specific, sturdy place. A linear atrium was carved to let in natural light and ventilated natural air while making the huge floor plates comprehensible. Exposed staircases, and gathering terraces on the upper levels, animated the public space of the public-oriented ground floor below. A new side entrance leads into a plaza that's popular with nearby residents. Douglas fir wood, salvaged from the federal days, adorns the building's public spaces throughout.

Everything around the robust concrete building has evolved; Rincon Hill is dotted with condominium towers of sleek glass. But the fit feels natural, an affirmation of the easy coexistence of future and past. Cathy Simon's gift as an architect has been to grasp how architecture can help nudge cities in new directions, and San Francisco is better as a result.

Choreographing the Public Realm

Justine Shapiro-Kline

Market Street cleaves San Francisco's two grids, tracing a long seam across the city from Twin Peaks to the Bay. Along its length, low-slung retail and housing keeps company with glassy pockets of new development. Downtown, the sidewalks teem with a mix of locals and visitors, while buses and trolleys shuttle along this vital thoroughfare. An ever-growing family of skyscrapers carves out a deep canyon of shade, drawing the eye toward the street's bright terminus. Here, a clock tower comes into focus, bathed in sunlight, and flanked by a forecourt of palm trees.

If the culmination of Market Street in a symmetrical, Beaux-Arts masterpiece presents itself as a logical achievement of city-building from a prior century, the Ferry Building's preservation was hardly assured. Designed by the City Engineer A. Page Brown, and conceived to support an explosion of ferry traffic at the turn of the twentieth century, the Ferry Building centralized operations to preside over an era of industrial growth at the waterfront. However, the building endured decades of neglect and obsolescence as the rise of personal automobiles and the construction of the Bay Bridge and later the Embarcadero Freeway redrew Bay Area circulation. It survived catastrophic earthquakes in 1906 and 1989, ultimately outlasting both the bridge and the freeway. The Ferry Building's adaptive reuse and rebirth, a century after its construction, ushered in a more considerable effort to reposition and reimagine San Francisco's waterfront for a post-industrial era.

Untangling the richly layered history of the Ferry Building as both a symbol and signal of the city in flux is critical to understand the context for Cathy Simon's practice and her work leading the transformation of this beloved landmark. It colors the backdrop for a project that succeeded thanks to design leadership that negotiates a delicate balance of vision, persistence, and collaboration. Moreover, it affirms the foundational importance of linking architectural imagination to larger scales of intervention and interplay in the public realm.

The Ferry Building's mix of uses reflects the hybrid goals and ambitions we hold for contemporary architecture, while its design productively mines opportunity from the contested space of historic preservation. The reinvention of the ground-floor baggage handling areas into an arcade lined with local foods and goods enlivens the space with foot traffic and filters the passage from city to waterfront façade, where several restaurants face out onto the Bay. Sunlight floods down from skylights in the central nave thanks to two long incisions in the upper-level slab. The opening up of the nave came about through a protracted negotiation that ultimately won the consent of the National Park Service. Other details are

subtler: the restoration of column capitals; the patching of the upper level mosaics; the insertion of interior glass curtain walls at each end of the commercial spaces.

Belief in design as a tool to renew and return historical buildings to active participation in the life of the city lies at the core of Simon's practice. Hers is a practice that conceives each work of architecture fully in dialogue with its context—able even to change the gravitational pull of its surroundings—and matches this intention with a rigorous understanding of how architecture, as a framework for activity, can elevate and support its users. The Ferry Building succeeds through the swirl of activity it draws into its orbit, the daily bustle building to a crescendo during the Saturday farmers' market, which spreads from the sidewalk out onto the pier. It exploits its symbolic status as the anchor of Market Street, poised on the boundary between city and water: a gateway and a beacon.

In contrast to this ultimate symbol of urban extroversion, the Oceanside Water Pollution Control Plant sets its sights on disappearing entirely, in order to claim a new public prominence through engagement and education. Situated in the city's southwest corner, where the gentle dunes of Ocean Beach give way abruptly to sandy bluffs at Fort Funston, Oceanside keeps company with the offices of the California National Guard and the San Francisco Zoo. Simon conceived the plant as a canyon within a vegetated hillside, invisible but for the concrete retaining walls and gates at entrance and exit. Offices, laboratories, and infrastructure encircle the interior courtyard, a composition of linked concrete forms that appear to hold back the hillside. Oceanside's circulation creates a series of superimposed loops: the vehicular path from Skyline Boulevard to Great Highway at grade level; the journey of staff through the interior, between and around the plant facilities within the courtyard; and the public walkway that circumnavigates the complex, snaking around buildings, ascending onto the hillside-roof, and finally returning visitors to the administration building terrace via a pedestrian bridge across the canyon floor.

The presence of visitors at the wastewater treatment facility is itself remarkable, an unprecedented achievement in public works at the time of the plant's opening in 1994. Simon's advocacy for the program in the design process was an extension of her instinctive orientation to position infrastructure at the center of the urban story. Whether contained within massive anaerobic digester eggs or shrouded by louvered concrete volumes, even as the plant's operations remain deliberately obscured, this public education initiative creates a space for essential infrastructure in the life and mind of the city. The resulting layered, sectional approach to circulation delineates a new

public realm above the plant, distinct but inseparable from an understanding of Oceanside.

The original Ferry Building, like Oceanside, possesses the distinction of being water dependent; the transfer of goods and people, much like the discharge of their treated wastewater depends wholly on the medium of water. Simon's architecture delights in the careful calibration of programs and spaces, which in turn balance at the interface between land and sea. Through the re-conception of the Ferry Building as a market and offices and the casting of the wastewater treatment plant as public infrastructure, Simon teaches us how the waterfront *made* the city. At the same time, her work illuminates that our urban future depends on these spaces of commerce and industry now as much as ever.

The juxtaposition of these two projects points to a second key aspect of Simon's work: a belief that architecture derives an enduring social power from the activity it elevates and enables, much more so than any attempt to focus the spotlight on itself. It reorients us to the natural environment, to the society in which we live, and even to our choices. This is evident in the way Simon describes her work:

> We offer a framework for activity, some of which we might anticipate, and
> some of which the building suggests. . . you allow it to play out as a place,
> which is incredibly rewarding.[1]

The loose-fit framework, which Simon derives from Lars Lerup's 1977 text, *Building the Unfinished*,[2] recognizes the delicate balance between technical demands and individual volition, the thread that connects private activity and urban life.

Simon's deft balancing of these multiple mandates is perhaps nowhere so evident as the San Francisco Conservatory of Music (SFCM). In the early 2000s, approaching its centennial, the Conservatory began a search for a new facility that would allow it to grow and expand in influence through an urban presence. Working with SMWM, SFCM identified a site in the Civic Center. Here, the preservation of a 1920s recreational facility combined with new construction on the adjacent lot would allow the institution to double in size while making multiple performance spaces public facing by way of a semi-public lobby. The resulting design harmonizes the disparate needs of classrooms, practice rooms, offices, and performance spaces through a sectional approach that stacks and wraps a recital, salon, and concert hall around a public atrium.

The Conservatory of Music underscores how the integration and expansion of a historic structure with new architecture can not only provide a new lease on life but also facilitate the reinterpretation of institutions themselves. The building's atrium, a limestone, steel, and glass composition, glows with the filtered and reflected daylight that streams through its south-facing windows. Surrounded with deep balconies and clusters of seating, the atrium, along with lounge spaces and a rooftop courtyard, offers a counterpoint to the warren of practice spaces that line the building's upper floors. The calibration of spaces for reflection and performance

plays out across a gradient from top to bottom. The concert hall, a space intent on holding sound and attention within its walls, becomes the glue that connects this institution to a citywide network of arts and culture.

It would be a challenge to conceive of three buildings with more disparate programmatic demands than the Ferry Building, Oceanside, and the Conservatory. Yet together they begin to illustrate the reach of Simon's practice and her indelible impact on the form of San Francisco and the Bay Area over the past four decades. These hybrid works house a multitude of purposes and users, in a constant process of transformation and renewal. They may take the adaptive reuse of a structure or site as the origin for a project but never as the destination. Above all, the work makes a deliberate contribution to the city's vibrant public life in ways that will continue to unfold.

Notes

1. Cathy Simon, conversation with Justine Shapiro-Kline, October 11, 2019.

2. Lerup, Lars. *Building the Unfinished: Architecture and Human Action* (Beverly Hills: Sage Publications, 1977).

San Francisco, 1988

The erosive power of water creates canyons and here became a metaphor for integrating building and landscape in this project programmed as both sewage treatment plant and public park. Nestled next to a dune and into ground adjacent to the Pacific Ocean, the pre-cast and in-situ concrete structure accommodates egg-shaped anaerobic digesters and heat recovery systems that were innovative when the project was built. Planted vegetation, carefully selected for the coastal environment, and pavers set in gravel demarcate areas open to the public and conceal pipes, tanks, and other infrastructure comprising the below-grade facilities. The situation of the plant partially underground preserved land for use by the San Francisco Zoo.

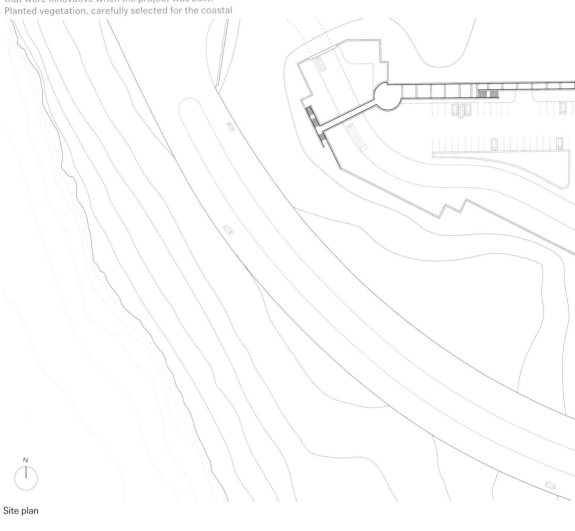

Site plan

Site section looking north

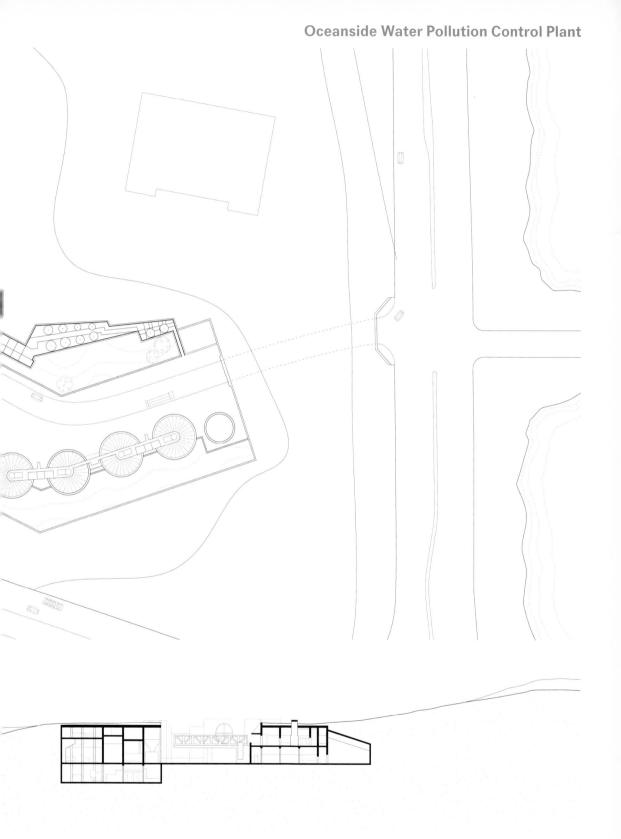

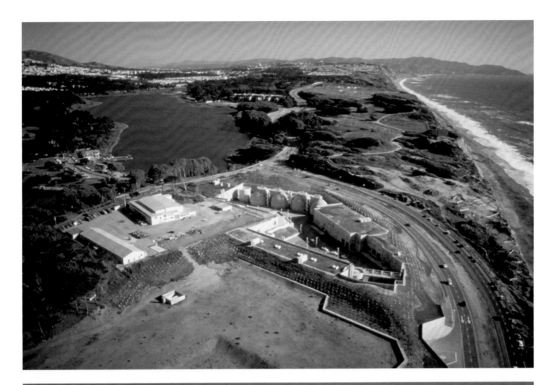

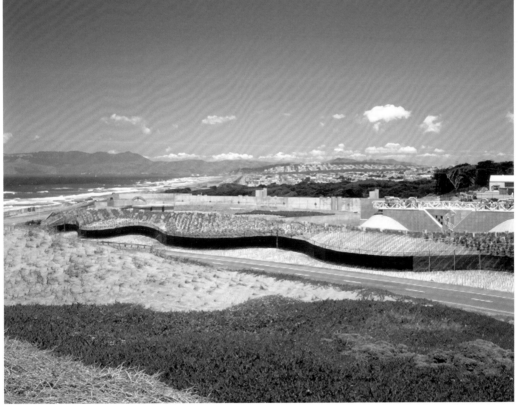

Aerial view looking south

View from berm looking northwest

Exhibit : Oceanside Water Pollution Control Plant

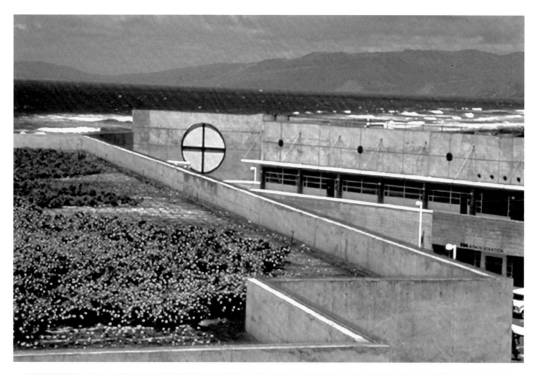

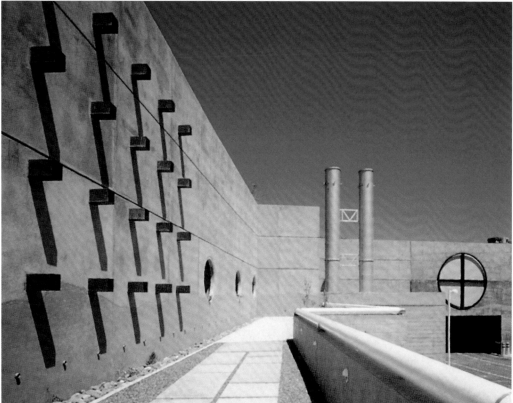

Partial view from vegetated roof looking west

View of elevated public walkway

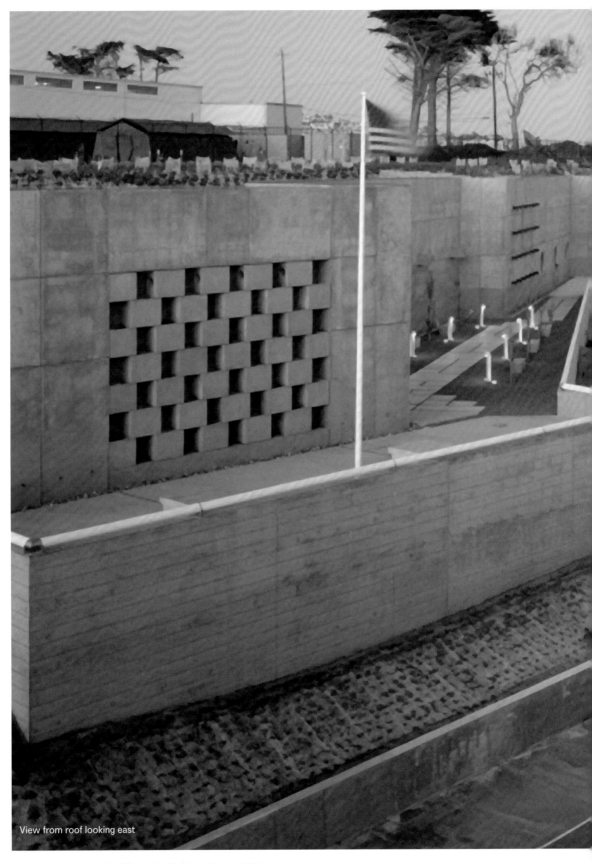

View from roof looking east

Exhibit : Oceanside Water Pollution Control Plant

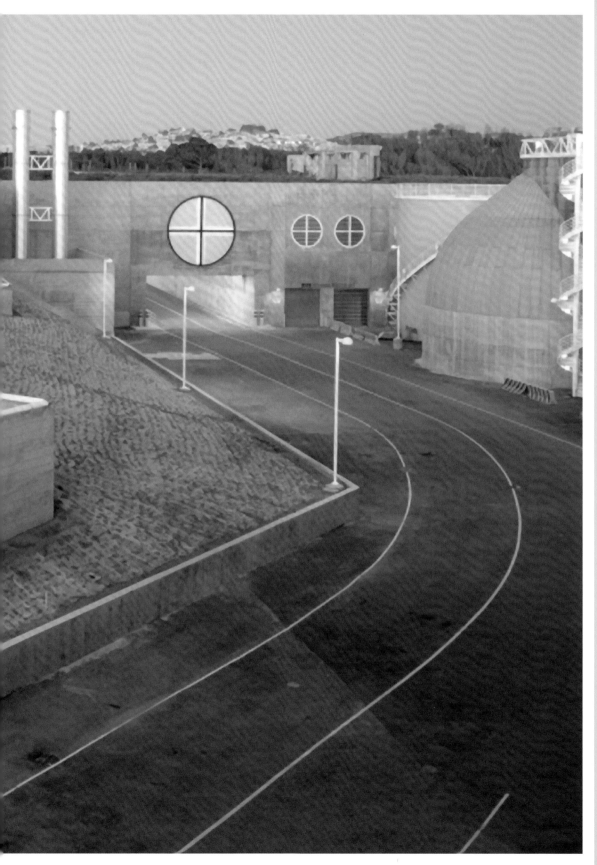

San Francisco, 2001

The first of San Francisco's historic finger piers to be restored was repurposed in this materially rich and environmentally conscious transformation of a 1930s industrial building into an open-plan office space suffused with natural light. Innovative active and passive heating and cooling systems make operating the building sustainable. Beyond extensive alterations to seismically retrofit the structure, the design employs preservation strategies that integrate existing railway tracks into the lobby floor and accommodate areas that provide public access to park space at the water.

Site plan

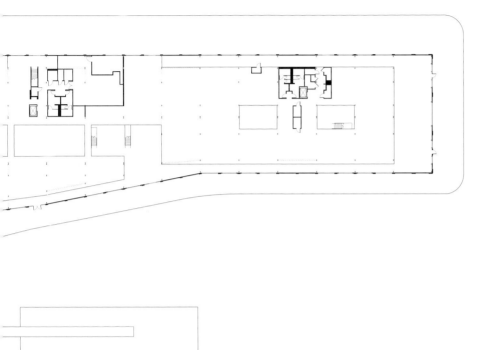

First floor plan

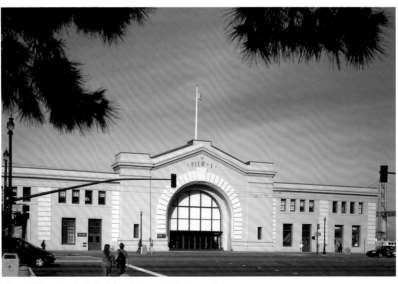

View of historic pier's bulkhead from the Embarcadero

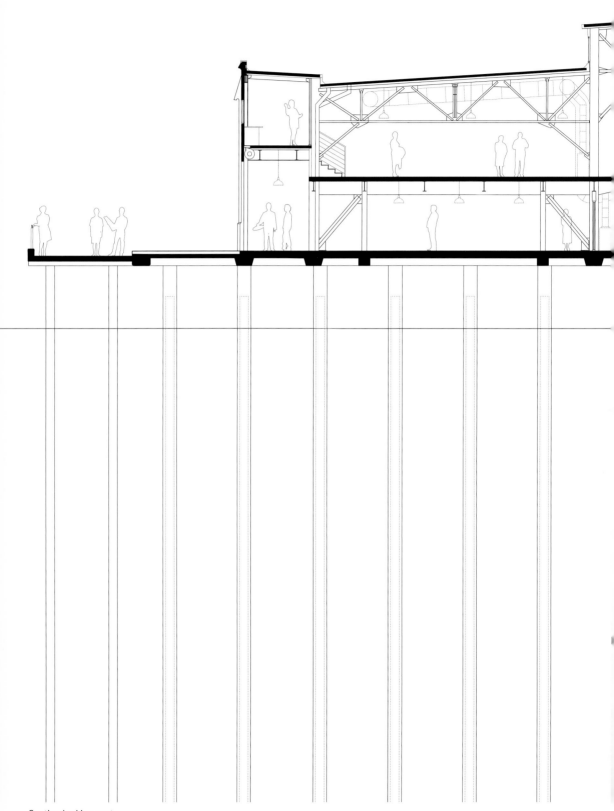

Section looking east

Exhibit : Pier One

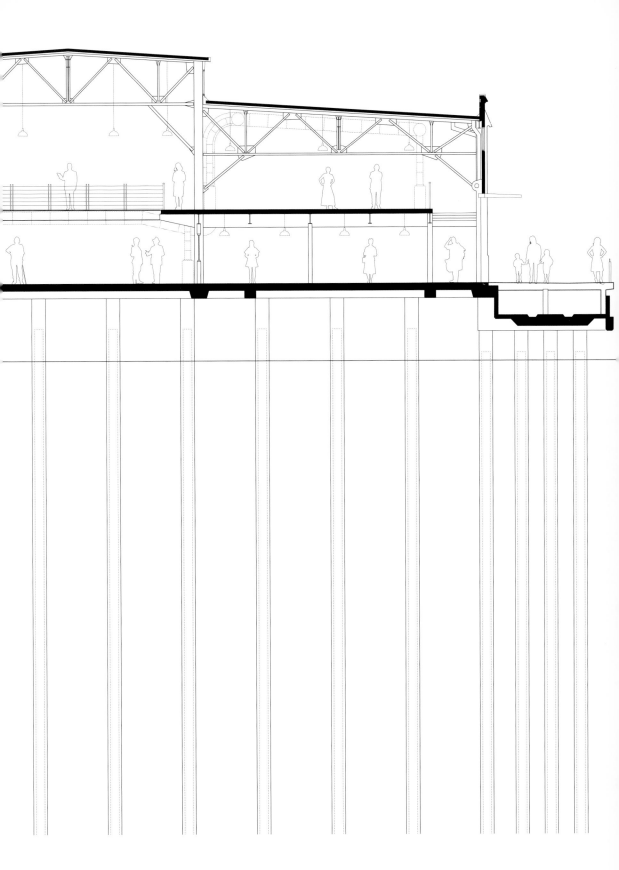

Public entry and lobby looking east

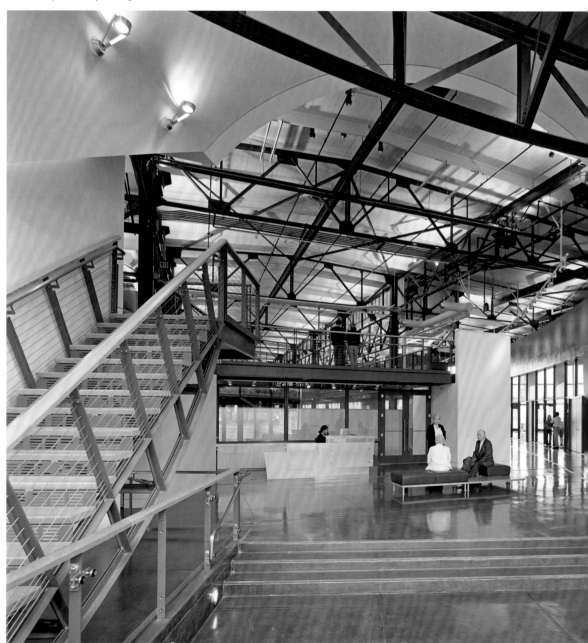

Exhibit : Pier One

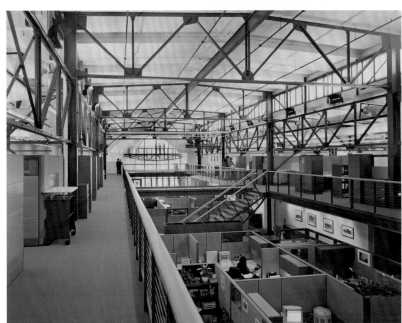

View of office space from the mezzanine level, which was added during renovation

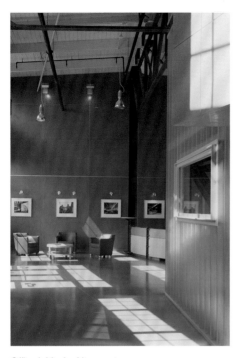

Office lobby looking west

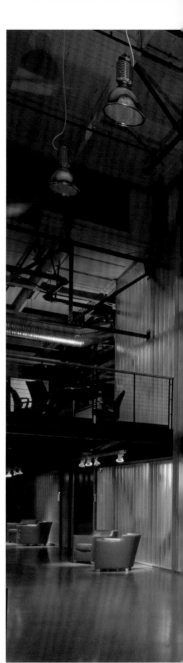

Pier apron and south façade, where the original metal roll-up cargo doors
were replaced by contemporary fenestration

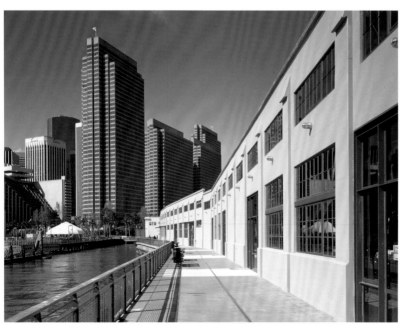

Exhibit : Pier One

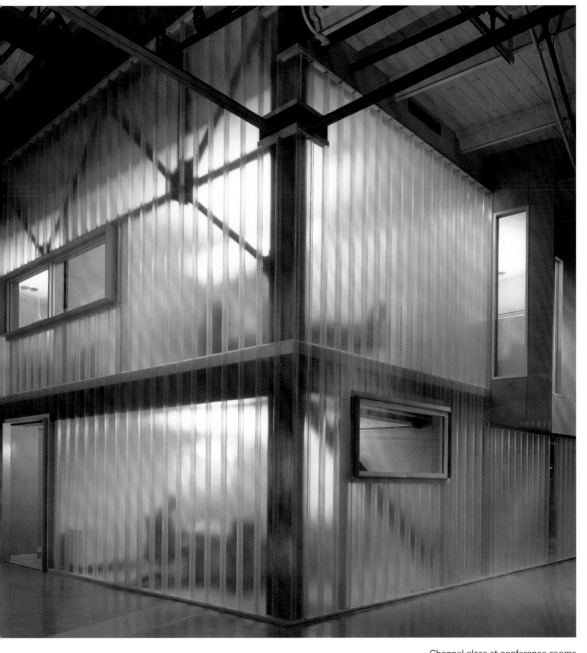

Channel glass at conference rooms

San Francisco, 2003

A conduit between the city and the water is established through this adaptive reuse project that brings together retail and office space while restoring a vibrant, skylit public realm to a building originally erected as a transportation hub at the turn of the century. The restoration of the nave, including the removal of ten bays of the second floor, affords a naturally lit public market committed to sustainable agriculture and local artisanal producers who participate in activating the ground floor.

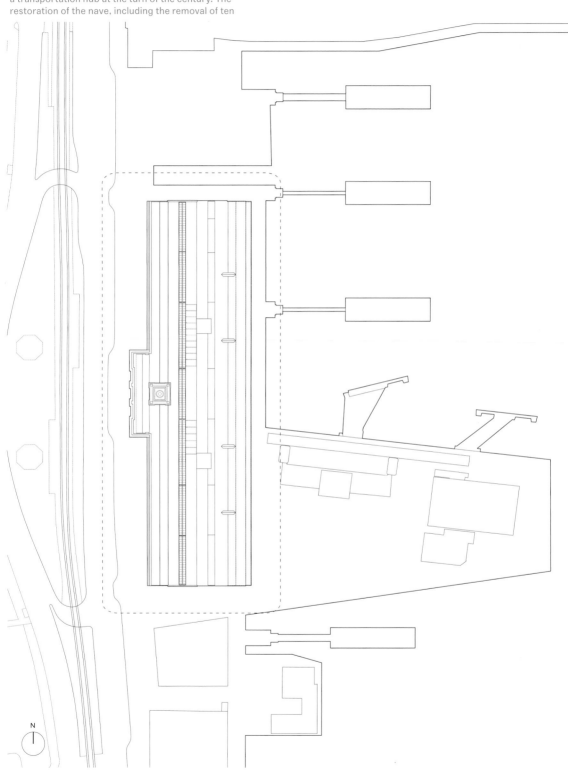

N

Site plan

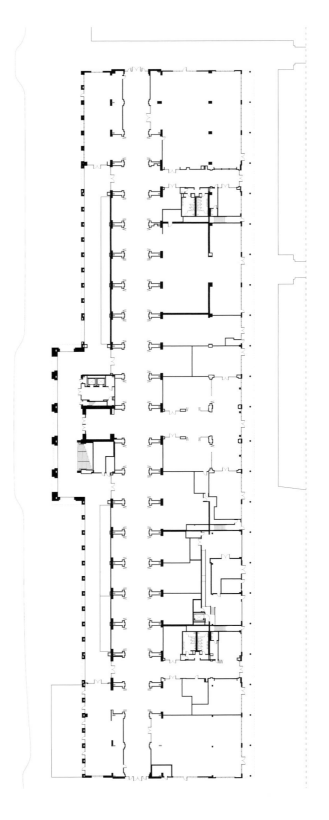

First floor plan

Aerial view of east façade during a market day

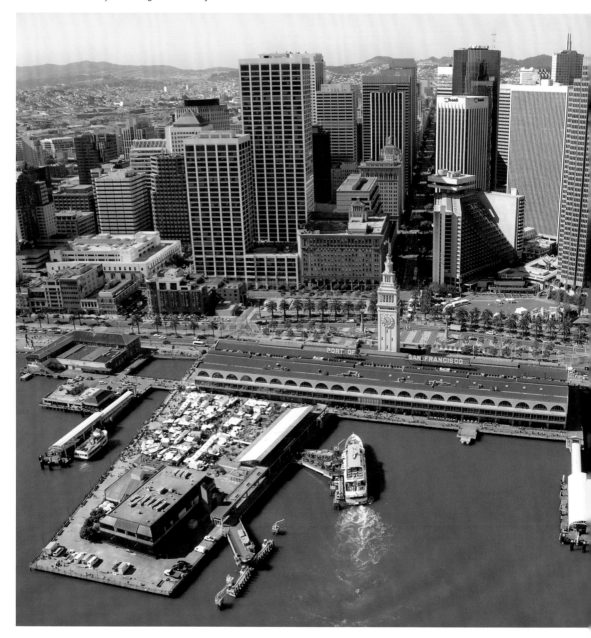

Exhibit : Ferry Building

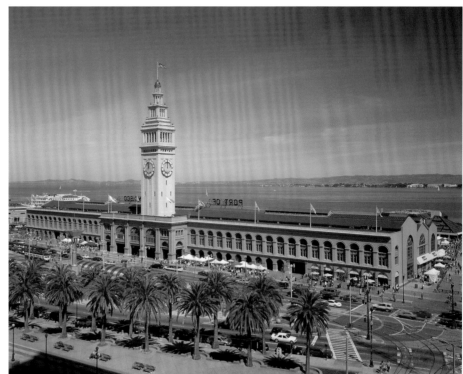

View of building from the south looking northeast

Section looking north

Exhibit : Ferry Building

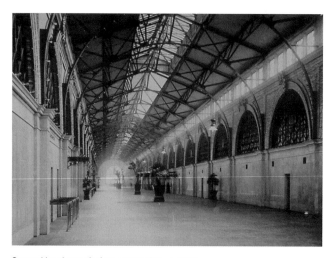

Second level nave before renovation, c. 1910

Marketplace at street level

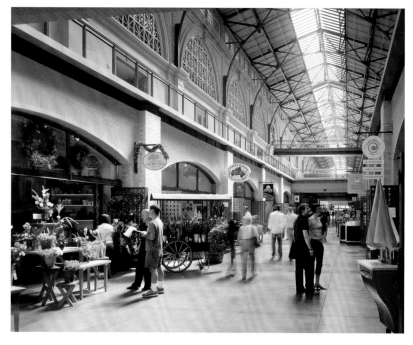

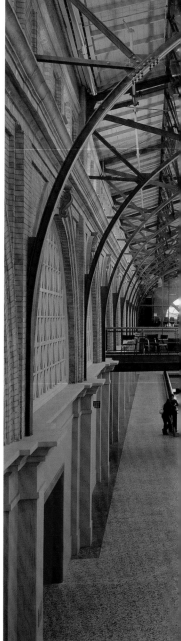

Exhibit : Ferry Building

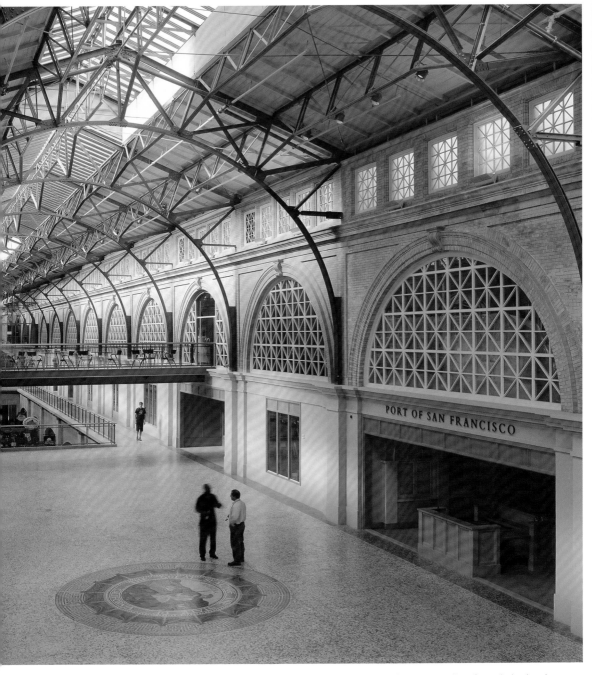

Second level and entrance to Port Commission hearing room

San Francisco, 2012

A responsive approach to climate change and sea-level rise is one feature of this design scheme for an island in the San Francisco Bay zoned for residential, commercial, mixed-use, and park space. The distinctive geometry of the urban plan is configured to channel sunlight and deflect wind away from dense residential fabric that features a transportation network with bike lanes, park spaces of various scales, including an art park, and carefully planned landscaping. Amidst planted windrows, neighborhood mews, a pedestrian promenade to the west, and a new ferry terminal, the proposal includes reinvention of three historic buildings, a twenty-acre urban farm, parklands, and sports fields, each envisioned as integral to the generation of community and an active public realm.

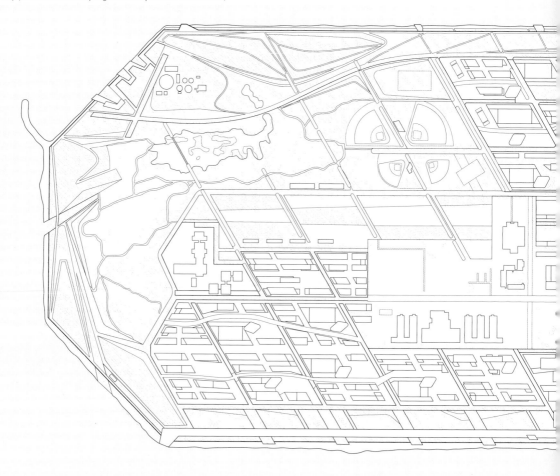

N

Master plan

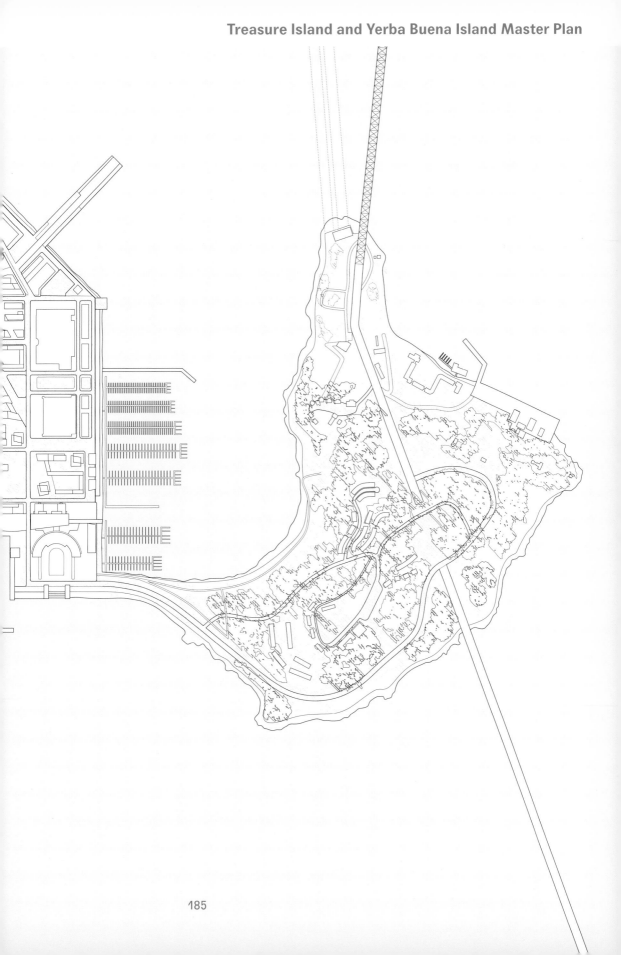

Treasure Island, Yerba Buena Island and downtown San Francisco

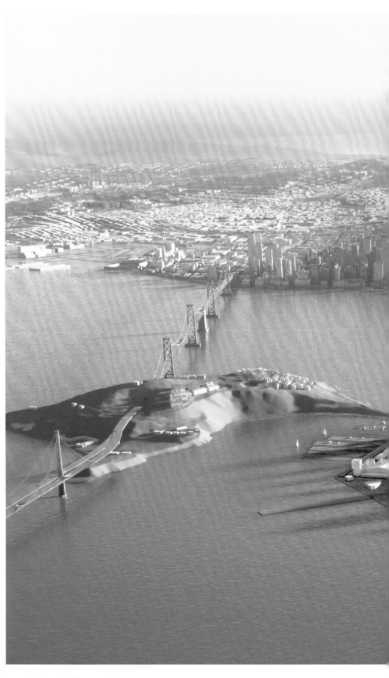

Exhibit : Treasure Island and Yerba Buena Island Master Plan

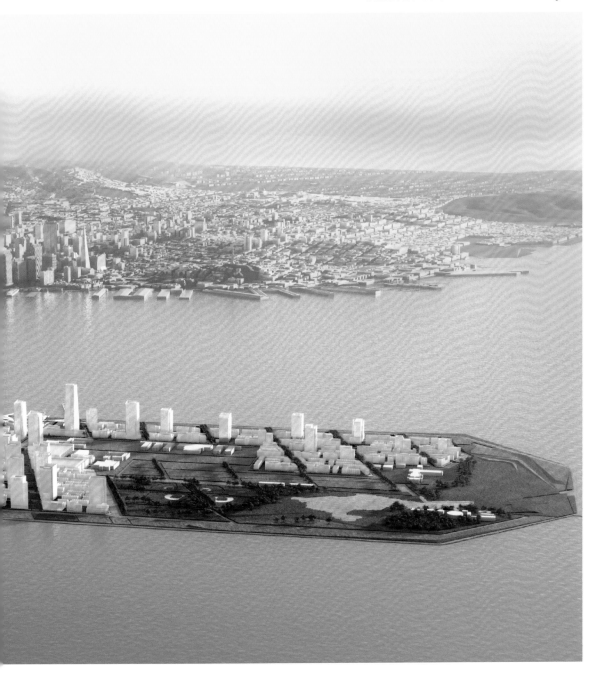

Treasure Island and Yerba Buena Island looking west

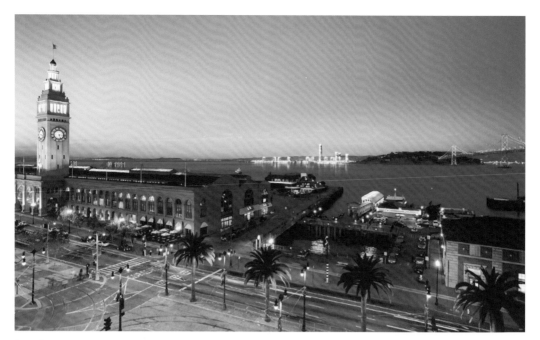

Ferry Building and Treasure Island development looking east

Towers of Treasure Island and Yerba Buena Island in the distance, as viewed from the east

San Francisco, 2014

Centered about a five-acre park located at McCovey Cove, the proposal's super-dike was designed to protect the mixed-use development from rising sea levels. With three additional acres dedicated to small-scale parks distributed around the commercial and residential zones and on refurbished piers, the project extends the urban plan for Mission Bay, seeking to expand and improve the original development, which is internationally notable for strategies that have activated the public realm and fostered a sustainable community.

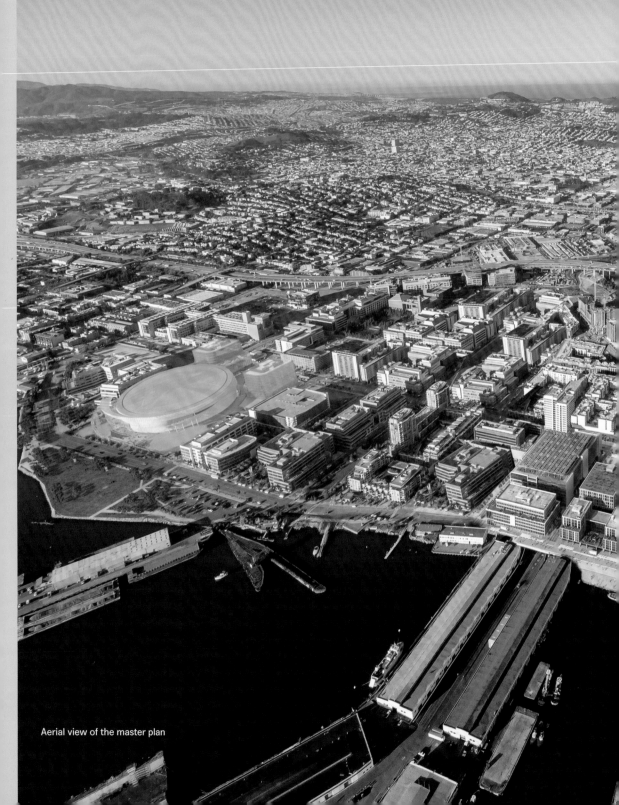

Aerial view of the master plan

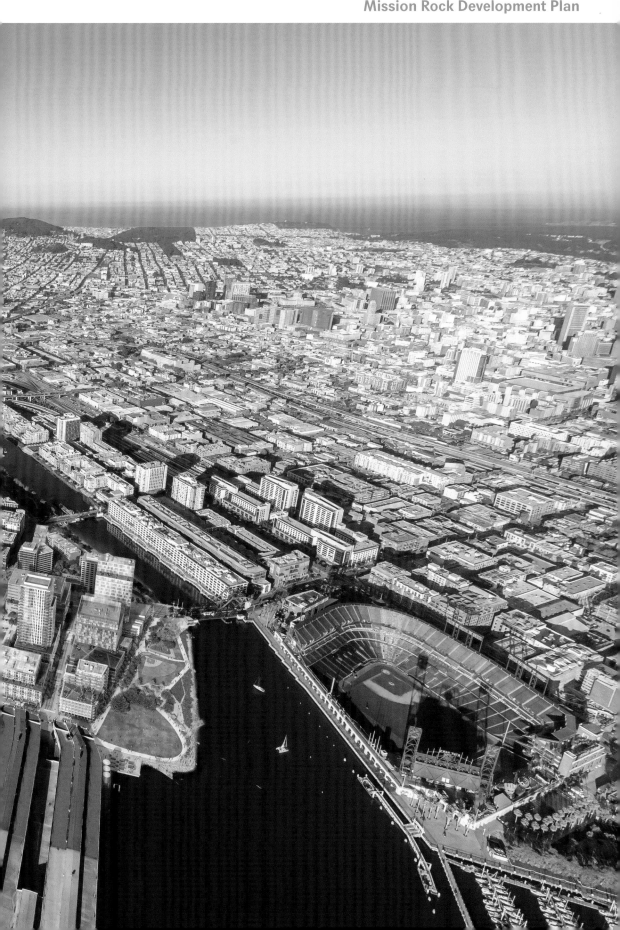

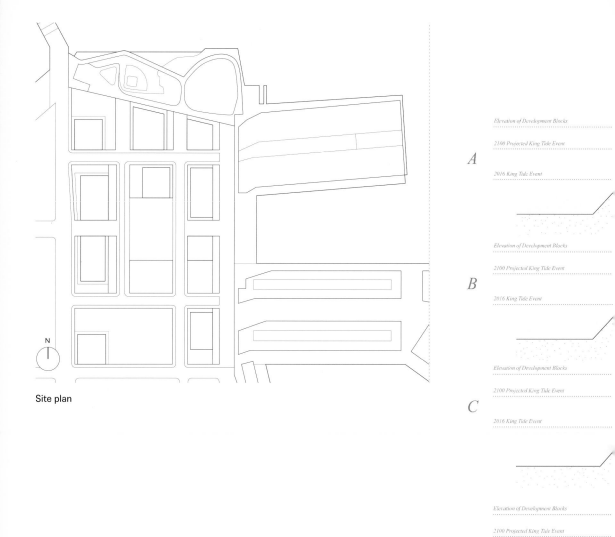

Site plan

Elevation of Development Blocks

2100 Projected King Tide Event

A

2016 King Tide Event

Elevation of Development Blocks

2100 Projected King Tide Event

B

2016 King Tide Event

Elevation of Development Blocks

2100 Projected King Tide Event

C

2016 King Tide Event

Elevation of Development Blocks

2100 Projected King Tide Event

D

2016 King Tide Event

Exhibit : Mission Rock Development Plan

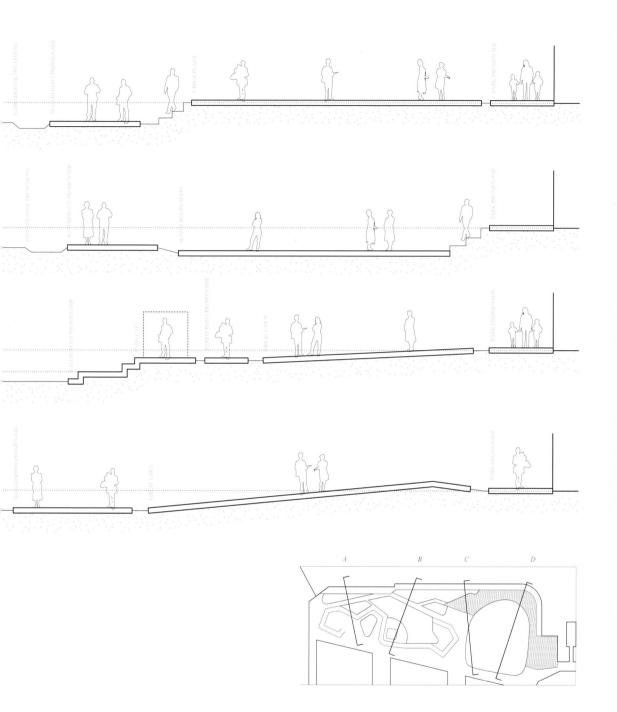

Sections looking east

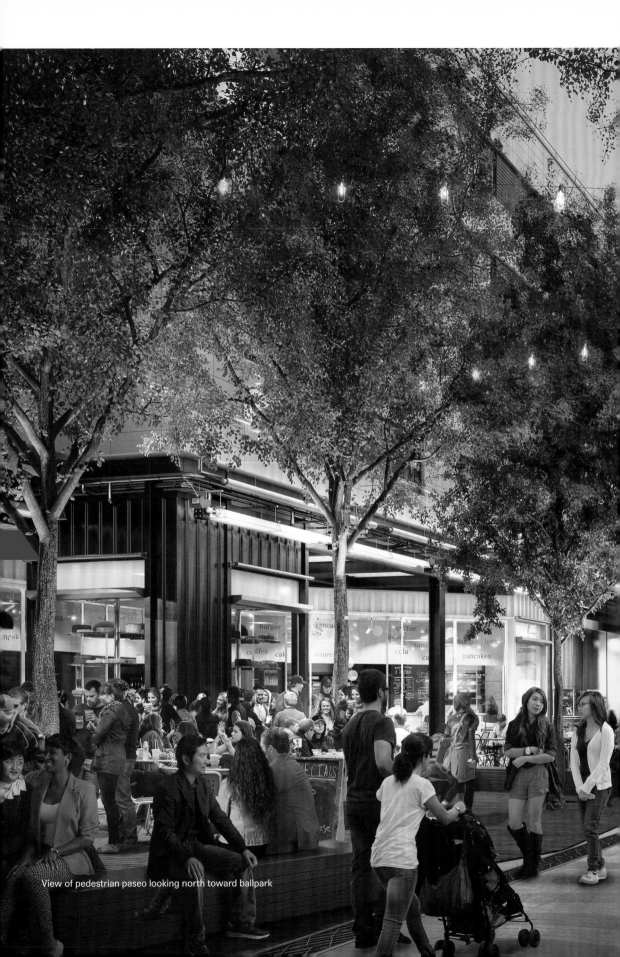

View of pedestrian paseo looking north toward ballpark

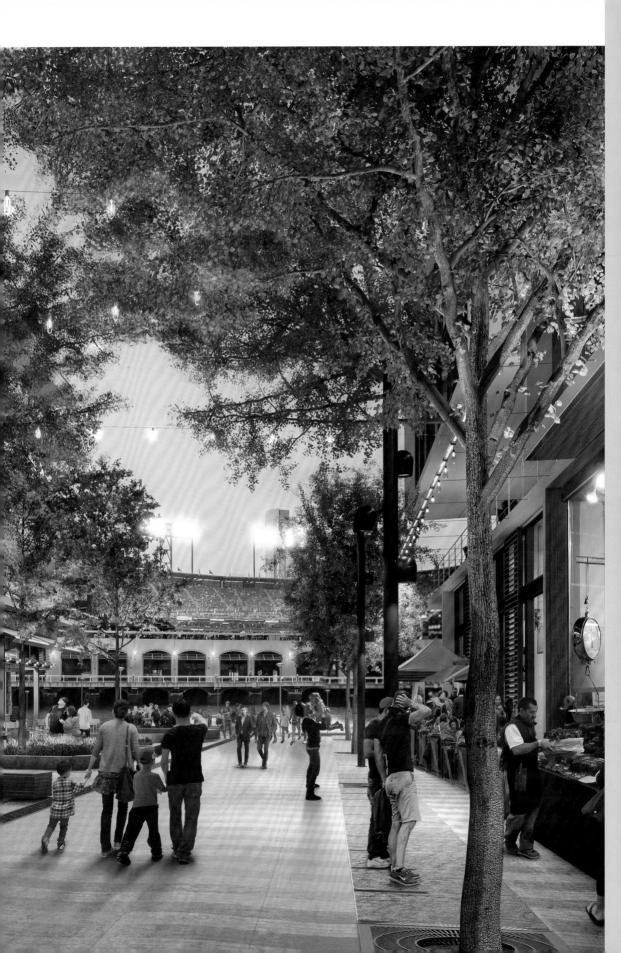

San Francisco, 1995

Sited on Market Street, a gateway to the theaters, museums, and parks that comprise the structures and spaces dedicated to the Yerba Buena Garden's cultural program, the proposal established a democratic, flexible, and demountable temporary theater pavilion designed for dance performance. Expansion of the structure could be achieved by way of plug-in dressing rooms, while the fly loft, meant to serve as infrastructure for lighting and announcements, was designed to support community awareness of cultural programming open to all.

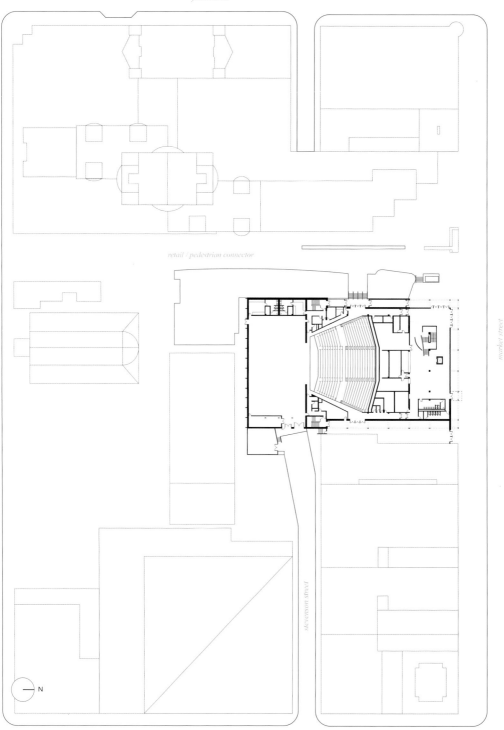

fourth street

retail / pedestrian connector

mission street

market street

stevenson street

N

third street

Site plan

Photo-collage of the model with view looking south
toward Yerba Buena Gardens and the Bay

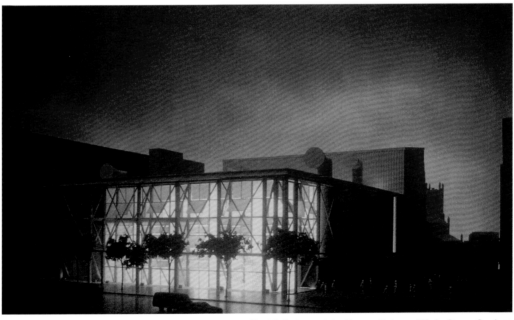

Model photograph looking south toward Yerba Buena Gardens

197

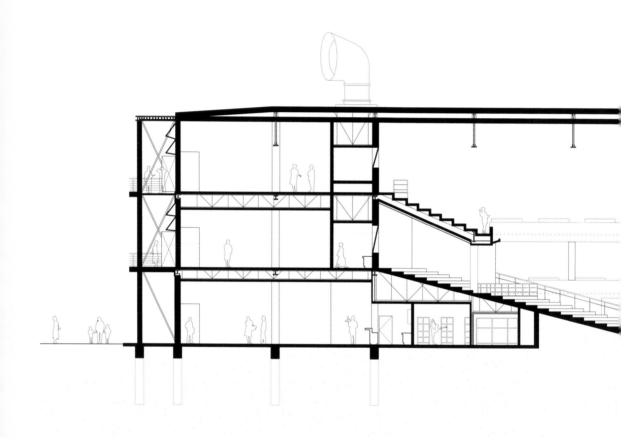

Section looking east

Exhibit : San Francisco Ballet Pavilion

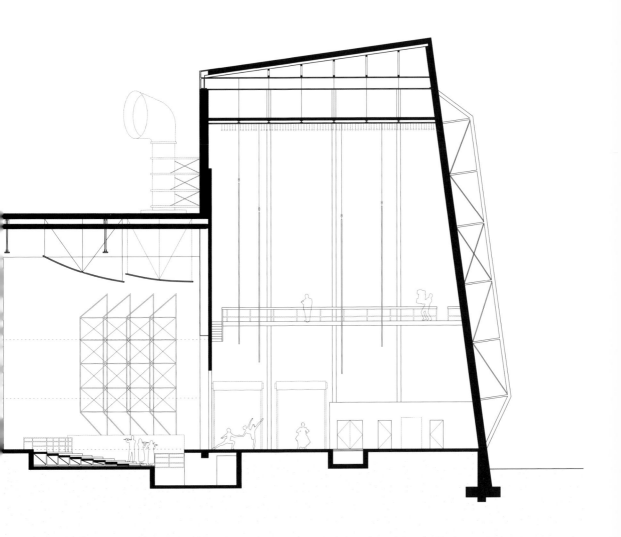

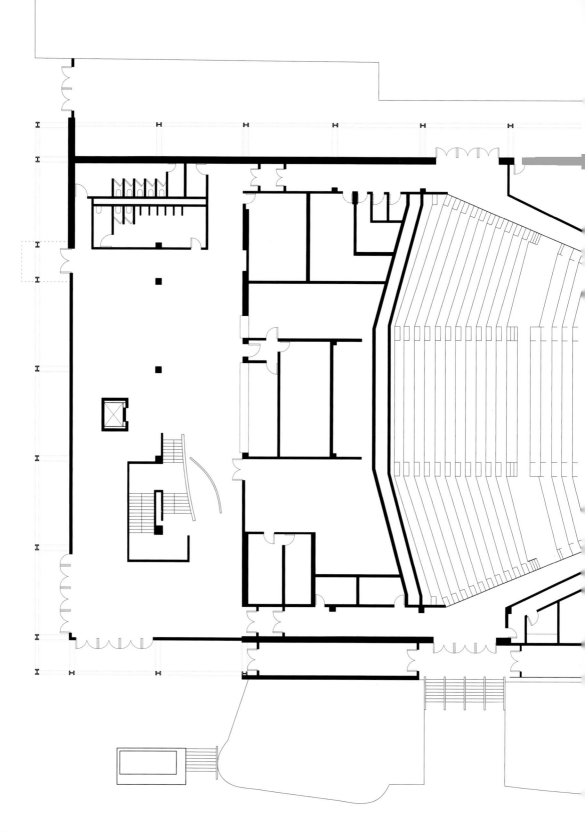

Plan

Exhibit : San Francisco Ballet Pavilion

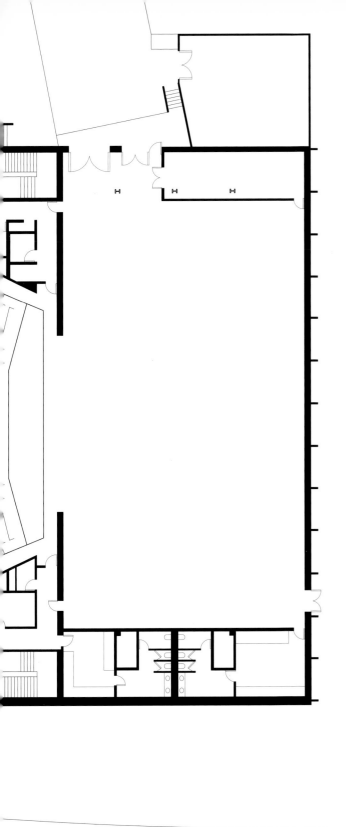

Model photograph of Market Street façade

San Francisco, 2006

Set within the dense urban fabric of the Civic Center, the augmentation of this neo-classical building extends the cultural program of San Francisco with multiple theater spaces for performance and a music conservatory that welcomes the public into its campus. The innovation of the architecture, seen through the balanced coexistence of the existing building, high-tech concert halls, and sophisticated education facilities, resonates with programming that embraces classical repertory and contemporary music. A variety of wood species mediate performance space and public space, serving acoustical purposes and as means for wayfinding. Lined with Brazilian Cherry, the main entrance atrium participates in welcoming the public and serves as a theatrical and unifying spatial element, showcasing quotidian practices of students, faculty, and visiting artists.

Site plan

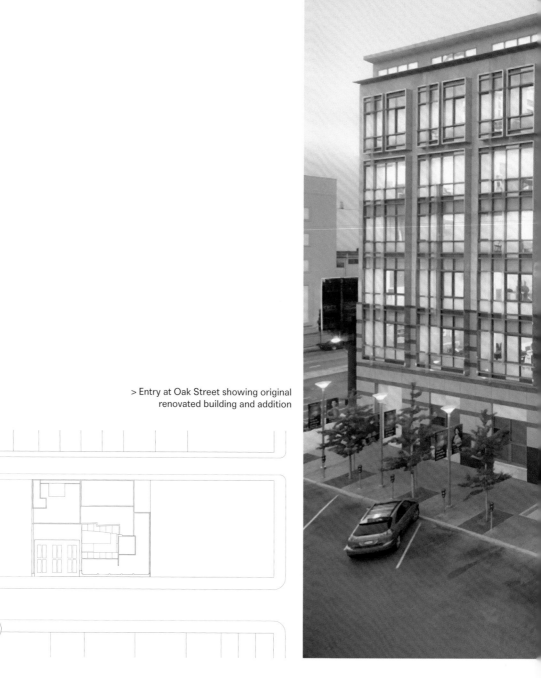

> Entry at Oak Street showing original renovated building and addition

N

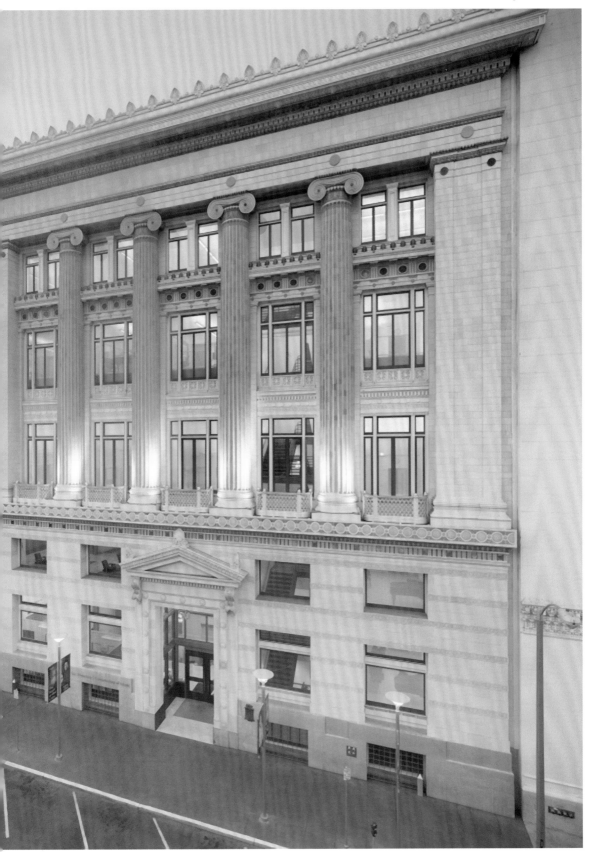

Concert hall > View of Atrium from lower level

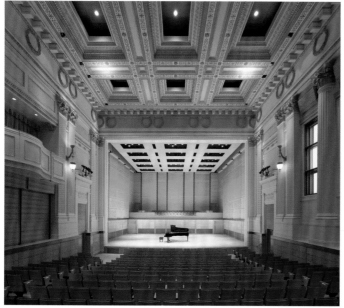

Exhibit : San Francisco Conservatory of Music

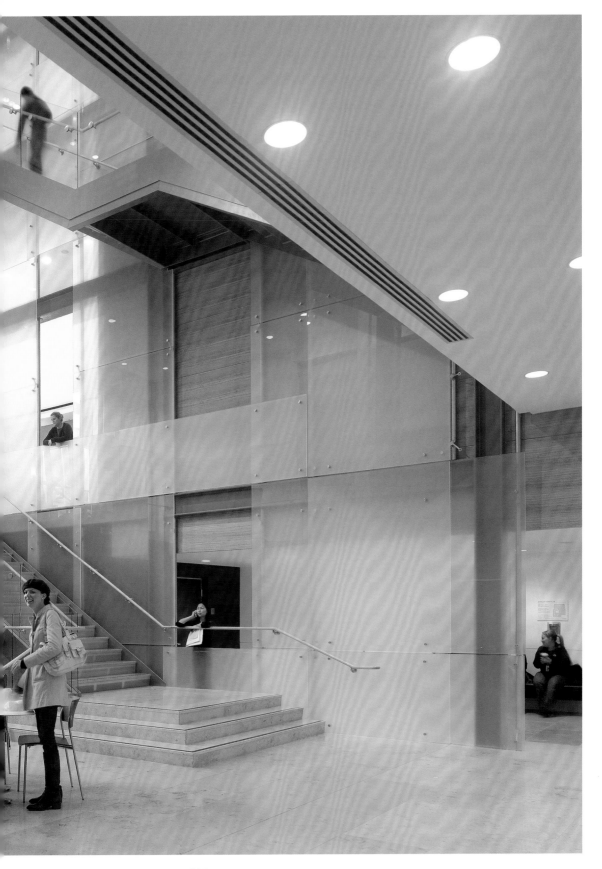

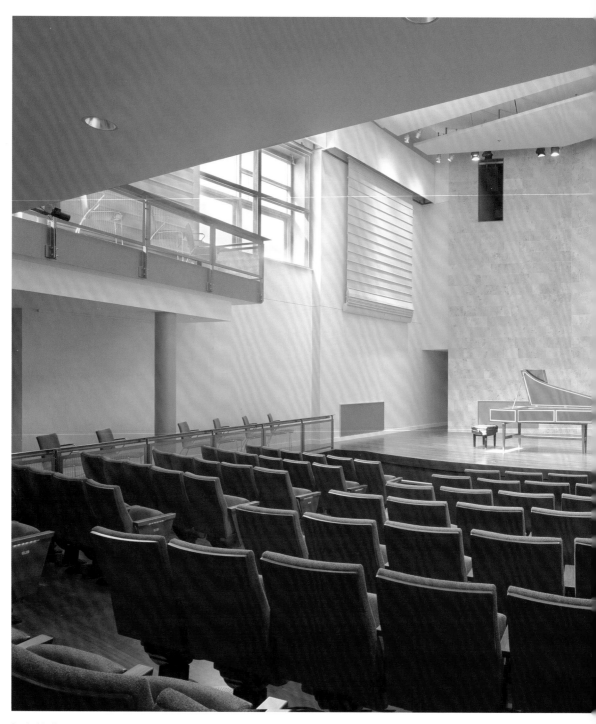

Recital hall

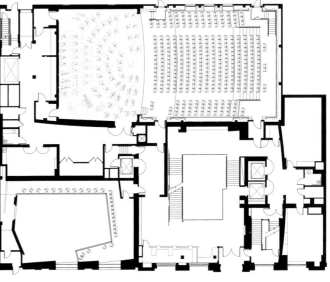

Plan

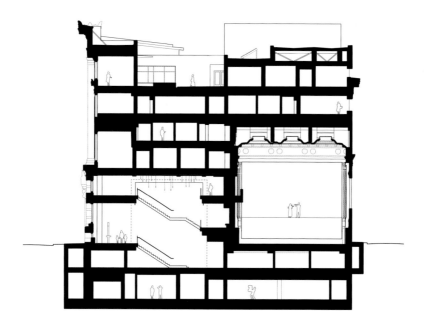

Section looking west

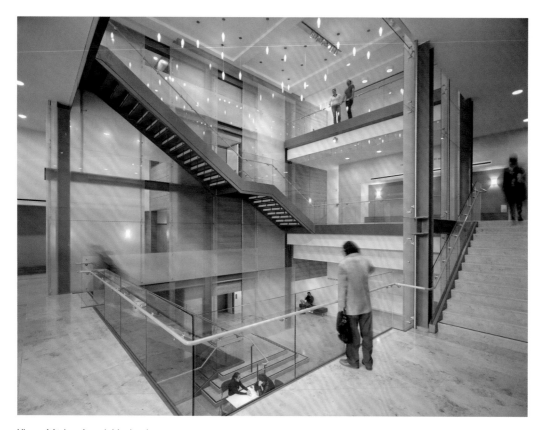

View of Atrium from lobby level

Exhibit : San Francisco Conservatory of Music

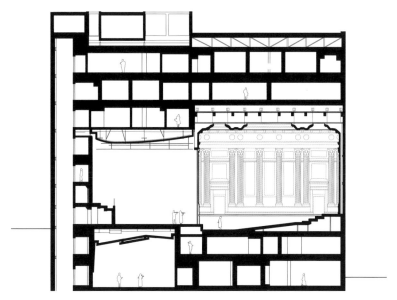

Section looking north

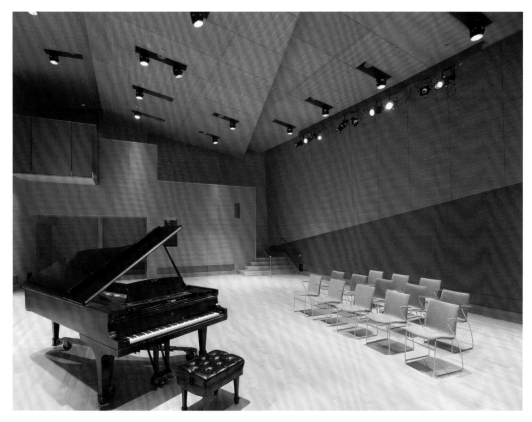

Salon

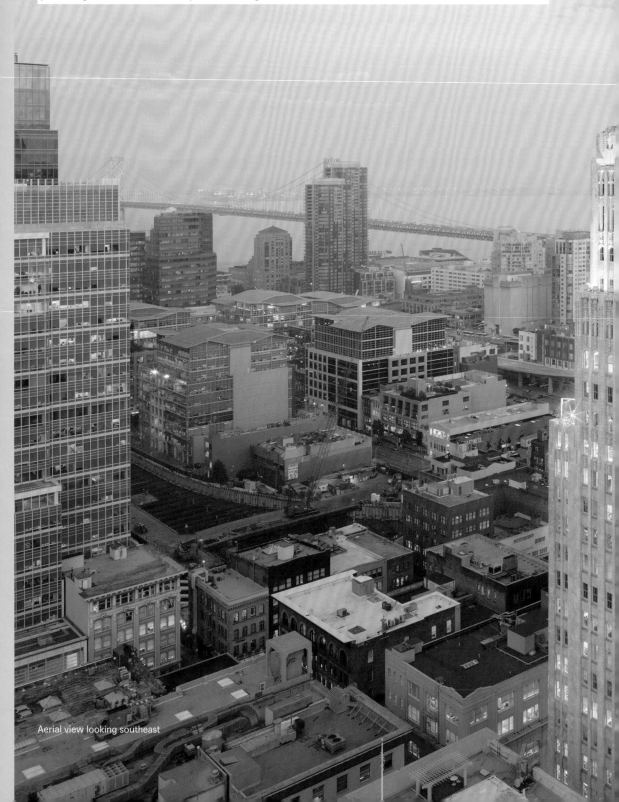

San Francisco, 2013

Restoration and revitalization of the iconic art deco structure, designed in 1925 by architect Timothy Pflueger, transformed this 26-story terra cotta and granite building into a state-of-the-art office building. The intervention strategy negotiated innovation and preservation, incorporating contemporary details and systems that meet LEED Gold standards while highlighting the building's unique character and preserving notable elements and spaces, including the lobby and its ornate original detailing. The insertion of a semi-public sculpture garden at the back of the building and the incorporation of clear glass at the ground-level envelope blurs the boundary between interior and exterior at the restored lobby.

Aerial view looking southeast

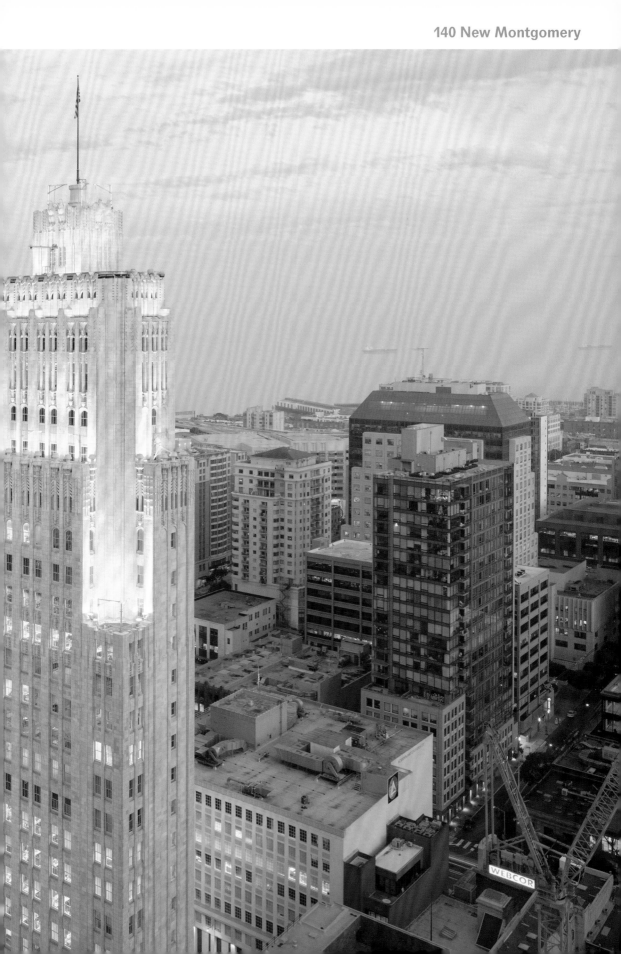

Section looking west

Exhibit : 140 New Montgomery

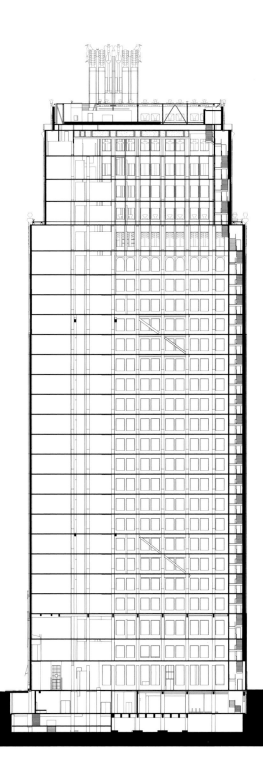

Section looking south

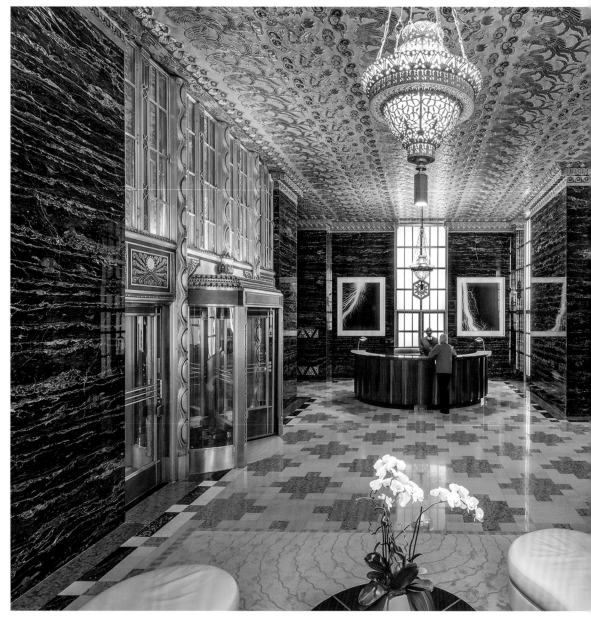

Refurbished lobby with Sugimoto "Lightning" series photographs

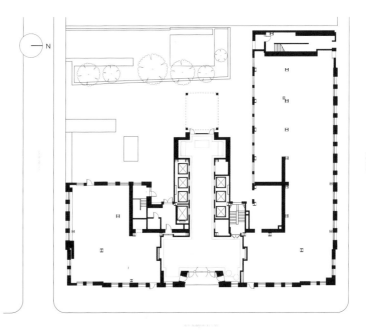

Plan

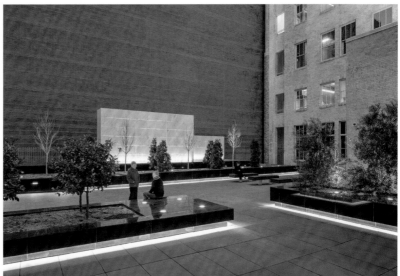

New garden courtyard looking west

South San Francisco, 2015

Locating a vibrant center for a burgeoning biotech campus was impetus for this ground-up construction project. The building is situated to offer views southwest toward the coastal hills, to the Bay at the northeast, and to shelter the entrance from strong winds moving off the adjacent San Bruno Mountain, and to define a new campus heart. The simple geometry of the volume is clad in precast concrete panels that vary in color, becoming lighter from east to west, and provide support for perforated metal sunshades. The interior spaces accommodate demand for a collaborative working environment capable of supporting the varied needs of contemporary office workers. Volumes of multiple

sizes, programmed as workspace and meeting rooms, are staggered horizontally and vertically within the central atrium that mediates two zones of office space. Tied together and to the office floors by stairs, the semi-transparent cantilevered or suspended volumes generate sightlines that foster a sense of community and a dynamic space for occupants who are afforded natural light and air through the porous envelope.

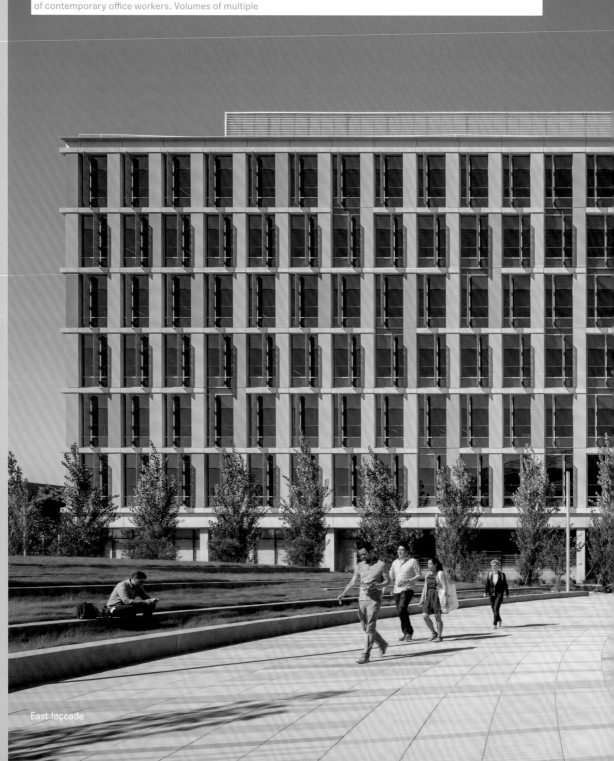

East façade

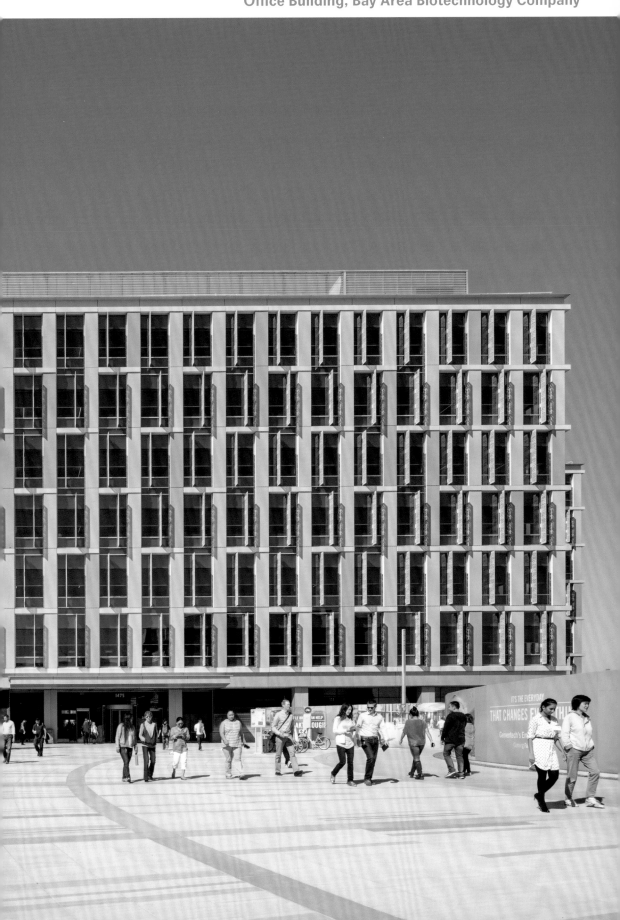

Site plan > Sunshades with perforated DNA pattern

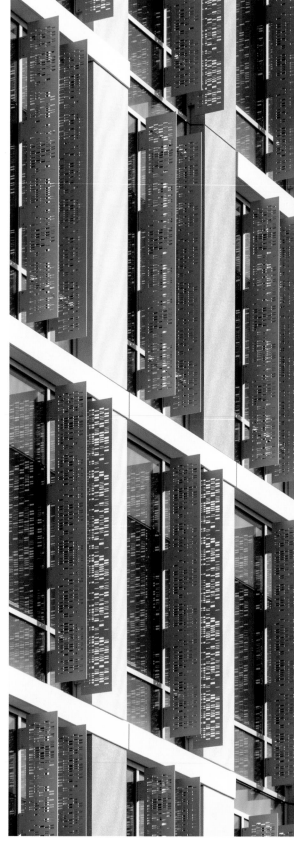

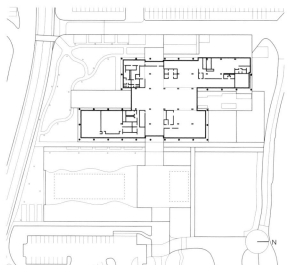

Exhibit : Office Building, Bay Area Biotechnology Company

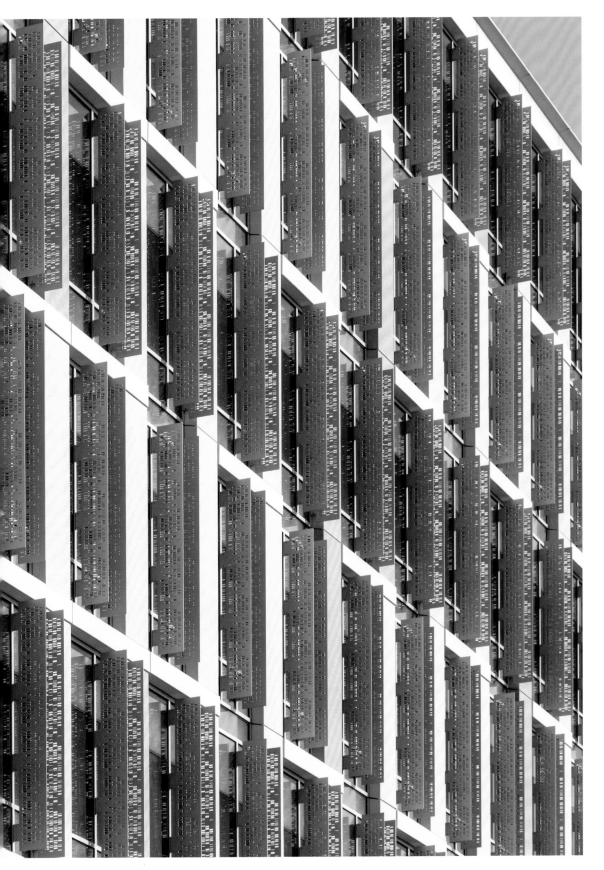

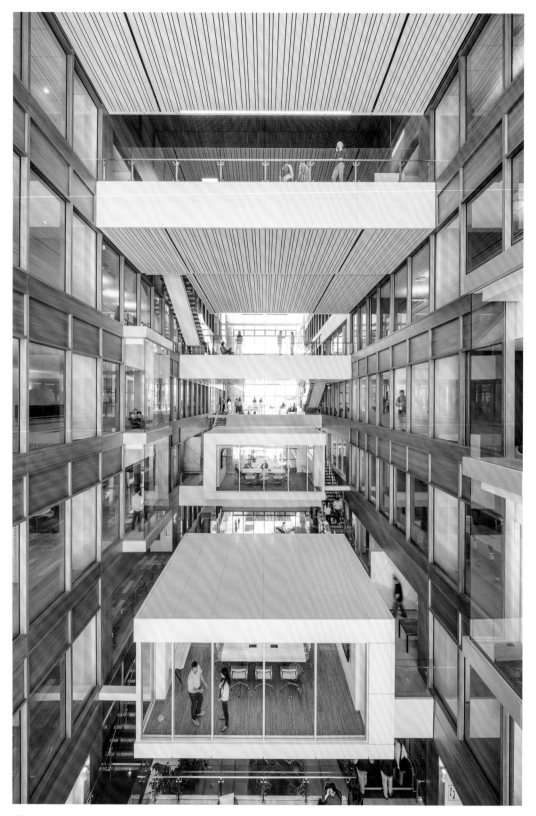

View of the Atrium looking south

Exhibit : Office Building, Bay Area Biotechnology Company

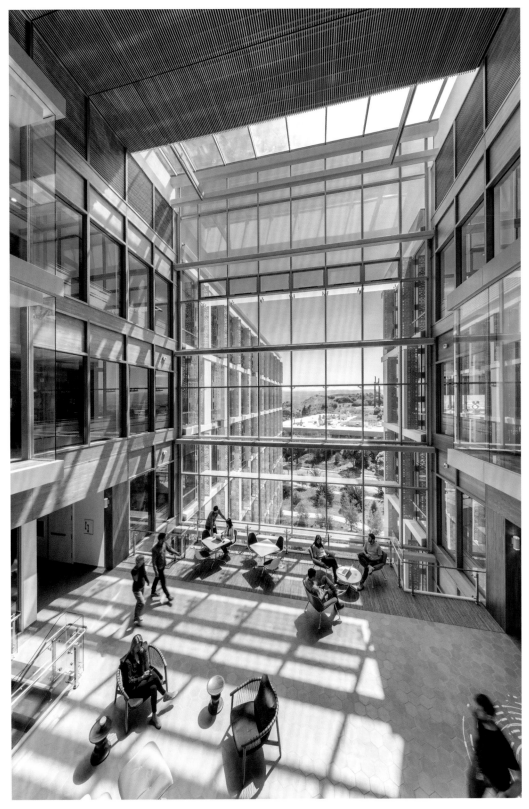

Interior view at fifth floor looking south

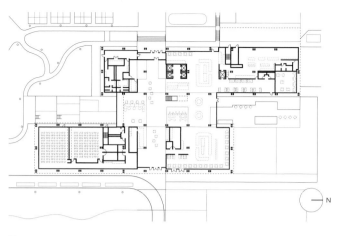

Plan
> Atrium bridge

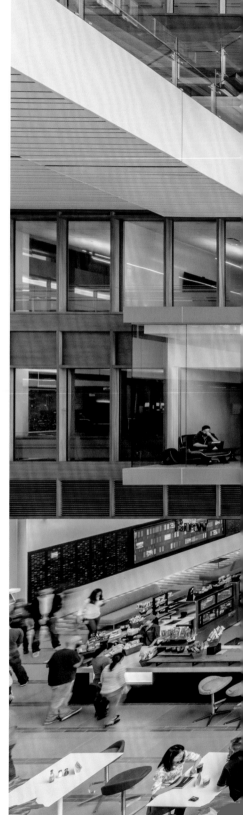

Section looking west

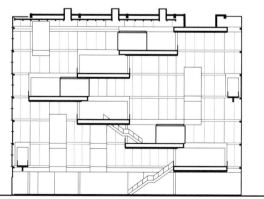

Exhibit : Office Building, Bay Area Biotechnology Company

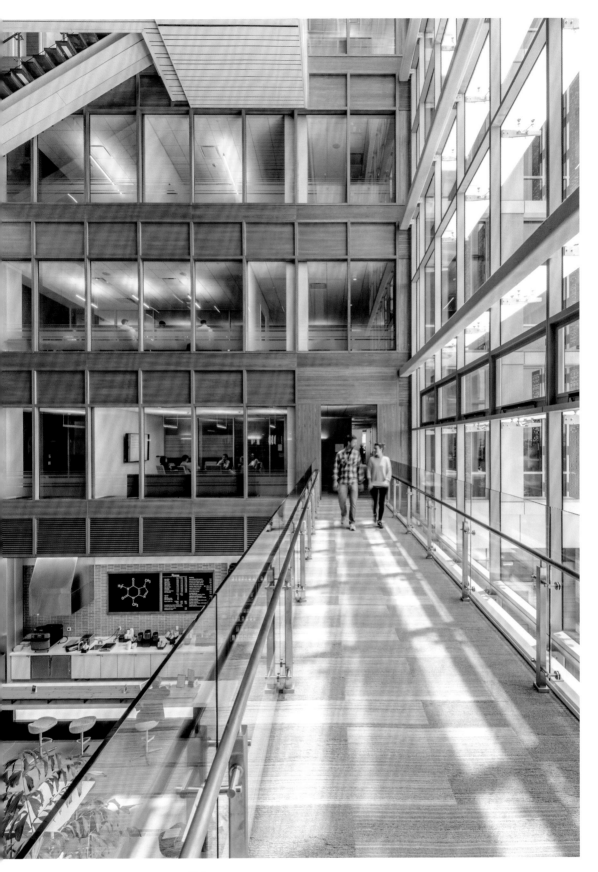

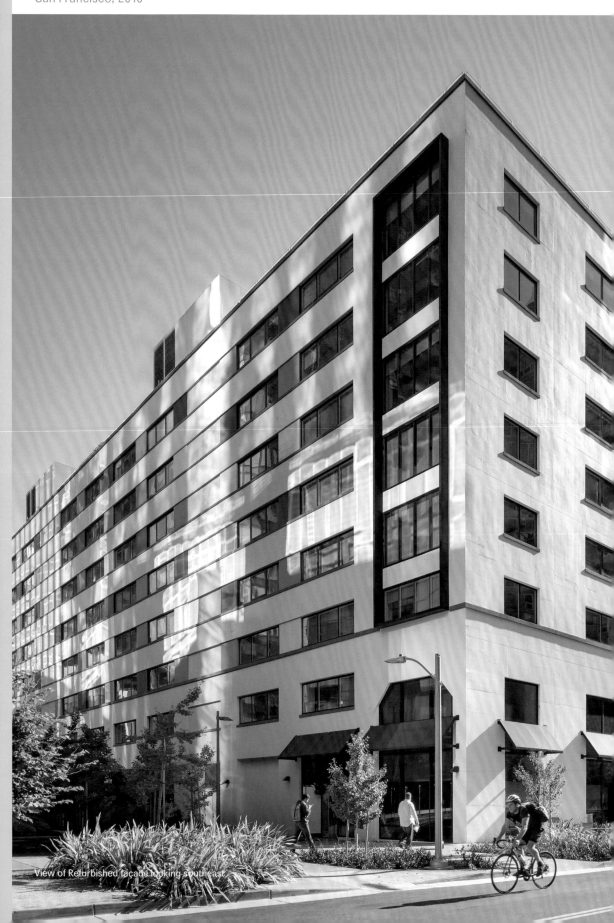

View of Refurbished façade looking southeast

Bay Area Metro Center

The transformation of a banal 1940s concrete structure into a light-filled workplace that brings various public agencies together under one roof was the overarching agenda for redesigning this city block not far from the Bay Bridge. Beyond providing a new civic realm and an exceptional and interactive workspace, the criteria for design necessitated accommodation of space for appropriation by public and private groups to host a variety of meetings and events. Integral to the engagement of both the public and surrounding context is a terrace overlooking the Bay Bridge, a two-story tree well, and perhaps most importantly, Rincon Place, the new public mews located mid-block and carved from a former parking lot. The addition of an eight-story atrium animates the entry level, bringing natural light deep into the office floors and providing occupants connection to the outside environment. This synthesis is further amplified by the incorporation of wood, introduced by the sculptural teak at the Beale Street entrance and continued at each interior floor, and on the suspended stair element connecting the floor of four different agencies in a gesture symbolic of a commitment to collaboration.

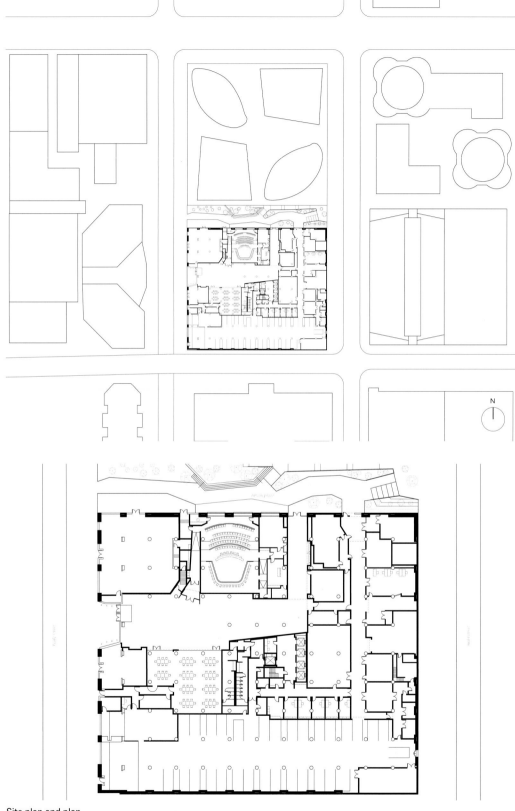

Site plan and plan

Exhibit : Bay Area Metro Center

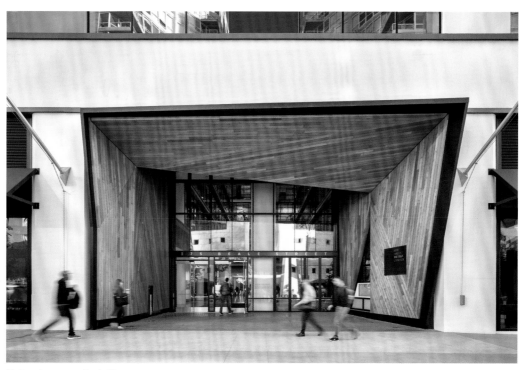

Main entrance on Beale Street

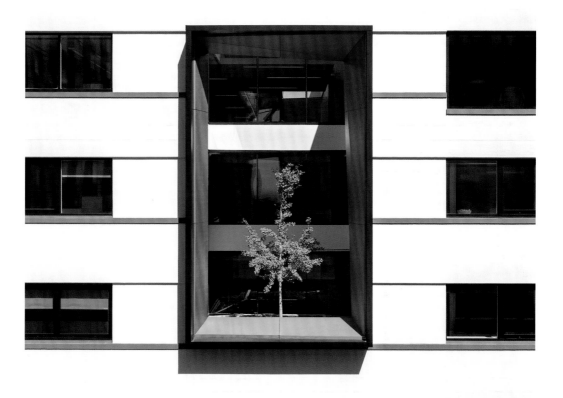

Tree well at south façade

Lobby looking east with entrances to Boardroom
and Meeting Rooms

Composite section and elevation

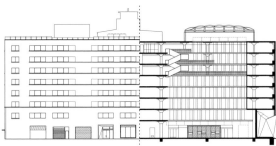

Exhibit : Bay Area Metro Center

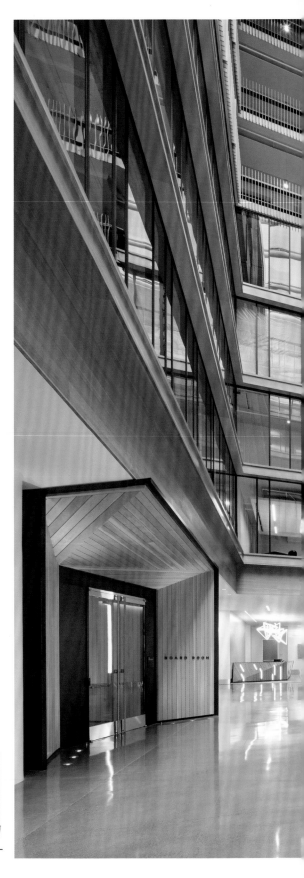

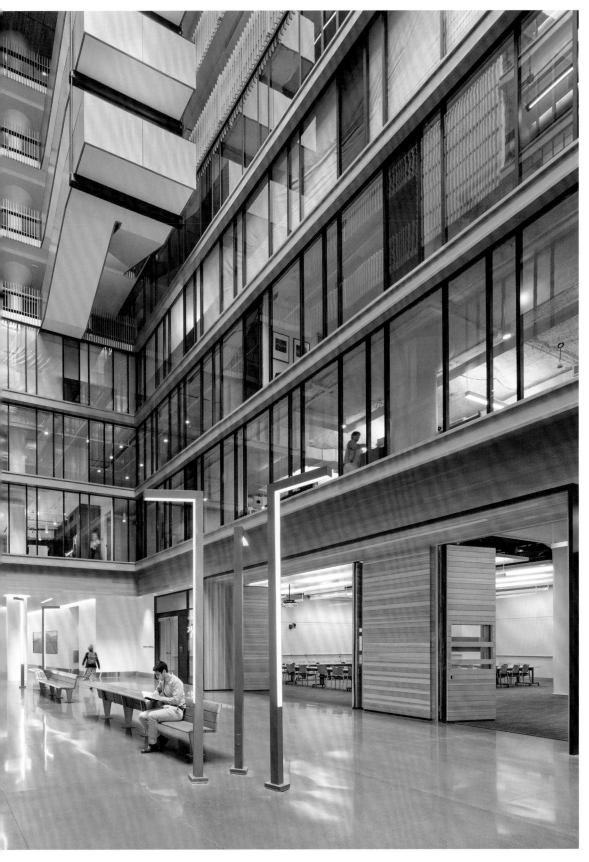

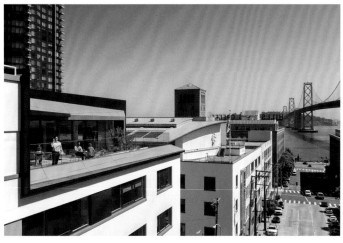

Eighth floor terrace looking east

Exhibit : Bay Area Metro Center

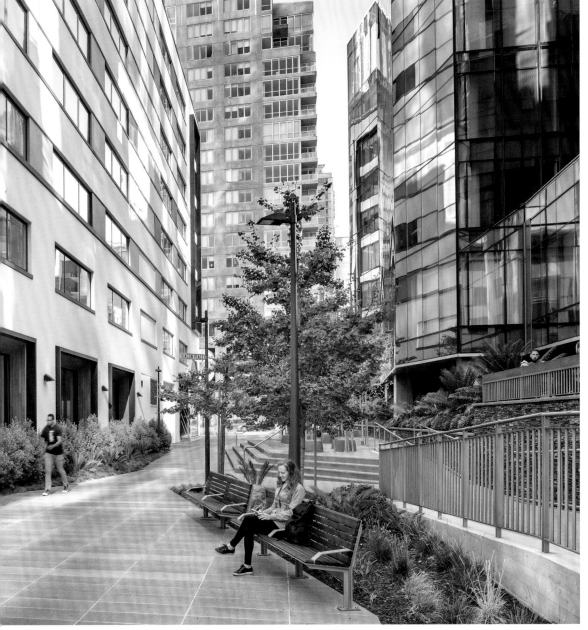

Rincon Place looking east

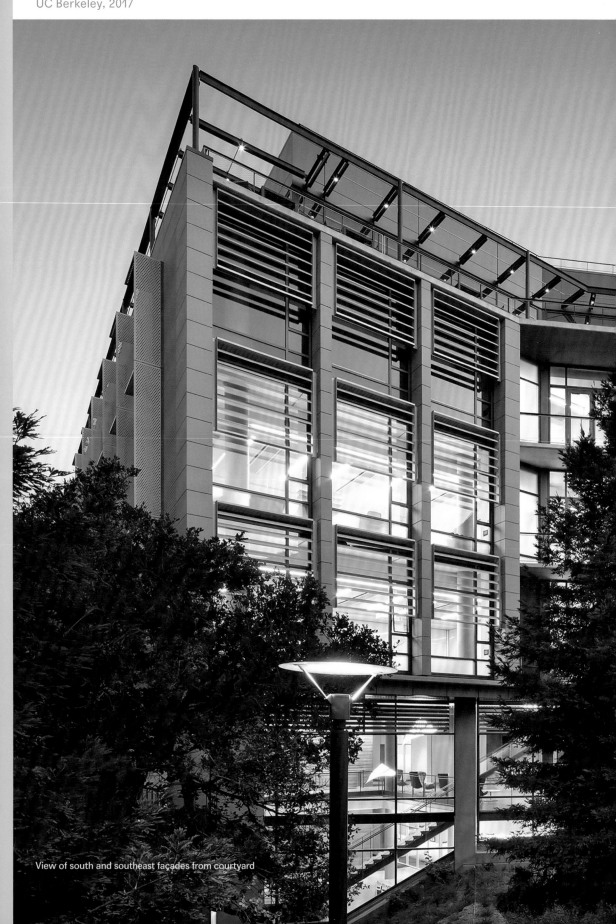

View of south and southeast façades from courtyard

Connie and Kevin Chou Hall, Haas School of Business

A highly articulated space for learning, collaboration, and socialization, this LEED Platinum building is part of the Haas School of Business at the University of California, Berkeley. The ground-up, terracotta-clad concrete structure connects to the original Charles Moore-designed business school via a redesigned courtyard; a redwood-rich riparian corridor to the north is a remnant of the original landscape. Designed as a counterpoint to the eccentric existing architecture, the structure incorporates advanced technologies and contemporary materials at both the interior and the façade. Tall, vertical windows with sunscreens protect the spaces at the southwest from the afternoon sun, while a grid at the south façade is expressed as an aluminum frame with horizontal louvers that mediate environmental conditions. The fenestration that punctures the terracotta façade gives way to a glass and metal enclosure at the sixth floor, flooding meeting rooms with natural light and opening up to a shaded terrace at the south and southwest. The building opens up to the campus on all sides, and to the city and Pacific rim beyond.

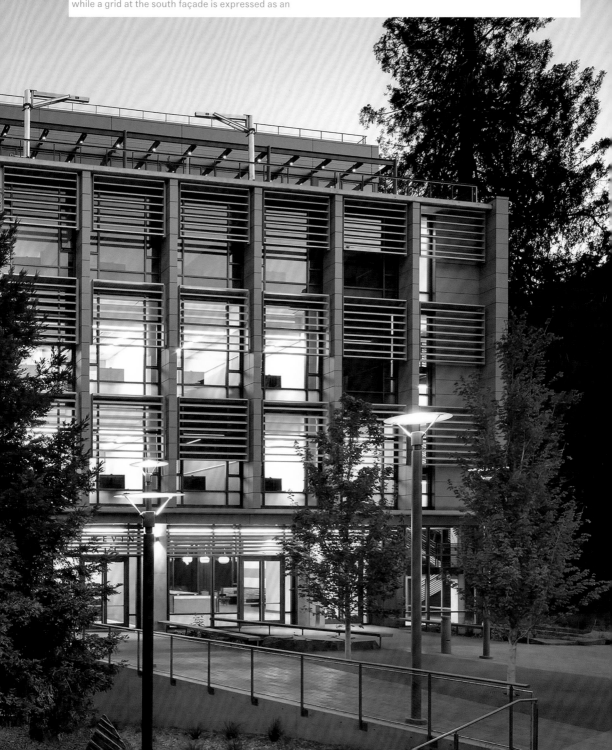

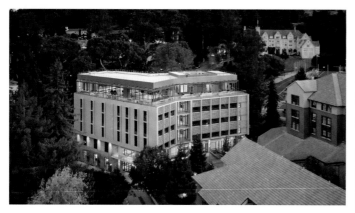

View of the campus looking northeast

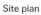

Site plan

Exhibit : Connie and Kevin Chou Hall, Haas School of Business

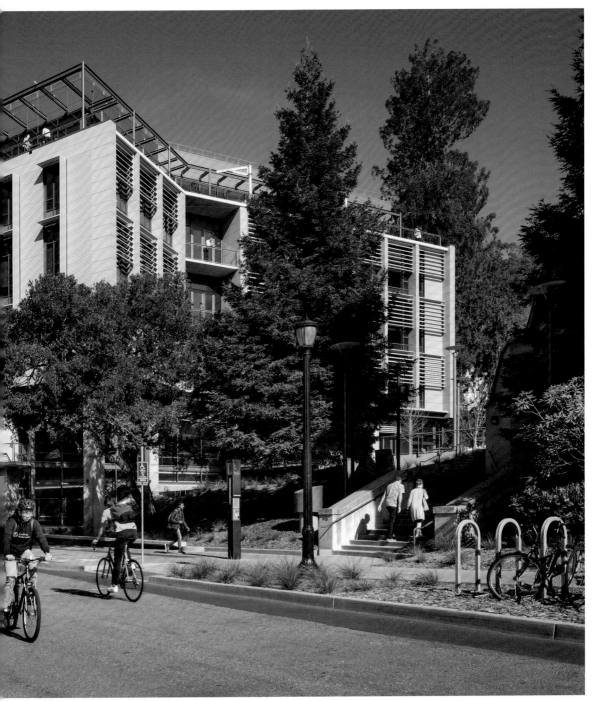

View from Campus Way looking north toward the Riparian Corridor

Double-height entry lobby

Section looking north

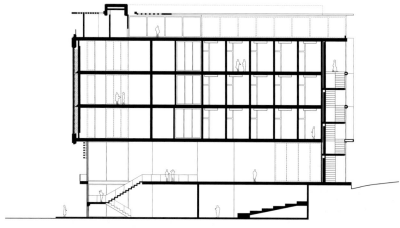

Exhibit : Connie and Kevin Chou Hall, Haas School of Business

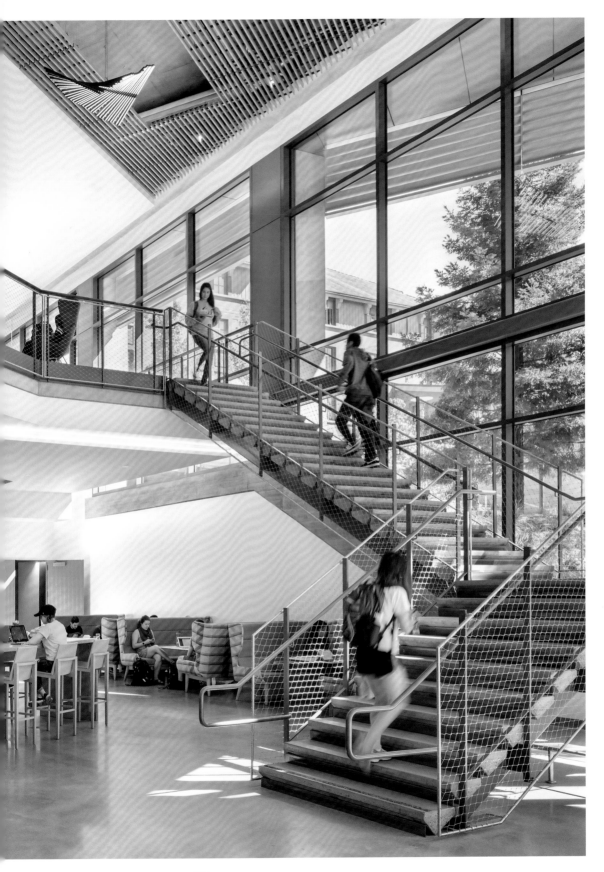

Lower-level entrance from College Way with balcony above

Plan, Sixth floor Event Space

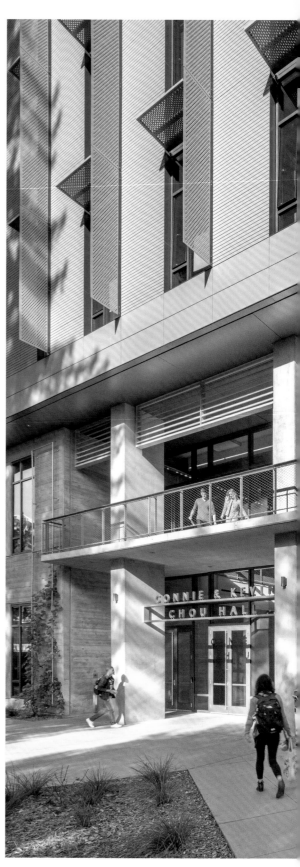

Exhibit : Connie and Kevin Chou Hall, Haas School of Business

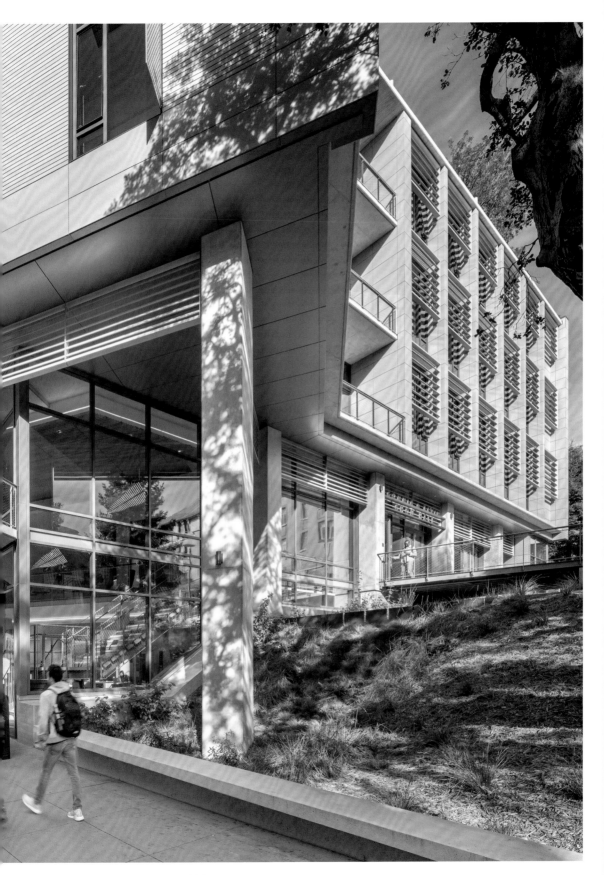

Project Partner Credits

OCEANSIDE WATER POLLUTION CONTROL PLANT, SAN FRANCISCO (SMWM)
Client: CH2MHill (now Jacobs) and Clean Water Program SF PUC
Partner: RHAA (Royston Hanamoto Alley and Abey: landscape architect)
Team: John Long, Alan Stiles, Linus Stempuzis, Bob Diaz, Ann Hawkinson, Mark Zall, Katherine Anderson, Bob Jochnowitz, Robin Severns

PIER 1, SAN FRANCISCO (SMWM)
Client: AMB (now Prologis)
Partners: Page and Turnbull (historic preservation), Rutherford and Chekene (structural engineer), Flack and Kurtz (WSP—MEP)
Team: Dan Cheetham, Michael Bernard, Matt Johnson, Barbara Shands, Doug Hoffelt, Donald Cremers, Gail Gordon, Kelly Myles Braun

FERRY BUILDING, SAN FRANCISCO (SMWM)
Client: Wilson Meany
Partners: BCV (Baldauf Catton Von Eckartsberg: retail architect) and Page and Turnbull (historic architect), Rutherford and Chekene (structural engineer)
Team: John Long, Andrew Wolfram, Eva Craig, Scott Ward, Dan Cheetham, Alyosha Verzhbinsky

TREASURE ISLAND + YERBA BUENA ISLAND MASTER PLAN, SAN FRANCISCO (SMWM/PERKINS & WILL)
Client: Wilson Meany and Lennar
Partners: SOM, BCV, Mithūn, CMG (landscape architect)
Team: Karen Alschuler, Eleanor Pries, Patrick Vaucharet, Gerry Tierney, Ned Reifenstein, Kamala Subbarayan, Noah Friedman, Ben Feldman

MISSION ROCK DEVELOPMENT PLAN, SAN FRANCISCO (SMWM/PERKINS & WILL)
Client: SF Giants
Partner: Hargreaves (landscape architect), later CMG (landscape architect)
Team: Karen Alschuler, Gerry Tierney, Paul Leveriza, Bill Katz, Geeti Silwal, Kristen Hall, Noah Friedman

SAN FRANCISCO BALLET PAVILION (SMWM)
Client: San Francisco Ballet
Partners: ARUP (all engineering disciplines), Auerbach (theater consultant)
Team: John Long, Dan Cheetham

SAN FRANCISCO CONSERVATORY OF MUSIC (SMWM)
Client: San Francisco Conservatory of Music
Partners: Page and Turnbull (historic preservation), Forell Elsesser (structural engineer), Kirkegaard (acoustician), Flack and Kurtz (WSP—MEP), Auerbach (theater consultant), Dan Wintrich (artist)
Team: John Long, Liza Pannozzo, Jackie Lange, Wahid Yonus

140 NEW MONTGOMERY, SAN FRANCISCO (PERKINS & WILL)
Client: Wilson Meany
Partners: Page and Turnbull (historic preservation), Holmes Cully (structural engineer), Integral (MEP), GLS (landscape architect)
Team: Andrew Wolfram, Robert Clocker, Joelle Colliard, Justin Helm, James Mallery, Aoife Morris

OFFICE BUILDING, BAY AREA BIOTECHNOLOGY COMPANY, SAN FRANCISCO (PERKINS & WILL)
Client: Bay Area Biotechnology Company
Partners: Rutherford and Chekene (structural engineer), ARUP (MEP), MPA (landscape architect)
Team: Bill Katz, Sarah Rege, Sara Anderson, Jaepyo Park, Elena Ma, Kerstin Kraft

BAY AREA METRO CENTER, SAN FRANCISCO (PERKINS & WILL)
Client: Metropolitan Transportation Commission
Partners: TEF Studio (office space planning and interior design), Holmes Cully (structural engineer), Pamela Burton (landscape Architect)
Team: Gerry Tierney, Andrew Wolfram, David Bradshaw, Aleks Janjic, Rosannah Sandoval, Drake Hawthorne, James Mallery, Joelle Colliard

CONNIE AND KEVIN CHOU HALL, HAAS SCHOOL OF BUSINESS, UC BERKELEY (PERKINS & WILL)
Client: Partnership for Haas Preeminence
Partners: Tipping (structural engineer), Integral (MEP), GLS (landscape architect)
Team: John Long, Paul Leveriza, Reinhardt Muir, Drake Hawthorne, Deanna Van Buren, Gerry Tierney, Jason Wilkinson

Acknowledgments

Occupation:Boundary serves
multiple functions, as a personal
and professional autobiography, a
selective history of the urban water-
front that includes reflections on the
roles architecture, culture and the arts
play at the threshold between land and sea,
and as an abbreviated survey of my architec-
tural practice and its ideals. Throughout my life
and career, there have been many people whose
influence has been invaluable in shaping the experi-
ences and thoughts that led to this book. The words
that follow are a modest attempt to acknowledge
these contributors.

I will begin by thanking my family. I am grateful to my late
parents, Bernard and Bitten Simon, whose humanistic values,
enthusiasms, and unconditional love and encouragement nur-
tures and inspires me, even now. My husband and life partner,
poet Michael Palmer, modeled a standard of accomplishment of
the highest degree and fostered my development as an engaged
reader, thinker, and designer. I also want to thank my brilliant daughter,
the artist Sarah Palmer, whose independent and creative spirit, wise
counsel, and unequivocal engagement with my ideas have kept me going
through every challenge with tenacity, love, and joy. That said, I'll also
mention her talented husband, artist Dillon DeWaters, and my two beautiful
grandsons Nico Mars DeWaters and Jasper Orion DeWaters, who share my
love of the ocean.

I acknowledge the extraordinary value of my education, which took place
first at the Little Red Schoolhouse in New York's Greenwich Village, then
in public schools on Long Island, and later at Wellesley College and the
Graduate School of Design, Harvard University (GSD). The professors in
the Wellesley Department of Art History opened my mind to the visual arts;
those lessons have been present ever since and sustain me, still. Professors
Jack Benson and John McAndrew were especially influential with respect
to my intellectual formation. Notwithstanding that a single woman never
graced the faculty at the GSD during the late 1960s when I was a student,
the training afforded me there has been indispensable. I am grateful to Dean
Josep Lluis Sert, and to Professors Eduard Sekler and Gerhard Kallmann.
Each of these figures inspired me in his own way. Visiting faculty members
Dolf Schnebli and Shadrach Woods demonstrated generous passion and
enthusiasm about urbanism. For me, they were a breath of fresh air. For all
these teachers, my gender was never considered to be an impediment to
accomplishment as an architect and designer; in fact, they conveyed the
opinion that it was an asset.

I began practicing as an architect in 1969. Many brilliant colleagues and col-
laborators have crossed my path during this time, and in doing so enriched

my life through design. The unconditional support and encouragement of Bob Marquis, the irascible, cigar-smoking, loving founder of Marquis Associates, along with that of Peter Winkelstein, helped me find my sea legs. The partners with whom I founded my firm, SMWM, in 1985, also must be acknowledged with gratitude for their collaborative spirit. Together we created a community dedicated to design, thought leadership, and creative dialog, which we sustained for nearly a quarter century. Over this time, there were more contributors than I can possibly enumerate here. In particular, I extend thanks to my partner and friend Karen Alschuler for her passion, energy, and her love of cities and 'the chase'. My partners Diane Filippi and the late Evan Rose established a high bar in terms of standards related to engagement and strategic thought. Further, I am grateful to, and have the highest respect for, the following special design collaborators: Bill Bondy, Andrew Wolfram, John Long, Bill Katz, Gerry Tierney, Dan Cheetham, Rob Clocker, Alyosha Verzhbinsky, Doug Tom, Liza Pannozzo, Deanna Van Buren, Jane Hendricks, Amanda Williams, Debin Schliesman, Sowmya Parthasarathy, Kim Kowalski and David Schellinger.

In 2008, SMWM joined Perkins & Will, allowing me to continue my design practice within a large-scale, collegial community. I am grateful to Phil Harrison for his support of me as a design and thought leader, to Richard Marshall for his acumen as an urban designer, and for the robust dialog we shared. Allison Held's enthusiastic embrace of my work was a consistent source of motivation. I have great appreciation to the firm for having confidence in me, and for supporting my research, travel, and desire to realize this book. Of many at Perkins & Will, I offer special mention to two of my New York colleagues, Joan Blumenfeld and Paul Eagle, whose friendship has enriched my life. It would be remiss not to mention the time I spent during 2015 as the William A. Bernoudy Architect in Residence at the American Academy in Rome; the expereince was inspiring and provided the context for taking an essential step in the research and formulation of this book.

I am lucky to have so many friends in my life, in particular, Anne Meyer, my oldest friend, and Augusta Talbot, Margaret Jenkins, Loretta Keller, Emily Marthinsen, and Jane Wattenberg. Each of these individuals offered generous counsel, unabashed love, and passionate encouragement of my practice, work, and this book. I could not have even dared to take this on without knowing that these women were by my side. I am also grateful to the Environmental Design Archives at UC Berkeley (EDA), the repository where SMWM's papers—drawings, models, masterplans, notes, and lectures—reside, along with the archives of Julia Morgan, Willis Polk, Beatrix Farrand, Joseph Esherick, and many other luminaries. I offer a special shout out to the archives' two amazing directors: Waverly Lowell, who was integral to the acquisition of the SMWM archive, and Christina Marino, the EDA's current leader, who, through a generous grant from the National Endowment for the Humanities, will guide digital access to the SMWM archive in the future.

Ashley Simone, my brilliant and tough editor, has done more to shape *Occupation:Boundary* than anyone else. Throughout this long process she has been an uncompromising critic and guide. I literally could not have done this without her clarity and rigor. I am grateful for all of that plus her willingness to stick with what has been a highly iterative process. Ashley, you

have taught me so much! Carrie Eastman was my writing collaborator. Her intelligence, logical thought process, and patient work helped bring careful research and a clear voice to the project. Our mutual love of swimming, and importantly, of Mumford, Melville, and Carson, was a constant subtext in our many conversations. Bárbara Miglietti redrew my projects; her beautiful drawings grace the Exhibit section of the book. I offer sincere thanks to Sarah Rafson and Laurel Mitchell for their help gathering images, a daunting task which they accomplished with patience and good cheer. The designer, Luke Bulman, deserves special thanks for meeting the book's subject head-on, responding with an extraordinary design that reinforces the ideas it contains. Many colleagues—architects, landscape architects, and photographers—generously shared their images with me, allowing the illustration of my thoughts with work of the highest quality. Finally, I am honored that three remarkable friends contributed thoughtful essays about my work to *Occupation:Boundary*: landscape architect Laurie Olin, whose practice continues to inspire me; John King, the steadfast urban design and architecture critic at the San Francisco Chronicle, who has written extensively about my Bay Area projects; and Justine Shapiro-Klein, whose work and outlook heartens me about the future of multidisciplinary architectural practice.

Ashley Simone is a writer, photographer, and educator whose practice investigates the intersection of architecture, art, and culture. She is the editor of *A Genealogy of Modern Architecture: Comparative Critical Analysis of Built Form* (Zurich: Lars Müller Publishers, 2015), *Absurd Thinking Between Art and Design* (Zurich: Lars Müller Publishers, 2017), *Two Journeys* (Zurich: Lars Müller Publishers, 2018), *Frank Gehry Catalogue Raisonné, vol. 1. 1954–1978* (Paris: Cahiers d'Art, 2020), and a co-editor of *In Search of African American Space* (Zurich: Lars Müller Publishers, 2020). Currently she is a professor in the School of Architecture at Pratt Institute in Brooklyn, where she teaches courses in visual representation and writing. She holds a master's degree in architecture from the Columbia University Graduate School of Architecture, Planning and Preservation.

Carrie Eastman is a writer and editor, designer, and educator whose writing has appeared in a variety of publications on architecture and urbanism. She has taught courses in urban history and theory at the College of Architecture, Planning and Landscape Architecture in Tucson and is a co-editor of *In Search of African American Space: Redressing Racism* (Zurich: Lars Müller Publishers, 2020), a volume of essays in which African American spatial typologies are reconsidered.

Carrie practices landscape design independently after having spent fifteen years working in and around New York City, where she contributed to several large-scale public projects along the former industrial waterfront. She has a master's degree in landscape architecture from the University of Virginia and a bachelor's degree in the history of art and architecture from Brown University.

John King is the Urban Design Critic at the San Francisco Chronicle — a post that ranges from architecture and planning to landscape architecture and the public realm of cities in all its forms. The author of two books on the buildings of San Francisco, he is an honorary member of the American Society of Landscape Architects and in 2018 was a Mellon Fellow in Urban Landscape Studies at Dumbarton Oaks in Washington, D.C. His work has been honored by such groups as the California Preservation Foundation, the Urban Communication Foundation and the California Newspaper Publishers Association, and he is a two-time finalist for the Pulitzer Prize in Criticism.

Justine Shapiro-Kline is an architect and urban planner who has worked across the U.S. on planning initiatives and infrastructure to advance adaptation to climate change and its impacts. Currently an Associate at One Architecture & Urbanism, her practice prioritizes collaborative design and planning processes to support the development of sustainable communities and resilient places. She received master's degrees in architecture and urban planning from Columbia University and a bachelor's degree in History & Literature from Harvard College. She is a member of the American

Institute of City Planners, the American Society of Adaptation Professionals, and co-founder of the Community Adaptation Learning Exchange.

Laurie Olin is a distinguished teacher, author, and one of the most renowned landscape architects practicing today. From vision to realization, he has guided many of OLIN's signature projects, which span the history of the studio from Bryant Park in New York City to the Washington Monument Grounds in Washington, D.C. Recent projects include the AIA award-winning Barnes Foundation in Philadelphia, Pennsylvania, Simon and Helen Director Park in Portland, Oregon, and Apple Park in Cupertino, California.

He is Professor Emeritus of Landscape Architecture at the University of Pennsylvania, where he taught for 40 years, and is the former chair of the Department of Landscape Architecture at Harvard University. Laurie is a member of the American Academy of Arts and letters and received the 2012 National Medal of Arts, the highest lifetime achievement award for artists and designers bestowed by the National Endowment for the Arts and the President of the United States.

Select Bibliography

Amenda, Lars. "Shipping Chinatowns and Container Terminals." In *Port Cities: Dynamic Landscapes and Global Networks*. New York: Routledge, 2011.

Bergdoll, Barry. "Rising Currents: Incubator for Design and Debate." In *Rising Currents: Projects for New York's Waterfront*, edited by Museum of Modern Art (New York, 12–31. London: Thames & Hudson [distributor], 2011.

Bernstein, Fred A. "Jorn Utzon, 90, Dies; Created Sydney Opera House." The *New York Times*, November 29, 2008, sec. Arts.

Berry, Wendell. *The Unsettling of America: Culture & Agriculture*. First Counterpoint edition. Berkeley, CA: Counterpoint, 2015.

Bierig, Aleksandr. "The High Line And Other Myths." *Log*, no. 18 (2010): 129–34.

"Biology: Pesticides: The Price for Progress." *Time*, September 28, 1962.

Bonislawski, Adam. "Brooklyn Bridge Park Is Turning Everything It Touches to Gold." *New York Post*, February 16, 2017.

Broussard, Albert S. *Black San Francisco: The Struggle for Racial Equality in the West, 1900–1954*. Lawrence, Kan: University Press of Kansas, 1993.

"Breuer's Ancillary Strategy: Symbols, Signs, and Structures at the Intersection of Modernism and Postmodernism." In *Marcel Breuer: Building Global Institutions*. Zürich: Lars Müller Publishers, 2018.

Building a Masterpiece: The Sydney Opera House. Burlington, VT: In association with Lund Humphries, 2006.

Buhler, Mike, and Jay Turnbell. "Introduction." In *Port City: The History and Transformation of the Port of San Francisco, 1848–2010*, by Michael R. Corbett. San Francisco, Calif: San Francisco Architectural Heritage, 2010.

Burrows, Edwin G. *Gotham: A History of New York City to 1898*. New York: Oxford University Press, 1999.

Caistor, Nick. *Octavio Paz*. Critical Lives. London: Reaktion Books, 2007.

Caro, Robert A. *The Power Broker: Robert Moses and the Fall of New York*. [1st ed.]. New York: Knopf, 1974.

Carson, Rachel. *Silent Spring*. Houghton Mifflin, 2002.

Carson, Rachel. *The Sea around Us*. Rev. ed. New York: Oxford University Press, 1961.

Chokshi, Niraj. "Racism at American Pools Isn't New: A Look at a Long History." The *New York Times*, August 1, 2018, sec. Sports.

Clark, Anna. "'Nothing to Worry about. The Water Is Fine': How Flint Poisoned Its People." The *Guardian*, July 3, 2018, sec. News.

Cole, Teju. *Open City*. 1st ed. New York: Random House, 2011.

Cook, Anne, Richard Marshall, and Alden Raine. "Port and City Relations: San Francisco and Boston." In *Waterfronts in Post-Industrial Cities*, 117–34. New York: Spon Press, 2001.

Corbett, Michael R. *Port City: The History and Transformation of the Port of San Francisco, 1848–2010*. San Francisco, Calif: San Francisco Architectural Heritage, 2010.

Corner, James. *The Landscape Imagination: Collected Essays of James Corner, 1990–2010*. First edition. New York: Princeton Architectural Press, 2014.

Craige, Betty Jean. *Eugene Odum: Ecosystem Ecologist & Environmentalist*. London: University of Georgia Press, 2001.

"Crossing Brooklyn Ferry. (Leaves of Grass (1867))—The Walt Whitman Archive." Accessed January 13, 2020. https://whitmanarchive.org/published/LG/1867/poems/76.

Curran, Winifred. "City Policy and Urban Renewal: A Case Study of Fort Greene, Brooklyn." *Middle States Geographer* 31 (n.d.): 73–82.

Cudahy, Brian J. *How We Got to Coney Island: The Development of Mass Transportation in Brooklyn and Kings County*. 1st ed. New York: Fordham University Press, 2002.

Delbanco, Andrew. *Melville: His World and Work*. 1st ed. New York: Knopf, 2005.

Delgado, James P, Denise Bradley, Paul M Scolari, and Stephen A Haller. "The History and Significance of the Adolph Sutro Historic District: Excerpts from the National Register of Historic Places Nomination Form Prepared in 2000.", n.d., 34.

Emerson, Ralph Waldo. *The Annotated Emerson*. Cambridge, Mass: Belknap Press of Harvard University Press, 2012.

Feddes, Fred. *A Millennium of Amsterdam: Spatial History of a Marvelous City*. Bussum: Thoth Publishers, 2012.

Ferrari, Michelle. *Rachel Carson: She Set out to Save a Species. . . Us*. A 42nd Parallel Films Production for American Experience. American Experience is a production of WGBH., 2017.

Foster, Hal. *Design and Crime: And Other Diatribes*. London: Verso, 2002.

Frank Gehry, Architect. New York: Guggenheim Museum, 2001.

Fradkin, Philip L. *The Great Earthquake and Firestorms of 1906: How San Francisco Nearly Destroyed Itself*. Berkeley: University of California Press, 2005.

Fradkin, Philip L. *Wallace Stegner and the American West*. 1st ed. New York: Alfred A. Knopf, 2008.

Fromonot, Françoise. *Jørn Utzon: The Sydney Opera House*. Milan: Electa, 1998.

Garrity Ellis, Elizabeth. "Cape Ann Views." In *Paintings by Fitz Hugh Lane*, edited by John Wilmerding, 19–44. Washington DC: National Gallery of Art, 1988.

Goldberger, Paul. "At Seaport, Old New York With a New Look: Old New York With a New Look." The *New York Times*. 1983, sec. Weekend. "Miracle Above Manhattan." *National Geographic; Washington*, April 2011.

Goldberger, Paul. "Robert Moses, Master Builder, Is Dead at 92." The *New York Times*, July 30, 1981, sec. Obituaries.

Gumprecht, Blake. The *Los Angeles River: Its Life, Death, and Possible Rebirth*. Creating the North American Landscape. Baltimore: Johns Hopkins University Press, 1999.

HafenCity Hamburg: neue urbane Begegnungsorte zwischen Metropole und Nachbarschaft = Places of urban encounter between metropolis and neighborhood. New York: Springer, 2010.

"Herzog & de Meuron Elbphilharmonie." *A+U Architecture and Urbanism* 2017:3 (n.d.).

Hewison, Robert. *Ruskin, Turner, and the Pre-Raphaelites*. London: Tate Gallery, 2000.

Hamilton, William. "Melville and the Sea." *Soundings: An Interdisciplinary Journal* 62, no. 4 (1979): 417–29.

Hargreaves, George. *Hargreaves: The Alchemy of Landscape Architecture*. London: Thames & Hudson, 2009.

"Harvard Design Magazine: No. 39 / Wet Matter." Accessed January 14, 2020. http://www.harvarddesignmagazine. org/issues/39.

Hein, Carola. "Changing Urban Patterns in Port Cities: History, Present, and Future." In *Port Cities: Dynamic Landscapes and Global Networks*. New York: Routledge, 2011.

Higgins, Adrian. "New York's High Line: Why the Floating Promenade is so Popular (Posted 2014-11-30 23:27:09)." The *Washington Post; Washington, D.C.* November 30, 2014, sec. Style.

Hirsch, Alison Bick. *City Choreographer: Lawrence Halprin in Urban Renewal America*. Minneapolis: University of Minnesota Press, 2014.

Hood, Clifton. *In Pursuit of Privilege: A History of New York City's Upper Class & the Making of a Metropolis*. New York: Columbia University Press, 2017.

Ivers, B. Cannon. *Staging Urban Landscapes: The Activation and Curation of Flexible Public Spaces*. Basel: Birkhäuser, 2018.

Jackson, John Brinckerhoff. *A Sense of Place, a Sense of Time*. New Haven: Yale University Press, 1994.

Jackson, Nancy Beth. "If You're Thinking of Living In/Fort Greene; Diversity, Culture and Brownstones, Too." The *New York Times*, September 1, 2002, sec. Real Estate.

Kamiya, Gary. "How Sir Francis Drake Sailed into West Marin." SFGate, August 10, 2013.

Kimmelman, Michael, and Josh Haner. "The Dutch Have Solutions to Rising Seas. The World Is Watching." The *New York Times*, June 15, 2017, sec. World.

King, John. "SF Giants Unveil Plan for a 5-Acre 'Constructed Ecosystem' along Bay." *San Francisco Chronicle*, September 30, 2019.

Kostof, Spiro. *The City Shaped: Urban Patterns and Meanings through History*. London: Thames and Hudson, 1991.

Krinke, Rebecca. "Overview: Design Practice and Manufactured Sites." In *Manufactured Sites: Rethinking the Post-Industrial Landscape*, 125–49. New York: Spon Press, 2001.

Lear, Linda J. *Rachel Carson: Witness for Nature*. 1st ed. New York: Henry Holt, 1997.

Lebesque, Sabine. *Around Amsterdam's IJ Banks: From Architecture and Art to Green and New Development Areas*. New York: Available in North, South and Central America through D.A.P./Distributed Art Publishers, 2011.

Lee, Spike, Sam Pollard, Ray Nagin, Sean Penn, Al Sharpton, Wynton Marsalis, Harry Belafonte, et al. *When the Levees Broke: A Requiem in Four Acts*. New York: HBO Video, 2006.

Levinson, Marc. *The Box: How the Shipping Container Made the World Smaller and the World Economy Bigger*. Princeton: Princeton University Press, 2006.

Lewis, Peirce. "The Monument And The Bungalow: The Intellectual Legacy of J.B. Jackson." In *Everyday America*, edited by Chris Wilson and Paul Groth, 1st ed., 85–108. Cultural Landscape Studies after J. B. Jackson. University of California Press, 2003.

Select Bibliography

Lindner, Christoph, and Brian Rosa. "Introduction: From Elevated Railway to Urban Park." In *Deconstructing the High Line : Postindustrial Urbanism and the Rise of the Elevated Park*, 1–20. New Brunswick, New Jersey: Rutgers University Press, 2017.

Loe, Hikmet Sidney, *The Spiral Jetty Encyclo: Exploring Robert Smithson's Earthwork through Time and Place*, Salt Lake City: University of Utah Press, 2017.

Lowry, Glen. "Foreward." In *Rising Currents: Projects for New York's Waterfront*, edited by Barry Bergdoll. London: Thames & Hudson [distributor], 2011.

MacCannell, Dean. *The Ethics of Sightseeing*. Berkeley: University of California Press, 2011.

Marshall, Richard. "Contemporary Urban Space Making at the Water's Edge." In *Waterfronts in Post Industrial Cities*, edited by Richard Marshall. New York: Spon Press, 2001.

Matziaraki, Daphne. "Opinion | 4.1 Miles." The *New York Times*, September 28, 2016, sec. Opinion.

McCullough, David G. *The Great Bridge: The Epic Story of the Building of the Brooklyn Bridge*. New York: Simon & Schuster, 2001.

Melville, Herman. *Moby Dick*. Colección Historias. Bogotà: Editorial Bruguera, 1958.

Melville, Herman. *Moby-Dick; or, The Whale*. The Library of Literature, 5. Indianapolis: Bobbs-Merrill, 1964.

Meyer, Elizabeth K. *Richard Haag: Bloedel Reserve and Gas Works Park*. Landscape Views. New York: Princeton Architectural Press with the Harvard University Graduate School of Design, 1998.

Meyer, John M. "Gifford Pinchot, John Muir, and the Boundaries of Politics in American Thought." *Polity* 30, no. 2 (1997): 267–84.

Meyhöfer, Dirk. *Hafencity Hamburg: Waterfront : Architekturführer = Architectural guide*. 1. Auflage. Hamburg: Junius Verlag, 2014.

Miller, Ross. *American Apocalypse: The Great Fire and the Myth of Chicago*. Chicago: University of Chicago Press, 1990.

Millington, Nate. "Public Space And Terrain Vague On São Paulo's Minhocão: The High Line in Translation." In *Deconstructing the High Line*, edited by Christoph Lindner and Brian Rosa, 201–18.

Moneo, José Rafael. *Rafael Moneo: Remarks on 21 Works*. New York: Monacelli Press, 2010.

Moore, Rowan. "The Bilbao Effect: How Frank Gehry's Guggenheim Started a Global Craze." The *Observer*, October 1, 2017, sec. Art and design.

Muir, John. *John of the Mountains: The Unpublished Journals of John Muir*. Madison: University of Wisconsin Press, 1979.

Mumford, Lewis. *The City in History: Its Origins, Its Transformations, and Its Prospects*. New York, N.Y.: Harcourt, Brace Jovanovich, Inc, 1961.

Mumford, Lewis. *The Highway and the City; [Essays*. 1st ed.]. A Harvest Book. New York: Harcourt, Brace & World, 1963.

New York (N.Y.). *The Improvement of Coney Island, Rockaway and South Beaches*. New York, N.Y.: Dept. of Parks, 1937.

International Orange: Bill Fontana, Acoustical Visions of the Golden Gate Bridge. Accessed January 17, 2020. https://www.youtube.com/watch?v=tQOla-1Y6Qo.

Oppenheimer, Michael, and Barry Bergdoll. "Climate Change and World Cities." In *Rising Currents: Projects for New York's Waterfront*, 31–39. London: Thames & Hudson [distributor], 2011.

Orff, Kate. *Toward an Urban Ecology*. New York, New York: The Monacelli Press, 2016.

Palmer, Michael, *Company of Moths*, New York: New Directions, 2005.

Palmer, Michael, *Thread*, New York, New Directions, 2011.

Palmer, Michael, *Little Elegies for Sister Satan*, New York, New Directions, 2021.

Patrick, Darren J. "Of Success And Succession: A Queer Urban Ecology of the High Line." In *Deconstructing the High Line*, edited by Christoph Lindner And Brian Rosa, 141–66. Postindustrial Urbanism and the Rise of the Elevated Park. Rutgers University Press, 2017.

Paz, Octavio. *The Other Voice: Essays on Modern Poetry*. 1st ed. New York: Harcourt Brace Jovanovich, 1991.

Phoenix Cities: The Fall and Rise of Great Industrial Cities. Bristol: Policy Press, 2010.

Piano, Renzo. *Renzo Piano: The Complete Logbook, 1966–2016*. Revised and Expanded edition. London: Thames & Hudson Ltd, 2017.

Rachel Carson Council. "Rachel Carson's Statement before Congress 1963." Accessed February 18, 2020.

"R.I.'s Pollution Problems Long in the Making — EcoRI News." Accessed February 19, 2020. https://www.ecori.org/pollution-contamination/2010/12/18/ris-pollution-problems-long-in-the-making.html.

Rinne, Katherine Wentworth. *The Waters of Rome: Aqueducts, Fountains, and the Birth of the Baroque City*. 1st ed. New Haven: Yale University Press, 2010.

"Robert Moses and the Modern Park System (1929–1965): Online Historic Tour: NYC Parks." Accessed January 14, 2020. https://www.nycgovparks.org/about/history/timeline/robert-moses-modern-parks.

Roberts, Sam. "200th Birthday for the Map That Made New York." The *New York Times*, March 20, 2011, sec. New York.

Rodin, Judith. "Preface." In *Rising Currents: Projects for New York's Waterfront*, edited by Barry Bergdoll. London: Thames & Hudson [distributor], 2011.

Rosenberg, Karen. "Soaring Nods to Industry, Camping on an Island for the Summer." The *New York Times*, June 2, 2011, sec. Arts.

Rubin, M. Jasper. *A Negotiated Landscape: The Transformation of San Francisco's Waterfront since 1950*. Second edition. Pittsburgh: University of Pittsburgh Press, 2016.

Rubissow Okamoto, Ariel. *Natural History of San Francisco Bay*. California Natural History Guides, 102. Berkeley: University of California Press, 2011.

Sanderson, Eric W. *Mannahatta : A Natural History of New York City*. New York: Abrams, 2009.

Sayer, Jason. "Gustafson Guthrie Nichol to Design San Francisco Shoreline Parks at the India Basin Waterfront." The *Architect's Newspaper* (blog), March 16, 2016.

Schapp, Ton. *Around Amsterdam's IJ Banks: From Architecture and Art to Green and New Development Areas*. Edited by Sabine Lebesque. New York: D.A.P./ Distributed Art Publishers, 2011.

Schlichting, Kurt C. *Waterfront Manhattan: From Henry Hudson to the High Line*. Baltimore: John Hopkins University Press, 2018.

Seidenstein, Joanna Sheers. "Inglorious Histories: Turner's Ancient Ports." In *Turner's Modern and Ancient Ports: Passages through Time*. New Haven: Yale University Press, 2017.

Smith, Andrew, and Ingvild von Krogh Strand. "Oslo's New Opera House: Cultural Flagship, Regeneration Tool or Destination Icon?" *European Urban and Regional Studies* 18, no. 1 (January 1, 2011): 93–110.

Smithson, Robert. *The Writings of Robert Smithson: Essays with Illustrations*. New York: New York University Press, 1979.

Snøhetta Works. Baden, Switzerland: Lars Müller Publishers, 2009.

Solnit, Rebecca and Joshua Jelly-Shapiro, *Nonstop Metropolis: A New York City Atlas*, Oakland: University of California Press, 2016.

Stapinski, Helene. "Reclaiming South Street Seaport for New Yorkers." The *New York Times* (Online); New York, July 27, 2017. https://search.proquest.com/docview/1923785072/abstract/B8C558885163484CPQ/1.

"Sublime Seas: John Akomfrah and J.M.W. Turner · SFMOMA." Accessed January 14, 2020. https://www.sfmoma.org/exhibition/john-akomfrah/.

Starr, Kevin. *California: A History*. 1st ed. Modern Library Chronicles, 23. New York: Modern Library, 2005.

Starr, Kevin. *Golden Gate: The Life and Times of America's Greatest Bridge*. 1st U.S. ed. New York: Bloomsbury Press, 2010.

Stungo, Naomi. *Frank Gehry*. London: Carlton, 1999.

Swift, Hildegarde Hoyt, and Lynd Ward. *The Little Red Lighthouse and the Great Gray Bridge*. New York: Harcourt, Brace and Co., 1942.

Tate Modern (Gallery). *Tate Modern: The Handbook*. London: Tate Publishing, 2016.

Treib, Marc. "J.B. Jackson's Home Ground." *Landscape Architecture* 78, no. 3 (1988): 52–57.

Tsai, Eugenie with Cornelia Butler, *Robert Smithson*, Los Angeles: The Museum of Contemporary Art, 2004.

Walter, Jörn. "Städtebau und Urbanität en der HafenCity." In *HafenCity Hamburg: das erste Jahrzehnt: Stadtentwicklung, Städtebau und Architektur*, 10–27. Reihe Arbeitshefte zur HafenCity ; 6. Hamburg: Junius, 2012.

Way, Thaïsa. *The Landscape Architecture of Richard Haag : From Modern Space to Urban Ecological Design*. London: University of Washington Press, 2015.

Weegee. *Naked City*. New York: Essential Books, 1945.

Weston, Richard. "Monumental Appeal: Reflections on the Sydney Opera House." In *Building a Masterpiece: The Sydney Opera House*. Burlington, VT: In association with Lund Humphries, 2006.

Whitaker, John. "How the New Whitney Museum Was Designed to Resist Climate Change." The Atlantic, May 27, 2015.

Wolff, Jane. *Delta Primer: A Field Guide to the California Delta*. California: William Stout Publishers, 2003.

Select Bibliography

Image Credits

Courtesy the Metropolitan Museum of Art, New York, cover
Cathy Simon, 4

ARCHIVE: Past
© Bernard E. Simon, 21
© Anne Meyer, 22
© Jim Kidd / Alamy Stock Photo, 22
Courtesy Brooklyn Museum, Gift of Mrs. Daniel Catlin, 25
Courtesy Smithsonian Institution, Gift of Louis P. Church, 25
© Wayne Thiebaud / VAGA at Artists Rights Society (ARS),
 NY, photo: Katherine Du Tiel, 27
Library of Congress, Prints & Photographs Division,
 LC-USZC4-7421, 28
Library of Congress, Prints & Photographs Division,
 LC-USZC2-780, 28
Courtesy National Archives, 30-N-42-1864, 30
San Francisco History Center, San Francisco Public Library,
 30
Library of Congress, LC-DIG-det-4a26913, 30
Courtesy The New York Public Library, 31
San Francisco History Center, San Francisco Public Library,
 31
Library of Congress, ca2272, HAER CA-181-A, 32
Courtesy New York Public Library, Miriam and Ira Wallach
 Division of Art, Prints and
Photography, b13668355, © Berenice Abbot, 32
© Wernher Krutein, 33
Structural Engineers' Association of Northern California,
 San Francisco History Center, San
Francisco Public Library, 33
Library of Congress, Prints & Photographs Division, LC-DIG-
 det-4a16074, 34
Max Guliani for Hudson River Park, 34
Courtesy Perkins & Will © Richard Barnes, 35

ARCHIVE: Work
© National Gallery, London / Art Resource, New York, 40
© RMN-Grand Palais / Art Resource, New York, Photo:
 Hervé Lewandowski, 40
© The Museum of Modern Art / Licensed by SCALA / Art
 Resource, New York, 41
Photo © 2020 Museum of Fine Arts, Boston, 41
© James Schwabel, Alamy, 42
San Francisco History Center, San Francisco Public Library,
 43
Courtesy Friends of the High Line, 43
© Joel Sternfeld, 44
Courtesy Friends of the High Line, 46
© Cathy Simon, 46
© Alex MacLean, 48

© Elizabeth Falicella, 49
© Etienne Frossard, 49

ARCHIVE: Culture
© National Gallery, London / Art Resource, New York,
 53 (left)
© Rex Gary Schmidt, 54 (right)
Courtesy Andrew Hoyem, San Francisco: Arion Press, 1979
 edition, Barry Moser (woodcut) and
Andrew Hoyem (type and design), 55
© Andrew Henkelman, 56
© The Ansel Adams Publishing Rights Trust, 56
Courtesy MFA Boston, 58
Photo © Tate, 58
© President and Fellows of Harvard College, 59
© Carl de Keyzer / Magnum Photos, 59
Courtesy Rijksmuseum, 59
© The Museum of Modern Art/Licensed by SCALA / Art
 Resource, New York, 60
© Smoking Dogs Films, Courtesy Smoking Dogs Films and
 Lisson Gallery, 60
The Art Archive at Art Resource, New York, Photo: John
 Webb, 61
© Weegee/International Center for Photography, portfolio
 4, 61
Public domain, 63
Courtesy New York City Parks Department Photo Archive,
 64
AP Photo/Horace Cort, 64
Courtesy National Archaeological Museum of Greece,
 Athens, 66
© Mstyslav Chernov, 67

ARCHIVE: Art
Photo © Tate, 70
Courtesy of the National Gallery of Art, Washington, 71
© Michelle Pred, photo: Robert Divers Herrick, 73
Courtesy the artist, © Bill Viola, photo: Kira Perov, 73
Courtesy the artist, Aaran Gallery, Tehran, and FOR-SITE
 Foundation, © Mandana Moghaddam,
photo: by Robert Divers Herrick, 74
Courtesy the artist and FOR-SITE Foundation, photo: Jan
 Stürmann, 75
© Cathy Simon, 75
© Cathy Simon, 77
Courtesy Public Art Fund, photo: Julienne Schaer, 78
© Marcello Leotta, 80
Courtesy Benesse Art Site Naoshima, photo: by Marsha
 Maytum, 81

STRATEGY: Interpret

© Holt/Smithson Foundation and Dia Art Foundation / VAGA at Artists Rights Society (ARS), New York, 86
Courtesy Alex Robinson, © Vittoria Di Palma, 87
Courtesy Library of Congress, LC-DIG-ppmsca-36413, 89
Courtesy Thaïsa Way, © Liesl Matthies, 91
© Cathy Simon, 92–93
Courtesy Cultural Landscape Foundation, © Charles A. Birnbaum, 94
© Courtesy Thaïsa Way, 94
Courtesy Hargreaves Associates, 95–97
© Michael Moran / OTTO, 98
© Cathy Simon, 99

STRATEGY: Invite

© Ajay Suresh, 102
© Richard Barnes, 103
Courtesy Anthony Cortez / Arup, © Timothy Schenck, 104
Courtesy the Whitney Museum of American Art, New York and Guy Nordenson and Associates, 105
© Estate of Gordon Matta-Clark / Artists Rights Society (ARS), New York, 105
© Tim Griffith, 107
© Cathy Simon, 107
© FMGB Guggenheim Bilbao Museoa, 2020, Photograph by Erika Barahona Ede, 108, 110
© Cathy Simon, 111
© Bjørn Erik Pedersen, 112
© Graeme Peacock, 114
© Cathy Simon, 115

STRATEGY: Rethink

AP Photo / Charles Gorry, 118
Courtesy Oceans 8 Films / Jon Bowermaster, 120
Courtesy Aerostockphoto, © Marco van Middelkoop, 123
© Ossip van Duivenbode, 124
Courtesy SCAPE, 126
Courtesy Rebuild by Design, 127
© Field Operations, 128
© Tom Leader Studio, 129
© David R. Foster. Image courtesy Harvard Forest, Harvard University, 130
© Sarah Palmer and Dillon DeWaters, 130

STRATEGY: Transform

© Edward Burtynsky, courtesy Nicholas Metivier Gallery, Torono, 132
© John Gundlach, 133
© Maarten Van De Biezen / EyeEm, 135
© Marco van Middelkoop / Aerostockphoto, 136

© Cathy Simon, 136
© Marco van Middelkoop / Aerostockphoto, 137 (top)
© Jeroen Musch, 137
© Cathy Simon, 139
© Christien Spahrbier, 140
© foto frizz, courtesy HafenCity, 141
© Thomas Hampel, courtesy HafenCity, 142
© Maxim Schulz, 143
©Maxim Schulz, 144
Marcus Leith, Tate, 145
Architekturzentrum Wien Collection, © Margherita Spiluttini, 145
© Nigel Young, Foster + Partners, 146

EXHIBIT

All drawings by Bárbara Miglietti
© Steve Proel, 164
© Jane Lidz, 164–67
© Richard Barnes, 169, 172–75, 179, 182–83
© Steve Proehl, 178
© San Francisco Public Library, 182
© SOM, 186–89
© Mission Rock Partners, 190–91, 194–95
© Gerald Ratto, 197
© Tim Griffith, 202–09, 214–23
© Rien van Rijthoven, 210–11
© Blake Marvin, 224–25, 227–39
Courtesy Folger Shakespeare Library, 255

Image Credits

The Tempest, circa 1800, Johann Heinrich Ramberg

ORO Editions
Publishers of Architecture, Art, and Design
Gordon Goff: Publisher

www.oroeditions.com
info@oroeditions.com

Published by ORO Editions

Author: Cathy J. Simon
Co-Author: Carrie Eastman
Editor: Ashley Simone
Essay Writers: John King, Laurie Olin, Justine Shapiro-Kline
Book Design: Office of Luke Bulman
Drawings: Bárbara Miglietti
Managing Editor: Jake Anderson

First Edition

ISBN: 978-1-943532-97-1

Color Separations and Printing: ORO Group Ltd.
Printed in China.

ORO Editions makes a continuous effort to minimize the
overall carbon footprint of its publications. As part of this
goal, ORO Editions, in association with Global ReLeaf,
arranges to plant trees to replace those used in the manu-
facturing of the paper produced for its books. Global ReLeaf
is an international campaign run by American Forests, one
of the world's oldest nonprofit conservation organizations.
Global ReLeaf is American Forests' education and action
program that helps individuals, organizations, agencies, and
corporations improve the local and global environment by
planting and caring for trees.